JOAN MIRÓ

Rosa Maria Malet

JOAN MIRÓ

RIZZOLI
NEW YORK

©1983 Ediciones Polígrafa, S. A.
Reproduction rights S.G.A.E. - F.J.M.
Translation by Kenneth Lyons

First published in the United States
of America in 1984 by:
RIZZOLI INTERNATIONAL PUBLICATIONS, INC.
300 Park Avenue South, New York, NY 10010

Library Congress Catalog Card Number: 83-62002
I.S.B.N.: 0-8478-0524-7

Printed in Spain by La Polígrafa, S. A.
Parets del Vallès (Barcelona)
Dep. Leg.: 25.132 - 1985

CONTENTS

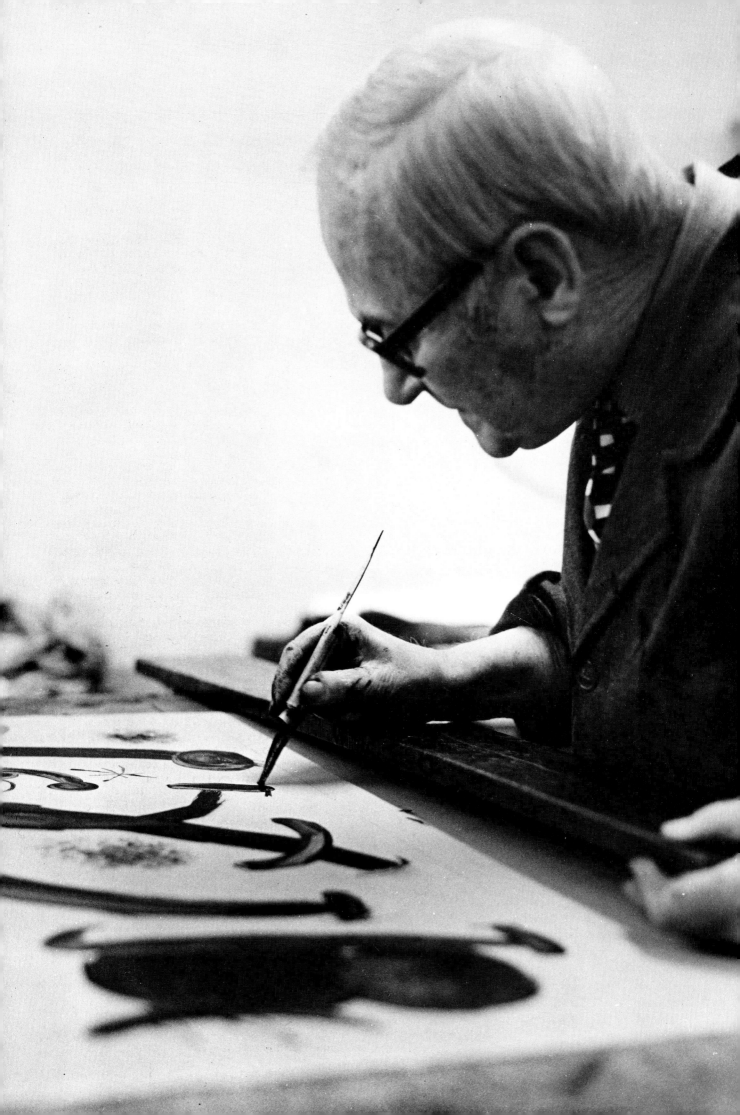

Childhood and learning years (1893-1915)

The rapid technological progress made during the twentieth century has led to an ever increasing specialization in many different professions. This phenomenon, however, does not seem to have affected the world of art in any very radical fashion. Joan Miró is possibly the leading exponent of that way of working that is closer in spirit to the context of the Renaissance — when an artist might find himself painting an *Annunciation* one day and designing a project for the building of new walls for his city the next — than to the atomic age. This is not a question of any kind of anachronism, but the logical consequence of two factors: on the one hand, his family heritage and, on the other, the eternally unsatisfied character that has led him to investigate all the possibilities to be found in materials, forms and colours; and that is why Joan Miró's work includes the most widely-varying fields: painting, sculpture, graphic work, tapestry, ceramics and theatre.

Joan Miró bears the same name as his paternal grandfather, who was the blacksmith of Cornudella, in the province of Tarragona. His father, Miquel Miró i Adzerias, abandoned the village for the city of Barcelona and the work in the forge for the more delicate operations of jewellery and watchmaking. He married Dolors Ferrà, daughter of a cabinetmaker in Palma, who often came to stay at the house of a relation, the shoemaker Oromí, whose shop was near that of Miquel Miró.

The fact of having his paternal grandparents in the province of Tarragona and his maternal ones in Majorca meant that the little Joan Miró made frequent journeys to both places from a very early age.

The various places where Joan Miró has lived or stayed are of fundamental importance if we wish to understand the deeper meaning of his work. In his native city of Barcelona, for instance, Miró first discovered the world of Romanesque frescoes through those recently installed in the Art Museum of Catalonia. The simplicity of these compositions, the richness of their pure colours, the assurance of line and imaginative use of form attracted the child as they were later to attract the artist. In Barcelona, too, he came to know the architecture of Gaudí with its curved and undulating rhythms, rhythms by which Miró admits to having been influenced. The role played by Barcelona in the development of Miró's career, however, was only a secondary one; it is not in any great city that we will find the painter's deepest roots.

Miró has always felt a strong affinity for the countryside of Tarragona. First Cornudella itself and later Mont-roig — where in 1910 the artist's parents bought the farmhouse that he was to reproduce in one of his most important paintings — meant his earliest contact with the work of the fields, the most insignificant blade of grass or the tiniest of insects; with, in short, the telluric force of the earth, on which Miró has always wanted to tread directly as he works, so that its force may rise in his body through his feet. The foot which is in contact with the earth and the eye which contemplates all its grandeur are two almost obsessive images that have appeared consistently throughout Miró's work, which is so very closely bound to the Tarragona countryside.

The discovery of the blue of the sea and of the light-filled sky of Majorca was a very abrupt contrast to the aggressiveness of the country around Mont-roig. In Majorca Miró discovered the Mediterranean — not in Barcelona, a city which in modern times has always seemed to live with its back to the sea. It was in Majorca that he was to capture the vivid colours, those intense blues that were to cover his canvases right through whole periods of his career as a painter. And it was also in Majorca that he first came to love the poetry and naive charm of folk art; in the *siurells*, for instance, those strange plaster whistles which are at the same time little sculptures of human and animal shapes, fashioned by the Majorcan peasants since time immemorial.

Miró's *Catalan-ness*, strengthened by the wide-ranging knowledge of his country that he has had since his childhood, manifests itself in all his work and in the way in which he does it. He himself has confessed that he works his canvases as a peasant does his kitchen garden. The fury of his moments of creative fever never obliterates the common sense that enables him to see which touch he must still give to one painting, which element is lacking in another.

The first drawings by Joan Miró still extant — now housed in the Foundation that bears his name — date from 1901, when the artist was eight years old. They are very realistic drawings, in which there is never any lack of colour: a vase of flowers, an umbrella, a fish, a tortoise... Perhaps the most remarkable of them all, because of the strange subject-matter of its composition, is one that depicts a scene at the chiropodist's establishment. A foot, that part of the human body with which Miró is so obsessed, appears as the central motif of the drawing (Fig 1).

The oldest of the artist's extant sketch-books contains drawings done from life, in Cornudella and in Palma, in 1905. The human figure, which he found so difficult to reproduce, does not appear in any of them.

The increasing interest the little Joan Miró showed in drawing was matched by a proportionally growing neglect of his schoolwork. In 1907, when he had arrived at an age to go to secondary school, his parents decided to enrol him at the Commercial School in order to provide him with the sort of accomplishments needed by anybody seeking a good steady job. If we consider how Barcelona society in those days was dominated by the mentality that subordinated everything to order, thrift and hard work (those worthy virtues immortalized for Catalans by Santiago Rusiñol in his play, *L'auca del senyor Esteve*), we will understand the natural reactions of Miro's parents to their son's ambitions. It would obviously have been difficult for them to agree to their heir becoming an artist, a figure then popularly seen as a man with a penchant for women, drink and a dissolute life in general.

At the same time Miró enrolled in the drawing classes at the famous art school popularly known as the *Llotja* because it was housed in Barcelona's Stock Exchange, the school where twelve years earlier Picasso had astonished teachers and pupils alike with his drawings, which were superior to those done by his masters themselves. Joan Miró was a diligent student enough, but he rejected anything that was not living creation and he hated any sort of academicism or conventionality. Of his years at the Llotja school, however, he retained one good memory: his happy relationship with two of his teachers, Modest Urgell and Josep Pascó.

In the Joan Miró Foundation we may see some of the artist's drawings done from originals by Urgell. The sentimentality of the cypresses and the tumbledown walls in the originals is lost in Miró's versions, which cease to be allegories of any kind to become pictures of real trees and stones. It was from Modest Urgell, however, that he

caught the taste for empty spaces, for the line of the horizon that defines sky and earth, and for the constant presence of the stars.

Josep Pascó was the teacher of decorative arts at the Llotja. Joan Miró's father, who, as I have said, was opposed to his son's passion for drawing, thought that Pascó might at least teach Joan something that would be of use to him in the jewellery business. Thanks to Pascó, at any rate, Miró learnt to appreciate the simplicity of expression and the vitality of colour to be found in the works of Catalan craftsmanship. Pascó, moreover, who was familiar with all the artistic movements of the day, tried to introduce new ideas from those movements into the field of decorative arts in an attempt to enliven the latter and prevent them from standing still. There are still two drawings extant which Miró did in Pascó's class in 1909: a peacock and a serpent, both models for brooches, which show very clearly the Art-Nouveau taste for arabesques and sinuous lines that then prevailed.

At the age of seventeen, after finishing his studies at the Commercial School, Joan Miró began to work as an apprentice accountant in the Dalmau i Oliveras chandler's business. But in a very short time, and partly as a result of his utter failure to adapt to this new occupation, he became seriously ill. This providential illness led to his being sent to spend a long period of convalescence in Mont-roig. And it was there, in close contact with nature, the wild local scenery and the work of the peasants, that he took the decision to devote himself entirely to painting.

Early youth (1915-1917)

On returning from Mont-roig, completely recovered from his illness and having decided to live for painting alone, Miró enrolled at the School of Art run by Francesc Galí, a private establishment of a rather more open spirit than the Llotja. The classes were not limited to the classic sessions within the school walls, for the students made frequent excursions into the country in order to draw the elements of nature in their natural setting, and there were also regular poetry readings and debates. This was Miró's first contact with the Catalan poets of the time, whose works he was to continue to read for the rest of his life.

The first exercise that Galí set his new pupil was to draw a still life in which there were only objects without any colour (a drop of water, a jug, a potato...). The teacher's surprise when he saw the result could hardly have been greater. His young pupil had transformed that ensemble of objects into "a magnificent sunset", to quote Galí's own words; that, at least, was the impression he received from Miró's colour-rich composition.

Galí realized at once what a gifted colourist Miró was, but he perceived with equal clarity the young man's ham-fistedness when it came to reproducing form. He decided to cope with this difficulty by blindfolding Miró with a handkerchief and then placing some object or other in his hands, or even making him feel all the contours of the head of one of his classmates. Then he was told to draw whatever he had had in his hands without having seen it. In this way Francesc Galí aroused a new sense in Joan Miró: that sense of touch that was to be so important in his work throughout his career.

It was at Francesc Galí's school that Miró first met the young man who was to be his closest friend during these early stages of his career as a painter. This was E. C. Ricart, with whom Miró was to share a studio some years later in the Carrer de Sant Pere més Baix.

Between 1915 (the last year of his studies at Galí's school) and 1918, Miró attended the drawing classes at the Cercle Artístic de Sant Lluc, where he learnt to draw models from life. From his sketch-books of this period we can form a very good idea of the young Miró's everyday life and interests, for the academic drawings of nudes alternate with sketches of dancers, clowns and other music-hall characters. Undoubtedly Miró was extremely anxious to perfect his style, but we can also see how his line became freer and more assured in drawing these characters from the world of entertainment that he frequented when he left his classes with his sketch-book still in his pocket.

At the Cercle Artístic de Sant Lluc Miró made the acquaintance of Joan Prats, who was to be his closest friend all his life, the ceramic artist Llorens Artigas, with whom he was to collaborate many years later, and J. F. Ràfols, the future author of *Miró before the Farmhouse*. These classes were attended both by artists just starting out on their careers and by men with reputations already well established, such as the great architect Antoni Gaudí, who was now, almost at the end of his life, an assiduous student in the drawing classes of the Cercle de Sant Lluc.

The first catalogued painting by Joan Miró, *The Peasant* (Fig. 6), is dated in 1915, at which time he was still studying at Francesc Galí's school. This subject, which here made its first appearance, was to be repeated again and again throughout his career. Thus we can see how the artist's roots in the earth and the influences received during his long stays in Mont-roig appear in his work from the very beginning. The actual form of the character is as it were drowned by the exuberance of the colours and the very thick, Fauvist-inspired brushwork. The influence of Fauvism, indeed, characterized by a certain distortion of the forms, unreal colours and thick brushwork, is evident in most of Miró's early works.

In 1916 and 1917 Miró painted a series of landscapes of Mont-roig, Cambrils, Siurana and Prades, as well as the one done in Barcelona entitled *The Reform* (Fig. 7), all of them displaying Fauvist characteristics. Miró himself has described as Fauvist his entire output up to 1918, but in using this terminology it should be borne in mind that Miró's Fauvism is not the same as that of the French artists of that school. In both, of course, it is a question of the juxtaposition of pure colours forming contrasts, letting the colours used act by virtue of their own expressive value, quite apart from any reality. Miró's brushwork, however, differs from that of the Fauves in that it is much thicker and much freer.

Apart from the influence of Fauvism, in the landscapes that he painted in 1916 and 1917 we may also find reminiscences of the work of Van Gogh, in *Prades, a Street* (Fig. 10), and of that of Cézanne, in *Siurana, the Village* (Fig. 12).

In 1916 Miró showed his canvases to Dalmau, the art dealer who was later to organize his first one-man show in Barcelona, and whose gallery was a sort of clearing-house for the latest trends of the time. The First World War had led many foreign artists to find a haven in Barcelona, and the city's intellectual and artistic life had become extremely animated as a result. The young Catalan artists were naturally very anxious to know what sort of work was being produced beyond the Pyrenees. It was in the Galeria Dalmau that all the art-lovers used to forgather, to have long conversations with Francis Picabia, who with Marcel Duchamp was the prime mover of a Dada group in the United States. The Dada movement's principal aim was to ridicule the hypocritical society that had permitted the circumstances that led to the outbreak of war in 1914. Its attacks on the bourgeoisie and on academic art took the most varied forms and were notable for their ingenuity and imagination. In Barcelona Picabia published the review "391". All the avant-garde reviews, moreover, arrived regularly: "Les Soirées de Paris", "Nord-Sud", a copy of which can be seen in one of Miró's paintings, and "L'instant", which was in fact published simultaneously in Barcelona and in Paris, and

for which, in 1919, Miró did his first poster (Fig. 8). The works of the great French poets of the time were translated into Catalan by J. V. Foix and Josep Maria Junoy; the latter was to write the presentation for the catalogue of Miró's first show.

At this time Miró was in a sense watching the way things were going; but, as he himself admits, he was not to feel influenced by the Dada movement until a few years later, when he was already living in Paris. It was still along Fauvist lines that he painted about a dozen still lifes and a series of nine portraits in the studio he was sharing with E. C. Ricart at No. 51 in the Carrer de Sant Pere més Baix.

Most of these still lifes betray the influence of Cubism and, more especially, of Cézanne. In his *Still Life with Knife* he presents us with a very particular interpretation of Cézanne, the Cubists and the Fauvists all at once. His struggle to give some order to his compositions and to represent objects with due respect for their identity, while at the same time playing with colour, becomes more evident in *The Blue Bottle* and *The Rose*. In *Nord-Sud* (Fig. 9) Miró achieves the balance he wanted between the colour and the objects. The colours of the cloths seem to be arranged in a circular rhythm that gives a certain lightness to the composition, while each of the objects keeps its identity and at the same time helps to form an entirely harmonious whole.

Joan Miró has always been an indefatigable worker, constant in his purposes even to the point of obstinacy; and thus, having arrived at a moment when he thought his work should take a new direction, between 1917 and 1918 he painted a series of nine portraits. With these nine paintings Miró was once again facing up to the problem of representing the human figure, that problem that he had found so difficult to solve during his student years. Miró's reaction to the human figure is, to some extent, a violent one. Thus in the *Portrait of Ricart,* for instance, the acid colours — yellow, blue, pink, green, mauve — that are emphasized by the stripes of the jacket contrast with the yellow of the background and with the Japanese print stuck on the wall behind the figure as though in a collage.

All the hands that appear in these portraits are clumsily painted and have a contorted, almost arthritic look. A good example of this is the *Portrait of V. Nubiola* (Fig. 13). These tormented hands give the portrait a sensation of extraordinary life and, at the same time, of violence. The table, distorted in accordance with Cubist ideas, seems to be a sort of prolongation of the sitter, who in leaning on it creates a particular rhythm within the composition.

The hieratical attitude in the *Self-portrait* (Fig. 11) — the first in a series of four painted in 1917 (this one), 1919, 1937 and 1960 — seems to have been taken from the Romanesque paintings that had made such an impression on Miró in his childhood. There is nothing to distract the eye from the subject of the composition. The artist appears here absolutely alone.

This series of nine portraits is completed by the *Portrait of Maria* (a peasant woman from Siurana), the portraits of *J. F. Ràfols, Heribert Casany, Juanita Obrador* and *Ramon Sunyer,* and by the *Standing Nude.*

Most of these canvases, which had been painted between 1916 and 1918, were exhibited at Miró's first one-man show, which was held at the Galeries Dalmau, in the Carrer de la Portaferrissa, Barcelona, from 16 February to 3 March 1918.

Period of details (1918-1922)

Having gone through this ordeal of seeing his paintings torn from his studio and hung up alongside one another in a different setting from their usual one, Miró decided to spend the summer in Mont-roig, in his desire to give his work a new direction. From there he wrote to his friend Ricart: "What interests me above all else is the calligraphy of a tree or of the tiles on a roof; leaf by leaf, branch by branch, blade by blade of grass..." This way of expressing himself reveals quite clearly a change in his attitude to his work.

Miró was now attracted by slow, meticulous handling, which may explain why in that summer of 1918 he painted only four landscapes: *Kitchen Garden with Donkey* (Fig. 16), *The Tile Works, The House with the Palm Tree* and *The Path.* In these canvases Miró would appear to be drawing up a sort of inventory of the fruits of the earth yielded by the countryside around Mont-roig. All the smaller plants are treated with the same delicacy as the trees and clearly considered just as important. Each separate part of the tilled ground is sharply differentiated from the one next to it. There is an accentuation of the tactile sense, so that in *Kitchen Garden with Donkey* the grass is shown in detail only on the patch of ground where the animal is grazing and has it within reach. The colour is not dissociated from what is depicted in each of these canvases, for it succeeds in creating an overall impression of the whole and at the same time respecting each detail.

During the winter of 1918-1919 he turned to portraiture once more and painted *Portrait of a Little Girl* (Fig. 14) and the second *Self-portrait* (Fig. 15), both done in accordance with the new, detailed approach that he had worked out during the previous summer. The colour here no longer functions independently, as was the case in the 1917-1918 portraits, but helps to underline the form and to give greater strength to the composition, whether in the blue of the little girl's dress or in the red of the jacket in the self-portrait.

The treatment of form, however, is not the same in these two works. The little girl's face, with its almond-shaped eyes, makes one think of Japanese prints, which were not difficult to find in Barcelona at that time. But the flattening in the self-portrait reminds us again of Romanesque paintings, with the addition of some of the Cubist discoveries, as may be seen in the folds of the cloth.

After finishing these two portraits Miró set out on his first journey to Paris, where he arrived on 3 March 1919. I have already spoken of the significance for Miró's work of Barcelona, Mont-roig and Palma, but as yet I have said nothing of the last geographical point which had a decisive influence on our painter. Paris, dominated at that time by the Dada movement, meant Miró's first real contact with avant-garde art. He also visited the Louvre, the first great museum he had ever known. The impact on the young man was too great. Miró returned to Catalonia without having painted or even drawn anything during his stay in Paris. He evidently needed time to reflect and to assimilate all he had seen. The real consequences were not to make themselves felt until his second trip.

On his return to Catalonia he went straight to Mont-roig, where he painted *Mont-roig, the Church and the Village* (Fig. 17), in the same spirit as his 1918 landscapes. Now this picture is an ascendant composition, in which there are three clearly demarcated planes, or levels, of depth. The differentiation, however, is not achieved by the use of perspective but by different degrees of realism. Thus we pass from the foreground, which is a stylized, geometrical plane representing patches of ground with different crops, to the third plane of the background, in which we have a vision of the village with all sorts of details.

The year after this he painted four still lifes: *The Card Game, Horse, Pipe and Red Flower, Cluster of Grapes* and *The Table* or *Still Life with Rabbit* (Fig. 19). These

are all canvases that have been very carefully worked out, dense almost to the point of preciosity and with Miró's exploitation of the discoveries of Cubism very much in evidence, for in them he makes considerable use of broken lines, intersecting planes and angles that give an effect of depth on a totally flat surface.

At first sight it might seem that Miró had made a very superficial analysis of the Cubist approach to painting. Really, however, he was very far from the sort of problems with which Picasso, Braque and Gris had concerned themselves.

The first visit to Paris had only been a sort of exploratory trip. Towards the end of 1920 Miró went there again, and this time he managed to find a studio. The sculptor Pau Gargallo, since he was a teacher at the Barcelona School of Fine Arts, could spend only the summer months in Paris. The two men came to an agreement and thus, while Gargallo was in Barcelona, Miró could use his studio at No. 45 in the rue Blomet and continue to spend his summers in Mont-roig.

Miró's financial situation at this time was really precarious. His family helped him, of course, though he never asked them for anything. But his régime of austerity was an extremely harsh one; his poverty was such, in fact, that he could only afford a proper lunch once a week. The few possessions he had in the studio — a frying-pan, a sofa and a chair — had all been bought at the *Marché aux puces.* In spite of all this, however, the cleanliness and tidiness of Miró's studio were proverbial among all his friends. Without this extreme neatness he found it impossible to work.

His beginnings in Paris were not only difficult on account of his financial straits. For Miró, who has always been rather shy and not very talkative by nature, did not find much support among the other Catalans who had settled in Paris. Llorens i Artigas was the only one who helped him to make some acquaintances in the world of art. It was through him, in fact, that Miró began to participate, though only as a looker-on, in the ''Soirées Dada'' and first met Tristan Tzara, the most notable leader of the Dada movement.

The rue Blomet, where Miró had his studio, was very soon to achieve a certain celebrity thanks to the *Bal Noire,* which was frequented by all the fashionable people in Paris. There he met various writers and artists, among them his neighbour, André Masson, around whom was formed the rue Blomet ''group'', consisting of Michel Leiris, Georges Limbour, Robert Desnos and Antonin Artaud.

In 1921 Dalmau succeeded in organizing an exhibition of Miró's work at the Galerie La Licorne in the rue de la Boétie. This was the painter's first show in Paris, but it was an absolute flop. Not a single canvas was sold.

After the failure of this exhibition Miró returned to Mont-roig, where he began to paint *The Farmhouse* (Fig. 20), the masterpiece of this period of details and also the key to his future work, which he did not finish until 1922 in Paris. *The Farmhouse* definitively represents Miró's rejection of the huckstering society that infested cities and his almost official alignment with the hard but sincere everyday reality of country life. The human aspect is present in every detail of this picture. The animals in it are all domestic animals, the plants those grown for his purposes by man and the objects those needed by man in all his daily tasks.

Miró made a very careful study of every one of these details, even to the point of taking grass from Mont-roig with him in his suitcase when he returned to Paris, so as to be able to finish the picture properly in the rue Blomet. All the elements, though studied separately, form a beautifully balanced whole. For instance, the detail of representing the cracks in the wall of the house and the

moss growing in them is intended to counterbalance the squared effect of the wire netting in the chicken run — which is only partly shown because, as Miró says, it would not have let the viewer see the animals inside. And the objects scattered all over the ground — the olive-pressing vat, the stool, the watering can, the bucket... — have been carefully placed by the farmer just where Miró has asked him.

The general effect of the plants almost suggests an endeavour to draw up an inventory of them all: the maize, the agave plant, the tree which is the centre of the whole composition, which has only one thorn but that one of enormous size, symbolizing all those that the tree might have. This disproportion in the representation of the vegetable kingdom is quite deliberate and is intended to show that for the artist a tree and a blade of grass are of equal importance.

Though rather reluctantly, Miró showed *The Farmhouse* to some art dealers who he thought might be interested, but none of them bought it. Finally it was hung in a café in Montparnasse where they used to let artists hang one work for a night, but this was equally unsuccessful. It was not until years later that the American poet Evan Shipman took an interest in *The Farmhouse,* which he wanted to buy for Ernest Hemingway. Neither of them had enough money, but by scrounging among their friends they managed to raise the five thousand francs demanded for the picture by Jacques Viot, who was at that time in charge of Miró's affairs. And thus *The Farmhouse* became the prized possession of Ernest Hemingway, with whom Miró was already acquainted, as they both attended the training sessions for boxers at the American Centre. Miró recalls that they made a strange pair, Hemingway so tall and burly and he himself small and thin, but they were both interested in keeping fit.

But the detailed treatment that culminated in *The Farmhouse* gradually began to lose ground in Miró's painting. In 1921 he painted *Portrait of Spanish Dancer* (Fig. 18), which was inspired by a coloured print. This painting is one of intense, precise line, stripped of any accessory element, unless we count as such the characteristic features of the sitter. Very soon this dancer was to become part of the private collection of another celebrated painter: Pablo Picasso.

During the summer of 1922 Miró painted what were to be the last works of his realistic period: *The Farmer's Wife* (Fig. 21), *Flowers and Butterfly* (Fig. 22), *The Acetylene Lamp* and *The Ear of Wheat.*

The Farmer's Wife might easily be mistaken for an enlarged and stylized fragment taken from *The Farmhouse.* This stylization gives the composition something of a feeling of aloofness from reality, underlined by the abstracted air of the character that gives the canvas its title, the model for which was not taken from life but from a figure in a crib. This is a detail that emphasizes yet again the interest Miró has always felt in folk art.

The first thing that strikes the eye is the disproportion between the huge feet and the rest of the woman's body. For it is in fact through the feet that Miró believes we come in contact with the energy of the earth that transforms reality.

The seed sown in Paris bears fruit in Mont-roig (1923-1924)

When Miró returned to Paris in the winter of 1923, his expressive resources in any sort of realistic line were exhausted. Along that particular road he could travel no further.

The Dada movement aimed at putting an end to all sorts of preconceived ideas and inventing new systems of

expression. And it was in the rue Blomet group that this new language was being worked out. Miró felt at ease among these friends of his and this gave him confidence to seek a way out of his difficulties.

The previous summer he had brought grass from Montroig to Paris to finish *The Farmhouse*. But this time he carried away with him all the enthusiasm of the rue Blomet and began to paint *Ploughed Earth* (Fig. 24).

Instead of reproducing reality as it appeared "before his very eyes", Miró decided to let himself be pervaded by what he saw and by the current of emotion that came from it. This would be what he was to paint when, back in his studio, he was left with only the impact of what he had seen. Miró himself has said that he does not seek a vision outside reality but, quite on the contrary, an escape in nature.

Ploughed Earth reminds us in many aspects of *The Farmhouse*. Once again we have the house, the kitchen garden, the domestic animals and the ones living in freedom, like the snail, the lizard, the birds... All of them are treated with all sorts of details, but there is an evident desire to attain to a more metaphorical, more poetic level. It is the same with the plants; in order to emphasize the fact that the pine is a living being, Miró endows it with such human attributes as an eye and an ear. The painting is flat and the selection of the planes is not made according to perspective rules, but rather as a result of an emotional selection, in which equal treatment is given to all the beings that appear on the canvas.

In *Ploughed Earth* we find the real and the imaginary coinciding inseparably; it was the imaginary that was increasingly to predominate in Miró's future work. And we must be careful not to confuse imagination, an ability to see what does not exist but is possible, with fantasy, which is the faculty of seeing that which does not exist and is, moreover, impossible.

The change initiated with *Ploughed Earth* continued with *Catalan Landscape*, sometimes called *The Hunter* (Fig. 25), in which the stylization is much more marked. The carob tree, for instance, presents the utmost in reduction to the imaginary. Its rounded form is transformed into a circle, from which a stem protrudes with a leaf at its tip. As was the case with the pine in *Ploughed Earth*, the carob tree acquires human attributes, since it is also endowed with an eye.

In much the same way the human character is reduced to what we might consider to be its fundamental attributes: the moustache, the beard, the stocking cap and the pipe. Since he is returning from a day's shooting, his skinny arms bear the weight of the gun in his right hand, with a flame coming out of the barrel, and there is a rabbit on the left.

The forms here are rendered schematic either by means of geometrical shapes — circle, cone, right angle, triangle — or through reduction to a simple line. This latter may be straight, as in the case of the hunter's body or that of the sardine, or ondulating, when it signifies life, thus contrasting immobility and movement. Sinuous, therefore, are the moustache and the sardine's tongue, the sun's rays, the heart, the flames...

In this canvas Miró introduced the letters "Sard", which have given rise to different theories as to their possible meaning: *sardana*, the name of the traditional Catalan dance, or *sardina*, in reference to the fish in the foreground. The ambiguity of these letters has been cleared up by Joan Miró himself, who has said that they are intended as a reference to the dead fish, going by the experience Miró has had of aquatic animals when they are out of their own environment.

During the same summer Miró painted *Pastoral*, which is rather a drawing on canvas than a painting, and in which he seems to have been compiling an inventory of the various figures and signs that were henceforth to be constant features of his vocabulary.

In 1924 Miró painted the first of a series of three canvases which between them represent a *Head of Catalan Peasant* (Fig. 30). Once again we are confronted by a motif which appears to be an enlarged fragment from another painting, in this case the head of the hunter in the painting of that name. Now, however, it resembles an automat or a puppet rather than a real human character, an effect that is underlined by the wooden foot that supports the peasant's head. The right angle, which is normally used to represent femininity, becomes a stocking cap. The eyes, joined by a horizontal axis, emphasize this robot-like effect of the character, who is smoking a large pipe.

Portrait of Senyora K (Fig. 27) is a good example of Miró's schematic symbolism of woman. The images of the triangle and the right angle appear again, this time to indicate the femininity of the character. The breasts, one presented frontally and the other in profile, are united by a vertical axis, echoing the horizontal axis I have mentioned as joining the eyes of the Catalan peasant. The earth offers one of its fruits, a vegetable, of which we can see the plant and the roots, while an equally schematic bird appears in the sky. The heart with its flames symbolizes the character's emotional life.

Still more schematic is the composition entitled *Maternity* (Fig. 31), which is a pure reduction to the symbolic. The woman is represented here by the elements placed at the ends of two lines crossing each other obliquely. At the lower end of one of these lines we see the rounded right angle that symbolizes the female sex, and at the other end a head like that of a dressmaker's dummy, with hair emerging from it. The other line goes from a round white breast, the lunar sign, seen frontally, to one that is between brown and black, the solar sign, and is seen in profile. The first of these is suckling a female child (as we can see from the hair), while beside the other is a male child. The woman's viscera are represented in this picture by a yellow undulating line that crosses the longer axis. Nothing else stands out against the transparent blue of the background. These few elements are enough to intone a hymn to life with the simplest representation.

The Bottle of Wine (Fig. 26), on the other hand, is — like the 1924-1925 *Dialogue of Insects* — a hymn to the earth and its most insignificant inhabitants. The motif that gives the composition its title has become a volcano, thus alluding to the living forces of the earth, which is also represented by the mountains. The snake and the insect illustrate what Miró wrote to Ràfols informing him of his interest in the smallest blade of grass, the life of the insects and everything that the countryside around Montroig could offer him.

The Carnival of Harlequin (Fig. 23) is the last work in this series presided over by the imagination. This is a picture with a very detailed treatment and one that requires careful observation. Miró painted it during a particularly hard period for him, when he was in fact really hungry, but he forced himself to undergo the discipline of work, as he has said himself, in the same way as an oarsman must spend a lot of time rowing upstream to strengthen his muscles. A sort of automat playing the guitar and a Harlequin with a large moustache are the principal figures in this composition. We also see a couple of cats playing with a ball of wool, a bird with blue wings that seems to be coming out of an egg, flying fish rising towards the stars, an insect emerging from the interior of a dice. On the table there is a large globe, an immense ear protrudes from the ladder, cylinders and cones with eyes are scattered over the floor. There is a window opening on to the exterior, where we can see

the sun and a conical shape that represents the Eiffel Tower.

The colours help to create the harmony of this picture, in which, though it is apparently so baroque, when we examine it closely we will realize that everything has been arranged in accordance with the academic system of dividing the surface of the canvas into a grid of squares.

The Carnival of Harlequin represents the synthesis of the forms conquered by Miró in the course of a year's hard, constant work. Just as he had done with *The Farmhouse,* in this later picture the artist has summed up one stage in his career — this time a brief but very intense one — before starting on a new one.

Surrealism (1924-1927)

At almost exactly the same time as Miró was painting *The Carnival of Harlequin,* the writer André Breton created the Surrealist movement and issued its First Manifesto, in which he proclaimed: "I believe in the future resolution of these two states, apparently so contradictory, which are dream and reality, in a sort of absolute reality, or surreality."

The Surrealists based their research on the infinite possibilities that are offered by the world of dreams. So important did they consider this state to be that they went so far as to provoke it by drugs or hypnosis. Some of the Surrealist writers, in fact, worked under such effects and believed that in this way they could bring to the surface of the conscious mind things that would normally remain hidden and unknown. The most classic of the working methods used by the Surrealist writers — and we should not forget that in its beginnings the movement was a strictly literary one — was automatic writing, which consisted in writing on the paper before them everything that came to the surface of their minds, however apparently disordered. The equivalent in painting was automatic painting. The Surrealists abandoned the idea of external models and accepted as valid only what came from the world of the subconscious. Their pictures, therefore, frequently represented what they had seen in dreams.

Joan Miró did not paint dreams, but through his work he placed within the viewer's reach certain elements that would make that viewer the one who dreamt. Miró has never worked under the influence of hypnosis, drugs or alcohol. His life — like his work — has always been methodical and orderly, but his artistic personality, his way of representing on canvas everything that his inspiration dictates to him, led André Breton to exclaim: "Miró is the most Surrealist of us all!"

From 1925 onwards, pictures by Miró were reproduced in the review "La Révolution Surréaliste", and the exhibition of his work that opened at the Galerie Pierre on 12 June 1925 had all the air of an official manifestation of the whole group. The printed invitation was signed by all the Surrealists and Benjamin Péret wrote the text presenting the catalogue.

The whole of fashionable Paris would appear to have attended this opening. The more Bohemian element was represented by characters like the celebrated Kiki de Montparnasse, rather more elevated social spheres by such figures as the Crown Prince of Sweden and the Comtesse de Clermont-Tonnerre. The owner of the gallery, Pierre Loeb, was afraid that the floor might give way under the weight of such a crowd. Even the police were present, as a precaution against any possible disturbance of the peace. Miró, as elegant as any dandy for the occasion, received all his guests with great ceremony and was later accompanied by many of them to round off the evening at a dance hall, where he electrified his friends by

dancing a tango, in the most correct dancing-school style, with a woman several inches taller than himself. All in all, this show was a memorable and successful one.

Some months later the same gallery organized an exhibition of works by the Surrealist painters which also included some canvases by Picasso and Klee. At this show Miró presented *The Carnival of Harlequin* and two other works painted in 1925. By now he was fully integrated into the group, with whose members he was on the best of terms, but this did not mean that he worked in obedience to ideas dictated by anybody but himself. His attitude was that of a believing rather than a practising Surrealist. It was very unusual indeed to see Miró among the members of the group at the Café Cyrano, in the Place Blanche; and even if he was there he rarely took any part in the discussions. His silences were famous even in those early days.

In 1925 Miró abandoned this fantastic painting through which, thanks to his ideogrammatic language, he transformed the objects, the landscapes and the beings of his familiar universe. From now on his painting was to be the expression of the movements of the live being, of its capture at the source. The atmosphere of these canvases makes one think of the painting of dreams, which is not the same as the painted dreams of some of the Surrealist painters.

This atmosphere of dreams is what characterizes the pictures (almost a hundred) painted during the winters of 1925, 1926 and 1927, and distinguishes them both from the rest of Miró's own output and from the automatic paintings of the other Surrealist artists. By and large, all of these canvases are monochrome paintings, dominated by the colour of the background — blue, grey, brown, etc. — on which allusive writings, stains and signs appear. The form, almost always rendered in light-coloured stains, lets the colour of the background show through. The notes of colour are there to bring out a detail from time to time, but they are infrequent.

Some of the works hide a barely decipherable reality from us: works like *Painting* (Fig. 37), for instance, in which we only recognize figures that we have seen before, such as the right angle or the circle. Generally it is a question of a transfer to canvas of impressions received in the course of a walk, or perhaps from reading, or as a result of hallucinations brought on by hunger. Unlike the Surrealists, Miró sought inspiration by concentrating on the forms produced by the cracks in a wall, damp stains or the movements of clouds. All these observations, carefully noted in his sketch-book, were used as starting-points for his compositions.

Although not very often, some of the compositions of those years originated in his working-out of a reality he had experienced, a landscape or some familiar scene. This is so in the case of *Smoker's Head* (Fig. 32) or *The Siesta* (Fig. 34). Thanks to the sketch-books of this period, now preserved in the Joan Miró Foundation, we can see that the latter painting was at first a descriptive composition showing two characters beside the sea. One of them is dozing, propped up against the wall of a house with a sundial pointing to twelve o'clock. But the whole has been transformed into a single white stain. The other character is swimming in the sea, near some rocks represented by the blue crest on the right. The sun is blazing down, at the height of its noonday splendour.

Painting (The White Glove) (Fig. 36) is possibly intended to recall a session of magic, with the magician's white glove a prominent element. A butterfly, with a red stain, gives the composition a note of colour and weightlessness.

The integration of words or phrases in his paintings produced what the artist calls "poem-pictures." It was around this time that he painted *Ceci est la couleur de*

mes rêves, Le corps de ma brune puisque je l'aime comme ma chatte habillé en vert salade comme de la grêle, c'est pareil and *Oh! un de ces messieurs qui a fait tout ça* (Fig. 28). In these paintings the poetical words combine plastically with the pictorial poetry at the same time as the words or phrases are integrated into the composition as another element.

With these paintings of dreams Miró opened up a new road — the road of abstract lyricism — in the world of contemporary art. In this he was anticipating by twenty years the creation of a suggestive space thanks to the combination of texture and structure, as has been recognized by artists all over the world.

During the summers of 1926 and 1927, which he spent in Mont-roig, Miró gave up this painting of dreams in order to return to landscape. With his feet once more treading that earth that gave him his creative impulse, he painted *Character Throwing a Stone at a Bird* (1926), in which the character of the title, with only one foot but that one of enormous dimensions, is depicted as closely bound to the earth; the *Landscape* known as that of the locust (1926), where we find again his world of little wild animals and insects; *Dog Barking at the Moon* (1926), in which the ladder appears like a premonition of the escape ladder so often found in the *Constellations* Miró was to paint in 1940 and 1941; and the *Landscape with Serpent* (Fig. 33), in which the serpent seems to give life to a desert landscape in brown and ochre tones.

In the course of each of these summers Miró painted fourteen canvases. His work was slow and meticulous, as was the work he did in Paris, but he really needed to return to the earth and to spend some time away from the subjective painting he was doing during the winter. The suggestive backgrounds of the dream paintings now disappeared and were replaced by compositions in which the line of the horizon — recalling his teacher, Modest Urgell — delimited sky and earth. It was a real line, but at the same time an ideal line traced by the contrast between the colours of the earth and that of the sky. It was the line that separates the real world from the world of ethereal things represented by the sky. The colour that filled these canvases had a strength hitherto unknown in Miró's work.

Inspiration through the masters of other ages (1928-1929)

During the spring of 1928 Miró made a journey to Holland, where he spent a fortnight visiting the principal towns and the most important museums. The result of this journey was his series of *Dutch Interiors*. The intimist realism of the seventeenth-century Dutch masters made a deep impression on Miró and revived his taste for the familiar objects we have already seen in *The Farmhouse*.

He bought postcards reproducing some of these compositions, which he used as a starting-point for painting the three canvases that form this series. He subjected the characters and the objects to a process of metamorphosis and then placed them in a space re-created according to the model. The whole process can be followed perfectly through the collection of preparatory drawings for the series preserved in the Joan Miró Foundation.

Dutch Interior I (Fig. 39) comes from *The Lute Player*, by H. M. Sorgh. The character of the title is playing a lute of such dimensions that one feels that, rather than the lute resting on his crossed legs, these legs seem to be emerging from the instrument. The head appears to be prolonged in the whiteness of the table, at which a woman is sitting with a music score in front of her. A cat is playing with a ball of wool under the table. In the left foreground a dog is gnawing a bone, a toad attacking an insect and a kitchen knife peeling an apple. On the other side of the composition we see a footprint on the floor, a bat flying and a picture — representing a landscape — hanging on the wall. To the right of this picture an open window lets us see a townscape of Amsterdam, with the canals, a bridge, a barge, a swan, some houses in the background... The interior space is delimited by the colours of the two walls and the floor and emphasized by the situation of the principal character in the corner where the three colours converge.

The meticulously detailed treatment of the *Dutch Interiors* is differentiated from anything we have seen in Miró's work so far — *The Carnival of Harlequin,* for instance — by the close ties that exist between form and colour. In both cases we are dealing with descriptive painting; but while in the earlier work the composition was based on a harmonious ensemble of figures, now the artist is arranging the surface using the rhythmical possibilities suggested to him by the elements of the composition when they are placed in a space. It is not just a sequence of figures, but a true ensemble.

In *Dutch Interior II,* inspired by Jan Steen's *Dancing Lesson with Cat,* Miró has followed the original model quite literally, but has introduced several variants, giving full rein to his imagination, like the sinuous line that seems to be trying to frame the composition; or he has considerably altered the relative dimensions of characters or objects according to the importance with which he wishes to endow them.

The last of the *Dutch Interiors* is, in its subject-matter, the most violent. It is a representation of a woman giving birth to a goat. This subject, which is one of extreme fantasy, has enabled Miró to let himself go in the violent contrasts of colour that accentuate the dramatic nature of the situation.

During the early months of 1929 Miró painted his series of four *Imaginary Portraits,* which are to some extent the continuation of the experiments he had been making with *Dutch Interiors,* for these portraits are likewise re-creations of works done by masters of an earlier age.

In painting these portraits Miró is not attempting to interpret the work of another artist, but rather using that work as a starting-point for an analysis of pure form, through a classic portrait in this case, that will finally produce an authentically *Mironian* figure. This process can be followed, just as if it were a film sequence, through the corresponding series of preparatory drawings. When Picasso was dealing with a problem like this he always maintained the relationship between the work chosen and the one he himself created from it. But this did not occur with Miró. He resorted to the pictures of other masters to replace the system of spontaneous creation by an elaborate reworking, generally in the aspect of form.

The *Portrait of Mrs. Mills in 1750* (Fig. 41), which is based on the work of the same title by George Engleheart, a pupil of Reynolds, is the first in the series and the richest in details. It is still very close to the *Dutch Interiors,* especially in its descriptive intention. The original work depicts a woman of the aristocracy, richly dressed and ostentatiously bejewelled, who is reading a love letter. Miró has followed the anecdote quite faithfully, but he has added humour in the way he represents the character's accoutrements.

In this portrait, and indeed throughout the series, it is the colour rather than the line that defines the forms and makes character stand out. We see the reappearance of the line of the horizon separating the yellow of the sky from the red and brown earth. The stains of colour made by the hat, the bodice and the skirt stand out from the background in order to form a surface that is organized without any help from the line.

The simplification is increased in *Portrait of a Lady in 1820,* based on a portrait by Constable. The character, with her sinuous silhouette, is defined by the masses of colours standing out against the yellow of the background. The five buttons fastening the blouse are all that is left of the model.

The most schematic of all these portraits is the one entitled *La Fornarina,* based on Raphael's work. Here Miró has not permitted himself any excess in the addition of decorative details. The character stands out against an absolutely bare background.

The *Portrait of Queen Louise of Prussia* deserves special mention. The origin of this character is to be found in an advertisement Miró cut out of a newspaper with a reproduction of the machine advertised. The next step was a drawing done by Miró on an underground railway ticket. The outline of the machine had suggested the silhouette of a female character wearing a long dress — an image that was quite familiar to Miró, for in his childhood all women wore dresses reaching to the floor. Little by little this character took on definitive shape and was finally placed in a pictorial space delimited by the colours.

The *Imaginary Portraits* mark the end of a period that had begun in 1924, in which Miró had thoroughly explored all the possibilities offered by painting as such, especially with regard to form and colour. It was at this point that the break came with a period he had outgrown and, at the same time, with Surrealism. Now Miró would appear to have felt some curiosity about the researches of the pioneers of abstract art, Mondrian and Kandinsky, though he was never to follow that path himself.

On 12 October 1929 Joan Miró married Pilar Juncosa in Palma. The young couple settled in Paris, at No. 3 in the rue François Mouthon. Miró's financial situation did not permit him to have a studio of his own, so he had to work in one of the rooms of their flat. They often visited Mont-roig and Barcelona, and it was in Barcelona, on 17 July 1931, that their only daughter, Maria Dolors, was born.

From the assassination of painting to the purity of form (1929-1934)

Between 1929 and 1931 Miró was going through a crisis of expression which he himself has called *the assassination of painting.* This may be due to the appearance of the works of this period. Painting as such practically disappears and is replaced by drawing and collage. And during the summer of 1930 he did a series of drawings on the theme of the couple and woman alone. The line, free and assured, succeeds in giving a very clear idea of both form and volume.

At the same time as these drawings he was working on what he called *Constructions.* For the first time he was working in three dimensions, though we cannot properly speak of the results as sculptures or objects. To the bidimensional surface Miró added keys, *objets trouvés,* shells, sandpaper, etc. Some fragments were painted, but painting always played a secondary role in these works. Miró's purpose was to show how the most ordinary objects may be turned into objects of art.

Miró's crisis of expression coincided with the crisis of the Surrealist movement. The whole group, with André Breton at their head, were faced with the necessity of adopting a political position. The title of the review they published, *"Le surréalisme au service de la révolution",* made it clear what sort of position it would be. But now the question for them was whether or not they should declare their adherence to the Communist party. Miró considered that he should refuse energetically to be an active member of any party; to his mind it would mean a regression, a loss of liberty on account of the discipline it would entail. Miró's work, anyway, is a sufficiently clear testimony on behalf of freedom to make the adoption of any political position unnecessary.

Miró and his family spent the summer of 1932 in Mont-roig. There he painted twelve small pictures on wood which he exhibited at the Galerie Pierre Colle in December of the same year. Except for *Man's Head* (Fig. 40), all of these paintings — *Flame in Space and Nude Woman* (Fig. 49), *Woman Standing, Woman Sitting, Bather...* — are variations on the female figure, a theme that has always interested Miró and one that he has not treated individually but rather taking the concept of woman as though it were a whole universe. In this case it served him as a plastic study of form and colour. The figure preserves its appearance, but is at the same time subjected to a plastic distortion that imposes a compositive rhythm. The colours are intense and vivid, the sober elegance of the acid tones predominant. In these paintings Miró again makes a study of real space to be integrated into pictorial space. Once more he uses the line of the horizon, the interior space without any attempt at perspective; another feature to reappear is seascape, which the artist has always felt to be something very close to him.

This series of small-format paintings on wood marked a transition to the large canvases of 1933. Throughout this year the painter's financial straits obliged the whole family to remain in Barcelona. In the flat in the Passatge del Crèdit, where his mother still lived, he painted eighteen canvases in which he put to the test his mastery of pictorial technique and his creative powers.

The first step to be taken in the creation of these eighteen large-scale pictures was to make up eighteen preparatory collages, one for each. This was done by cutting out fragments of newspaper advertisements or commercial catalogue illustrations and sticking them on to a sheet of Ingres paper. The result was a composition totally lacking in colour — most publications in the thirties were in black and white — from which was to come a new approach to the interrelationships of all the elements, with regard to both the form and the colour he was gradually to instil into each of them. Then he created a space, hitherto lacking on the white surface of the paper, in which to insert the figures that made up the composition. This previous operation eliminated the possibility of the artist's spontaneous inspiration being the only factor appreciable in the whole. The collage obliged Miró to concentrate and to reflect on what his pre-established plan could be expected to produce. And the result is a rigorous fining-down of the form that reduces the composition to its bare essentials.

An examination of a *Painting According to a Collage* (Fig. 42) will show us the method followed by Miró to transform the original collage into a painting. In this case we see a row of plates in the upper left-hand corner; a wheelchair in the opposite corner of which nothing is left but the wheels; some glasses just left of the centre and on the lower right-hand side which have been turned into stains of white, red and black; in the middle there are knives and choppers of various shapes, some of which have taken on humanoid features; of a folding carpenter's measure there remains a sinuous line to the right of centre; and a saw, in the lower left-hand corner, is shown schematized in its essential lines, as are some pliers lying nearby.

The space into which all these forms have been insinuated has been created on the basis of a gradation of sober colours — grey, dark green, ochres, blue — which do not so much delimit a space as suggest one. Unlike the *Dutch Interiors,* in which Miró was subjecting a given composition in each case to a process of metamorphosis,

in each of the *Paintings According to Collages* he is creating a composition on the basis of elements which are not, apparently, bound by any common ties.

Of all Miró's vast output these eighteen *Paintings According to Collages* are among the works that best reveal the reflective way of working that characterizes this artist, who has never let himself be carried away by spontaneity or gratuitousness.

During the summer of 1933, which he spent in Mont-roig as usual, Miró managed to escape from the austere discipline he had imposed on himself with the *Paintings According to Collages* and worked with greater freedom on a series of *Collage-drawings.* Among these special mention should be made of the *Collage in Homage to Joan Prats,* today in the Joan Miró Foundation. Joan Prats, a prominent figure in the world of avant-garde art in Catalonia all his life, and also, as I have said before, Miró's closest friend, was a hatter by trade with a shop of his own. And Miró wanted to pay his friend an apt compliment by presenting him with a collage in which pictures of hats cut out of a magazine would be combined with the forms drawn. Throughout this series of collages the fragments stuck on to the surface are no longer taken from commercial catalogues but from turn-of-the-century postcards and schoolbooks of the same period, with all the evocative power they possessed. The drawing in arabesque that is combined with the collage plays a very important role in these works.

On two of the preparatory canvases for tapestries done during the winter of 1933-1934, we again find inscriptions: *Escargot, femme, fleur, étoile* (Fig. 44) and *Hirondelle amour,* as in some of the 1925 paintings. In the present case, however, their intention is very different. While the words that appeared in the works of the Surrealist period had an evocative power that strengthened the composition, in these later canvases the writing is a much more integral part of the whole and is intertwined with the characters depicted. The latter — painted in flat tones of red, yellow, white and black — stand out against a very elaborately painted background, in which the gradation from the greens to the browns or deep reds is a very gentle one, and one that undoubtedly complicates the work of any weaver commissioned to transform these canvases into tapestries.

"Savage paintings" (1934-1936)

When everything made it appear that Miró had found his own medium of expression, when he had finally attained to a perfect mastery of form and colour, a new crisis suddenly occurred — or, rather, not so much a crisis as a change in the guide lines he followed. Once again the painter revealed his constant urge to go further, to run the risk of trying new paths that would surely lead to new pictorial solutions, whether through technique or through the materials used.

At a time when his sojourns in Mont-roig were becoming more and more prolonged, and his ties with the avant-garde in Paris gradually loosening, Miró's pictorial universe began to be peopled by monstrous beings that seemed to be heralding the political unrest that was to come. Speaking of the paintings he did during the two years before the Spanish Civil War, Joan Miró has described them as "savage paintings". The first sign of this savagery is to be found in a series of fifteen large pastels that he did in the summer of 1934. Here Miró gave up flat paint and made use of chiaroscuro to create an atmosphere of anguish. The characters that appear in these works have organic forms reminiscent of some of the bones or vital organs of human beings, and this gives them the Dantesque aspect of creatures in a nightmare. Their overall effect betrays a new dramatic content

surrounded by an eroticism that is camouflaged by distortion, an eroticism that had always been latent in earlier works and one that was gradually to become more evident in future, but which was never to prove vulgar or gross. For Miró sex is an element of effusion, a means of dislocating established rules and turning conventional values upside down.

Immediately after this he set to work on eleven paintings on the rough, unpleasing surface of cardboard. Other monstrous characters, completely distorted, made their appearance in this new series of paintings. These deformed creatures were not the product of fantasy but came, as is so often the case in Miró's work, from everyday life: the woman, the Catalan peasant, the animals round the farmhouse, the mountain and the sea. In *Three Women* (Fig. 46) the imbalance in the volume of each figure is compensated by the imbalance in the others. The large white stain of the head of the character on the right, with its spindly legs and sex, contrasts with the great black mass, to which Miró has added sand, of the character in the middle. The third character, reduced to two rounded stains of colour, seems to be suspended in the air.

In the same spirit, but at a much higher pitch of cruelty and aggressiveness, in 1936 he painted *Woman and Dog before the Moon* (Fig. 47), a picture in which it seems that only the dog is to be saved from the extremely violent treatment to which the female figure has been subjected. The latter, seen in profile, shows a thickened, swollen tongue which is stretching out as though trying to reach some non-existent being. The contrast of the strident colours accentuates the dramatic quality of the composition.

At the end of 1935 Miró painted *Signs and Figurations.* This is a series of six compositions which he himself has called *graffiti on tarred paper.* The rough, wrinkled surface of the support suggests to the artist the idea of doing improvised graphic signs, getting away from figurative representation. This thick paper covered with sand and tar gives him the idea of the rapid strokes that he draws with the brush as though he were working directly on the surface of a wall.

Through the works of this period we see a Miró who feels attracted both by aggressive forms and by unusual supports. The monsters are the principal figures of the *savage paintings,* as though in an endeavour to anticipate the approaching catastrophe of the Civil War. The only way of defeating them is by letting them show themselves. This was what Miró did, and between 23 October 1935 and 22 May 1936 he produced six paintings in egg tempera on copper and six paintings in the same medium on masonite. He resorted to a craftsman's technique once again and worked these twelve paintings with most elaborate care. The fineness of the line makes a remarkable contrast to the aggressiveness and distortion of the figures and the landscape.

Man and Woman before a Heap of Excrement (Fig. 45), painted on copper with short, precise brushstrokes of great delicacy, is a good example of this meticulous way of working that is such a contrast to the anguish of the composition. Once again we see the line of the horizon separating the sky of terror, painted black, from the earth, on which we see the two characters gesticulating; their sexes and their extremities seem to have been lengthened, as though wishing to draw nearer to one another, but without succeeding.

The countryside around Mont-roig and the characters and animals of the farmhouse are also present in these paintings, but they have been radically transformed because of the aggressiveness of the content.

On 18 July 1936 the Civil War broke out. From now on Miró gave up his painting of testimony and replaced it by a sort of violent, direct exorcisms, the 27 *Masonites* (Fig. 48).

What is savage about this series is not the representations but the mere act of painting itself. The monsters are replaced by the painter's direct attack on the support which gives him his stimulus. The material of the background, masonite, is never wholly hidden. On top of it Miró deposits the white of the casein, the black of the tar, sand, asphalt... The landscape disappears, the beings are reduced to their most basic characteristics. The forms, undoubtedly, are very much those of Miró, but clearly schematized: forms deriving from the sphere, from the nail of a big toe, from a bean. A phallic form appears frequently, sometimes representing a whole character.

The "masonites" have all the force of a shout; as such, however, they cannot go any further. They are the equivalent of a spontaneous manifestation by the artist against certain events, but they do not open up any new road. Miró had to leave Mont-roig, and leave Spain, if he was to find himself and his proper medium once more.

From tormented painting to simplification (1937-1938)

In the autumn of 1936 Miró returned to Paris. The atmosphere there was very different from what it had been on his last departure for Spain. The authoritarian political régimes, in the ascendant over most of Europe, had turned Paris into a city of exiles and refugees. And in Miró's case moral suffering was accompanied by material hardship. He found himself obliged to put up in a modest apartment in the rue Jules Chaplan, where there was just enough room for him and his wife and child to live, but certainly not enough to work in.

In 1937 Miró attended the drawing classes at the *Grande Chaumière*. Once again he found himself face to face with the living model. The hundred or so drawings that he did there still show signs of the process of metamorphosis initiated in his more recent works. The model is always subjected to some distortion, born of violence and the inner suffering Miró was going through at the time. The mere fact of capturing the reality of the model's attitude, however, brought the coherence of form back to him.

Since he had no studio of his own, when he was not drawing at the *Grande Chaumière* he worked on the mezzanine of the Galerie Pierre. It was there, through the five months from January to May of 1937, that he painted one of his fundamental works, *Still Life with Old Shoe* (Fig. 51), in a style that has been described as tragic realism. The tragedy shows clearly through the objects, the colours and the threatening cloud effects. What we see is certainly not a representation of any specific events in the Spanish Civil War, but the tragedy is there. A fork stuck into an apple, a bottle, a crust of bread and a shoe express with the utmost simplicity all the horror of the war in Spain. The objects, caught by reality, swell in the same way as the nudes of the *Grande Chaumière,* which makes their presence menacing and obsessive. The hard, rough colours seem to transfigure the objects. It is as though a ray of light came from outside the canvas to accentuate still further the reliefs and volumes. Miró, who had always expressed himself through flat paint, seemed to have regressed. In fact, however, the modelling of the objects and the phantasmagorical shadows were absolutely necessary to express the panic that affected everybody and everything in Spain at that time. In 1937 Miró painted *The Reaper,* also known as *Catalan Peasant in Revolt,* for the pavilion of the Spanish Republic at the Paris International Exhibition.

Luis Lacasa and Josep Lluís Sert (many years later Sert was to build Miró's studio outside Palma and the Joan Miró Foundation in Barcelona) were the architects commissioned to design this pavilion. The building as constructed was functional and austere, and the architects worked in close cooperation with the plastic artists. Picasso painted *Guernica* for exhibition there and Calder built his mercury fountain, while Juli González created the sculpture *Montserrat* and Alberto the one entitled *The Spanish People Have a Way that Leads to a Star.* Products of folk art were shown side by side with these avant-garde works.

Miró did his painting on six panels of *celotex* — the material that lined the whole interior of the pavilion — measuring altogether 5.5×3.65 metres. This was the artist's first monumental work, a work that unfortunately disappeared later, for it was very probably dismantled at the same time as the pavilion itself, and all that has remained of it is a photograph.

The contrast between Picasso's *Guernica* and *The Reaper* is evident. While the former brings out all the suffering and despair of a whole people, the latter is one of Miró's typical characters, in the style of the "savage" paintings, making evident in itself the aggressiveness and rage of the whole community through the individual. We can recognize the character — whom we have seen before — by his *barretina* (the red stocking cap that was still part of the Catalan peasant's typical costume). Now, however, instead of a wine jug or a sporting gun it is a sickle that he has in his hands. The violence of this character is conveyed by his gesture, his attitude and the features of his face. The scene, which has nothing anecdotal about it, is reduced to the peasant's head with the sickle in his raised hand. The expression on his face is perfectly comparable to that we find in Miró's monsters, with his eye starting out of its socket, the nose disappearing into the forehead, the teeth sharpened like knives. It is the painting of a shout of rage that nobody has ever expressed better than Miró.

In complete contrast to this work Miró then painted a series of six extremely delicate pictures on plywood, pictures we might truly describe as poetic. Apart from notes made in the street, the artist always developed themes which at the beginning were mere suggestions. The representations that appear in Miró's paintings do not allude to specific facts or events but to generalizations. Only at the start of his career did he paint portraits and landscapes which, despite the transformation to which he subjected them, were based on a specific reality. But as from 1923, when Miró ceased to internalize visions and began to externalize inward experiences or states of mind, his work became a generalization based on things he experienced.

The delicacy of the paintings on plywood later gave way to the aggressiveness of works like *Head* (Fig. 52), painted on the same support. In this work Miró incorporated a new element, a towel stuck on to the hard surface of the plywood. This towelling gave a new texture to the background, producing a sort of irritability that underlines the brutal aspect of the composition. The irregular perimeter of the head occupies almost the whole of the surface; there is only enough space left to emphasize the outline with an intense blue. The single eye, which is extremely large, seems to be observing us sharply. The rough texture of the towelling, stiffened by the glue, is made to seem even rougher by its greenish ochre colour.

Today, perhaps, we should not be quite so astonished to find a towel stuck on to the surface of a picture. We are accustomed by now to seeing objects, papers, pieces of wood, etc., combined with painting; but if we go back to 1937, when Miró painted this *Head,* we will realize what courage it must have taken to produce a work like this one. And it is in this very aspect that Miró's merit lies. He has always done things in a very personal way, a

way that has left no room for doubt as to the authenticity of his work, but one which has at the same time opened up new roads for future generations.

The last masterpiece of what has been described as the period of "tragic realism" is *Self-portrait I* (Fig. 53), which Miró did during the closing months of 1937. This portrait is a large drawing done in lead pencil with some slight touches of oil painting. Miró worked in front of a looking-glass with the intention of making a preparatory sketch for a painting. The drawing, however, became increasingly more meticulous, more complicated and more detailed, and in the end it occupied the whole canvas. In 1960 Miró was to make an exact copy of this drawing and on top of it he did his own new version, twenty-three years later, of the self-portrait. The colour, applied with a very thick stroke, underlines the sitter's most characteristic features, with special emphasis on the eyes. The contrast between his almost baroque manner of working in 1937 and the free, specific line of 1960 is very evident.

Of this *Self-portrait I* it might be said that it is Miró's only unfinished work, since he never reached the stage of applying the paint on it; but the drawing is sufficient to classify it as definitive. A portrait first intended to be a realistic transcription of the painter's face gradually acquires a presence that takes it beyond reality. For the first and only time Miró transcribes his own face with a markedly tragic conception. The artist has since said that he used it as he might have used any other object: to work on it as a painter. And he went on to say that the eyes are like sparks: in one there is a star, in the other the sun, here a sort of bird, there a flower; and the hairs are like flames.

The eyes, with their astral appearance, appear again in *Self-portrait II,* painted in 1938; this time they are so enlarged that they occupy a large portion of the canvas.

It is rather difficult to compare these two *Self-portraits.* The first is a realistic drawing without any colour. The second retains no connection with the model and is a perfect harmony of colours. The apparent lack of any relationship between one and the other makes the two portraits complementary works, which at the same time mark the break between tortured painting and simplification.

Very close to *Self-portrait II,* as far as the compositive concept is concerned, is *Une étoile caresse le sein d'une négresse* (Fig. 50). Here Miró has abandoned his tormented graphism and acid colours. The composition is flat, the graphism extremely simple and the forms, which are isolated, tend to have something of the nature of signs.

The way in which Miró's writing evolved towards the sign is quite clearly shown in a series of pictures entitled *Portraits I, II, III* and *IV.* The theme is always the same: a single character, very much simplified. *Portrait I* still retains some of the characteristics of the "savage" paintings. The colours of the background belong to a tormented atmosphere. The enormous head leaves hardly any space for the sun, which peeps out timidly, like a ball of wool with needles stuck in it.

Portrait II (Fig. 55) is simplification carried to an extreme. Standing out against a background of Prussian blue we see the flattened circular mass of the head and the semicircular shape of the body. The colours occupy strictly delimited surfaces which are determined by the forms. This painting is surprising in its lack of detail.

Portrait III follows much the same lines as to austerity of forms and maximum expressiveness of colour. *Portrait IV,* which ventures even further into the world of signs, might well be taken as an emblem of femininity, on account of the preferential position accorded to the sign that represents the female sex in Miro's work: an almond shape painted with two different colours that are separated by a vertical line, the whole being surrounded by undulating black lines. These four *Portraits* indicate the direction Miró was taking, while at the same time announcing what might be expected of the style of his maturity, which was to be based on the use of a limited number of pure colours, their richness coming from the powerful contrasts, the exact point of placing and an extraordinary sense of rhythm. All of this would be combined with an increasing simplification of the flat forms and a progressive transformation of the forms into signs.

Varengeville and the Constellations (1939-1941)

Varengeville, a little village on the coast of Normandy, was to play a very important role in Miró's work just before the Second World War. For in August 1939 Miró rented the Clos des Sansonnets there, and he and his family stayed in this house until May of the following year. All the works of this period, which are of capital importance in the context of Miró's work, were inspired by the place and by the special circumstances created by the imminence of war.

Miró is a man who has always been very sensitive to scenery. But his experience in this regard had so far been practically confined to the Tarragona countryside and that of Majorca. He could hardly have found anything more dissimilar to those regions than the scenery of the coast of Normandy, with its wild beaches, stormy seas and low-sweeping mists. Both the atmosphere and the light are radically different from those of the Mediterranean.

Both Majorca and Tarragona had played definitive roles in the formation and affirmation of Miró's personality as an artist; it was in those places that he had received the strength of the earth, which, as he has so often said, comes up through his feet. Varengeville proved to be a source of inspiration which, though temporary, was not on that account any less important — not because of the earth but through its skies.

Before settling in Varengeville himself, Miró painted a series of pictures inspired by the various short stays he had already made in the village, as the guest of the architect Nelson. This was the series entitled *The Flight of a Bird over the Plain,* consisting of four paintings done according to rough sketches done on the train. Rather than sketches, in fact, we might describe these as notes taken from life, jotted down on an underground railway ticket or in the white margins of a newspaper. From the double (and opposed) movement of the train and the flying birds Miró produced some compositions that are full of energy, extremely bare but highly thought-provoking in their simplicity. It was through the birds that Miró began his approach to the skies of Normandy.

The artist and his family settled in Varengeville when the war had ceased to be merely imminent and become threateningly present. He felt an inner compulsion to escape from the reality that surrounded him, for which he felt an enormous repulsion. And so Miró escaped into himself, going ever more deeply into his inner being, into his thoughts. His secluded life in Normandy was favourable to this process of introspection, in which a fundamentally important role was played by the sky and the night with its stars — with which Miró associated music. In the course of a conversation with J. J. Sweeney, he said: "I felt a deep desire to escape. I deliberately shut myself up in my mind. The night, music and the stars began to play increasingly important roles in my pictures. And music was beginning to be of as much importance to me as poetry had been in the twenties..."

Between August and December Miró painted two series of small pictures, *Varengeville I* and *Varengeville II,* the first on a red background and the second on sacking. The

dominant characteristic in both of these series is the assurance of the brushwork and the firmness of the line drawn over the background. The characters still come from the "savage" paintings, but we may already detect a tendency to movement and to the establishment of a relationship between the figures which frees them from their isolation. Between them these two series, but principally *Varengeville II,* already herald the famous series of the *Constellations* (Figs. 57 to 60).

The first of the *Constellations* — *The Sunrise* — is dated 20 January 1940, and was painted in Varengeville; the twenty-third, and last — *The Passing of the Divine Bird* — was finished in Palma on 12 September 1941. Miró painted the first ten gouaches of this series in Varengeville with an undivided enthusiasm and dedication that would make one think he was quite unaffected by the terrible events that were convulsing Europe. But by 20 March the advance of the German troops forced him to interrupt his work. With the greatest difficulty the painter and his family managed to get on to the last train leaving for Paris. As if things were not complicated enough, his daughter, Maria Dolors, had her arm in plaster. Miró and his wife decided that she would look after the child, while he took care of the portfolio containing the *Constellations,* which was his only luggage. On arriving in Paris they caught a train that took them to Perpignan, from which they then made their way to Girona. There they were met by Joan Prats, the artist's lifelong friend, who advised them not to go on to Barcelona, for Miró might find himself in serious difficulties on account of having painted *The Reaper* for the pavilion of the Spanish Republic at the Paris International Exhibition in 1937. The Miró family, therefore, spent some time in Vic and were finally able to move to Palma.

The *Constellations* represent a new step forward in that adventurousness that has always characterized Miró's work, that eagerness to set himself new problems in painting and find new solutions to them. The first operation consists in the preparation of the paper which is to be used as the support. Miró wets it and scrapes it, to bring out a live, wrinkled surface. Here we find once again that tactile sense that the artist had learnt at the classes in Francesc Galí's school. After that he applies the colours of the background, which pass very gently from one tone to another with that extreme sensibility that is such a very personal characteristic of Miró. These transparent backgrounds, apparently all resembling one another but really so different, create a space that seems to demand the participation of the line and the pure colours.

The figures are the descendants of those of the preceding years, but the particular arrangement of the lines and colours takes away the aggressiveness they had shown in earlier works. The characters are no longer seen as isolated and cruel, but rather as caught up in a whole network that gives shape to the composition and frees them from any trace of violence. The iconography of the *Constellations* appears to be endeavouring to represent the whole order of the cosmos. The characters symbolize the earth. The stars are a reference to the unreachable world of the sky, our only experience of which can be visual or tactile. The way in which the stars are represented is very broadly varied: from the four lines crossing at a central point, which is their most frequent form in Miró's work, to the .wo opposed triangles, or the circles of colours united by broken or undulating lines. The birds and the ladder of escape are used as a liaison between the earthly world, of which we have a direct experience, and the celestial world, which is the source of imagination.

The apparent complication of lines, reminiscent of a sort of spider's web, is accompanied by an extreme simplification of colours. The great lines that dominate the compositions are those that give shape to the characters and the animals, while at the same time arranging the distribution, the dimensions and the colour of the secondary elements. As the painter himself said to J. J. Sweeney, "some forms suggested here called for others there to balance them. And these new forms in turn called for others again. It seemed an endless process..."

Within this complexity of forms the colour plays a fundamental role. The range Miró uses is an extremely restricted one: frequently three or four pure colours are sufficient accompaniment for the various tones of black. Colour is systematically subjected to form and the way in which the forms are superimposed on one another determines the differences of colour. For instance, if a black circle is superimposed on a red one, the surface common to the two is yellow. This particular characteristic in the distribution of the colour was to become one of the most typical features of Miró's work, and was finally to produce that chequering of colours that is so specifically his alone. Although the yellows, blues, reds, oranges and greens appear in such restricted fashion, they nevertheless give considerable force to each of these gouaches. This chromatic richness, despite its sparingness, can only be explained by the rightness of the way in which each colour is applied in its proper place.

Miró finished the series of the *Constellations* in Palma and Mont-roig. With these small-scale works the cycle of cruel paintings is closed. The aggressive forms of the previous years disappear. Miró, who was to some degree living in isolation in his own country, was to seek a new way of expressing himself and was again to find a new road that would lead him to the period of his fullest powers.

It was in this same year — 1941 — that Miró, living almost in seclusion in Palma, received the encouraging news of the success of his first large-scale retrospective exhibition, at the Museum of Modern Art in New York. It was also at this time that J. J. Sweeney, who had organized the show, published the first monograph on Miró.

A language of his own (1942-1946)

In 1942 Miró and his family settled in Barcelona again, this time in the Carrer Folgueroles. The painter continued to work in his studio in the Passatge del Crèdit, where he had been born and where his mother was to live until her death in 1944.

With the *Constellations* Miró crystallizes the beings, the stars and the signs of his inner universe. He rejects external sources of inspiration. He resorts neither to models nor to dreams nor to the impulse of instinct. He dispenses with the external world and brings out everything that comes from the very depths of his ego. From now on it will be more impossible than ever to establish similarities between Miró and any other painter. The least experienced gallery-goer will not mistake his work, the most brazen of painters will not be able to plagiarize it. Miró's work is now unmistakable. And the reason is very simple: Miró speaks a language of his own which everybody can understand but cannot repeat, since the speaker does not use any direct reference to the external world.

Miró's output in 1942 and 1943 was very abundant, but practically all of it continued to be done on paper. He made use of all the materials that a sheet of paper could take: pencil, India ink, watercolour, pastel, gouache, paint mixed with benzine, coloured pencils and even such unusual ingredients as blackberry jam. His work at this time almost amounted to alchemy. While certain other painters have made it their chief concern to attain to a

perfect mastery of technique, Miró takes a delight in exploring every possibility of the unexpected in the materials he uses and looks forward to the emotional impact of surprise that will condition the creative process. He does not submit the material to his will, but rather expects from it all the suggestions it can offer him. This spirit of adventure and investigation was not only to continue presiding over all Miró's creative work throughout his career, but was in time to become even more accentuated.

Despite the apparent limitation as to theme of all these works on paper — Woman, Bird, Star — his eagerness to find new resources led to the invention of new forms. And thus women, stars and birds became common themes with infinite possibilities of combination thanks to the artist's imagination. Another constant in all these works is the apparition of characters on different scales. A character occupying practically the whole of a composition, for instance, is contrasted with another, of much smaller dimensions, who appears to one side and is generally done with different handling, as is the case in *Painting with Art-Nouveau Frame* (Fig. 56). This is one of the few paintings on canvas done during 1943, and the only one ever painted by Miró with any thought for the frame. There is a curious history behind this work and its frame. Joan Prats, who was indefatigable in his visits to Barcelona's flea market (*Els Encants*), once bought there an Art-Nouveau frame. When Miró saw it he immediately asked his friend to leave it with him for some time. Prats agreed, of course, and was most pleasantly surprised when, on going to fetch it again, he found it surrounding the painting in question.

The repertory of signs and figures invented by Miró at this time was a very large one. For the artist was not only endeavouring to express himself but at the same time working out his own language. Since this language was to be a living thing, however, it was naturally liable to development. Some of the forms were to be laid aside, and others definitively established: the characters, with their attributes; the heavenly bodies — sun, moon and stars — that were to constitute Miró's cosmology; the signs, like the ladder of escape, formed by four or six intersecting lines, the undulating or broken line terminating in a ball at either end and, finally, the spiral that grows out of a central point.

After four years without painting on canvas, in 1944 Miró began to do so again, using small formats as a general rule. He worked the background with modulations of colour, or by bringing out the texture of the canvas in such a way as to create a space in which the figures stood out very clearly. He continued to use pure colours, which he placed in perfectly delimited areas.

Most of these canvases are surprising in their simplicity: one or two characters, some stars, other heavenly bodies or signs, and no more. This is because of the constant refining process to which Miró subjected his language, in order to say as much as possible with a minimum of elements. The characters are not engaged in any specific action, nor are they expressing any sentiment or passion; they merely participate in the totality of the cosmos.

As regards Miró's pictorial output, the year 1945 may well have been one of the periods that contributed most to making his name known to the general public.

Except for two paintings with black backgrounds, the pictures he did at this time were painted on a very uniform light-coloured background, usually either greyish blue or pale blue. The space is occupied by characters of considerable dimensions, birds, heavenly bodies and signs. Among the most frequent signs we find those black circles, generally grouped in pairs by means of curved, straight or broken lines, which symbolize the stars as they did in the period of the *Constellations*. Their arrangement

in the space, which is different in each canvas, gives life and movement to each.

Most of the characters are drawn with fine, delicate strokes. Miró applies his pure colours with moderation here, changing them at each point at which one form is superimposed on another and emphasizing those parts of the human body that most interest him, especially the eyes, the female sex and the feet. In these canvases we see how the form of the eye and that of the female sex can be interchangeable, which represents a certain economy in the number of forms used, a characteristic that we will find again in many of Miró's later pictures. Side by side with this very precise way of working we also find in many of these canvases signs and figures that are created almost in a single gesture with a thick brush soaked in colour. This is the case of *Woman and Bird in the Night* (Fig. 62). This opposition of styles creates a rhythm in the composition and, by contrast, helps to emphasize both figures.

The painter's abundant output in 1946 kept to the general line of the paintings done in the two preceding years, but with a marked tendency to greater freedom of writing and invention. This may be seen in *Woman and Bird at Sunrise* (Fig. 61), in which Miró shows us that he has not the slightest objection to centring the composition on a character showing the attributes of both the male and female sexes.

From now on Miró was to abandon his tormented distortions once and for all; in future he would incline more to humour or to the brutal force that gesture and colour place within his reach.

International recognition (1947-1951)

While Madrid knew nothing of Miró, and was indeed to continue to ignore him until 1978, when he finally had a large-scale retrospective there, in Barcelona he was now known to a comparatively small number of friends, poets and artists. In Paris, after his first exhibition in 1921, he had had several other shows and had made his way from failure to some measure of success. Quite a few of the more discerning members of the public in the French capital recognized the merit of his work and accorded it the importance it deserved, but to the public in general he was an unknown, or at best an inconspicuous figure.

It was in the United States that the merits of Miró's work were first recognized on the international level. The first large-scale retrospective that he had there — the one held at the Museum of Modern Art in New York in 1941 — certainly helped to make him and his work much more widely known, as did his exhibitions at the Pierre Matisse Gallery. The general public now accepted Miró and was eager to see his work.

This favourable reception accorded to Miró by the American people was ratified by the commission he was given in 1947 for a large mural painting intended for a restaurant situated in one of the most imposing skyscrapers in Cincinnati. Miró rented a large studio in New York, where he stayed from February to October of 1947. He did not begin to work on the mural until he had made a close study of the characteristics of the premises in question and the intended position of the canvas, which was to measure ten metres in length by three in height. This huge piece served to put to the test the degree of stylistic maturity attained by the artist. And with it there could be no doubt that Miró's work, made up of signs and colours, adapted perfectly to this vast scale.

The eight months that Miró spent in the United States marked an important turning-point in his life. On the one hand they confirmed the real validity of his work and the widespread fame he had gained; on the other hand it had been made clear that, when Miró left his easel painting to

try his hand at monumental work, the result was well up to his usual standard. From this time on, commissions for large-scale works were to come to him with ever-increasing frequency.

On his return from New York, and before going to Paris for the spring, Miró painted a mural and fourteen canvases. In these works we see once again the contrast between spontaneous elements, executed with a gesture, and forms worked out with the utmost care, in which the colour is very precisely distributed. This is evident in *The Red Sun Gnaws at the Spider* (Fig. 63), in which the large black graphic sign in the centre and the smaller one on the right, underlined by the surrounding red, are contrasted with the character on the left, very precisely drawn and carefully coloured, as well as the little signs scattered over the green background: the female sex in the lower right-hand corner, the eyes that seem to be trying to provoke the viewer, the stars.

In *Mural Painting for Joaquim Gomis* (Fig. 64), which Miró painted at about the same time, it is the rough background of fibrocement, scraped and rubbed by the artist so as to get all the possible different nuances from it, that contrasts with the delicate line used to represent the characters — who represent the family of that friend of Miró's for whom the work was intended. The result is a composition of extreme sharpness, in which everything is exactly where it should be; we can see clearly how, if we attempted to make any change in the arrangement of the elements, the work would cease to be a "Miró", since the artist displays more than sufficiently the perfect mastery he had attained in the balance of his paintings and in the distribution of the elements that go to make them up.

In the spring of 1948 Miró returned to Paris for a one-man show at the Galerie Maeght, where all his subsequent Paris exhibitions were to be held. At this he presented his most recent works: paintings and ceramics. All his friends came to the opening, which was also attended by representatives of museums and galleries. Paris, in short, welcomed Miró's return with great enthusiasm and confirmed its previous recognition of his work: that work created on a basis of constancy and risk, and always with eagerness to pursue new goals and not to let himself be carried away by the sort of success that leads to stagnation.

His success in New York and Paris stimulated Miró to work as never before. He settled down in Barcelona again and there, between 1949 and 1950, he did 55 paintings, about 150 drawings and quite a number of sculptures, objects, etchings and lithographs — among these last being those intended to illustrate Tristan Tzara's book, *Parler seul.*

The canvases painted during these two years represent two clearly differentiated working methods: some of them are very carefully worked out indeed, while others are absolutely spontaneous. Hitherto we have found these two tendencies coexisting in one and the same work. But now Miró differentiates the two styles, one of which is the result of a period of reflection and the other the manifestation of an impulse. These two styles, which complement and balance each other, had never been so clearly differentiated as they were now.

The first thing that attracts one's attention about the more elaborate paintings is their great diversity as to background. Take *Characters in the Night* (Fig. 65), for instance. Miró had always shown himself greatly concerned to achieve very delicate textures in the backgrounds of his works, but never before had he reached such a high degree of sensibility. The colour is applied on the canvas leaving both warp and woof quite visible. The green becomes ochre and the ochre yellow or red, passing very gently from one tone to the other. The rubbings and scrapings give an appearance of age to the

backgrounds, which thus make the compositions seem still more noble. All of these operations prepare the ground for the apparition of the forms. The drawing is extremely delicate, and since Miró's vocabulary of forms is already established it permits a very broad range of possible combinations. Like any other language, it has an infinite number of ways of expressing itself. Characters, birds, heavenly bodies and signs play fundamentally important roles in Miró's iconography. It is no good trying to give a precise meaning to each and every one of the artist's works, for the signs he uses acquire a universal validity. Miró's language has been compared to music, and there is indeed a certain parallel, for just as music has no concrete meaning, so we cannot attribute any wholly univocal intention to Miró's work either.

The rhythm created by the precision of the drawing is underlined by the application of the pure colours that the artist distributes over the surface in the divisions and border areas generated by the forms. Black and white are of capital importance, along with other primary colours such as red and green.

As a reaction against the more elaborate paintings, during 1949 and 1950 Miró painted a second series of pictures, in which his spontaneity is given free rein to express itself. In this series it would seem that all materials are permitted: as supports he uses not only canvas but also cardboard, masonite and sandpaper; oil paints may be accompanied by charcoal, gouache, pastel or watercolour; and there is also room for unusual objects, such as wire, plaster or string.

All of these pictures seem to contain the seed of what characterizes the slow-handling canvases, though in the primitive state. The fined-down backgrounds give place to stains and trickles. We find materials of a certain thickness, like plaster, and knotted cords are also a frequent motif.

We might say that, while the principal characteristics of the slowly-worked-out canvases were order and moderation, those of these later works were gesture and instinct. These contrasting ways of working — which we might compare to the qualities of *seny* (common sense) and *rauxa* (impulsiveness), traditionally supposed to be conflicting elements in the Catalan character — have been present at all stages in Miró's career. And although Miró, as an artist, has captured all the spirit of the bohemian days of the early Surrealists in Paris, and all the skyscraping grandeur of New York, he has never lost those Catalan roots that have, paradoxically, assured him of international fame as a universal painter.

During the closing months of 1950 and the early part of 1951, Miró was working on the execution of a mural painting measuring 1.9 by 5.9 metres which had been commissioned by Harvard University. This meant another "testing" of his work, and one which proved beyond a doubt that Miró's handwriting, so to speak, was perfectly capable of leaping over the limits imposed by easel formats. Before being sent to its destination, this work was presented to the Parisian public as part of an exhibition entitled "Sur quatre murs" at the Galerie Maeght. The show also included a large-scale collage by Picasso, some engraved plaster plaques by Braque and Léger's mosaic for Audincourt.

In the course of 1951, and before starting on what was to be an extremely prolific period, Miró painted about ten canvases that seem to mark a pause between two periods of great activity. Here we find once again the discoveries made during the immediately preceding stage, particular use being made of the techniques employed in the elaborate style. What characterizes these canvases, a typical example of which is *Dragonfly with Red Wings Pursuing a Serpent Gliding Spirally towards the Comet-Star* (Fig. 66), is their cotton-like atmosphere. Miró

applies the background colours as though in a sort of nebula, which not only communicates a very special atmosphere to the backgrounds but at the same time contrasts with the pure colours arranged in a chequered pattern within the volume of the characters, animals and heavenly bodies.

"Je rêve d'un grand atelier" (1952-1960)

In 1952 and 1953, Miró painted about sixty works in different formats. They were all exhibited in 1953, first at the Galerie Maeght in Paris and then at the Pierre Matisse Gallery in New York. Though they are of extraordinary quality, they contribute nothing new to distinguish them from those of the immediately preceding years.

In *Smile of the Blazing Wings* (Fig. 67), we again find the chequered patterns of different colours, which have now become one of the characteristic features of Miró's work. The sun (the heavenly body of the day) and the stars (those of the night) stand out in all their splendour against a grey background that is very carefully worked, as is usual with Miró.

The pure colours and classic palette are enriched, however, by colours hitherto unusual in his work, like the acid yellow that appears in one of the squares.

Most of these works, done in the precise, elaborate style that might by now be considered classic, have very poetical titles, like the one just mentioned, or like *The Setting Sun Caresses Us in the Moonlight,* or *The Jasmine Drenches the Girl's Dress in its Golden Scent,* which illustrate the interpenetration between painting and poetry in Miró's work.

In an article entitled *Je rêve d'un grand atelier,* which was published in "Cahiers d'Art" in 1932, Miró wrote: "The more I work, the more I feel like working. I should like to try my hand at sculpture, ceramics or graphic work, or to have a press. And also to try, as far as possible, to go beyond easel painting, which to my mind has rather petty objectives, and through painting to get closer to the masses of humanity, of whom I never cease to think."

Curiously enough, when (in 1952) Miró started to move away from easel painting, it was in fact through works in smaller formats. He used supports of unusual proportions, vertical or horizontal bands in a variety of widths. And he was equally prepared to use irregular fragments of fibrocement or cardboard, materials that he found very exciting and which he permitted to suggest new forms, but which had never before been seriously considered as artistic materials.

This first step was definitive when he received a commission to paint a large canvas for the Guggenheim Museum. Now, for the first time in his career, Miró was working on a large-scale (2 by 4 metres) canvas directly, without any maquette or other preparation, just letting himself be guided by the impulse of gesture. And he succeeded in creating a tempestuous climate in the background which encouraged him to release all his energy on the canvas.

The treatment of the background is an equivalent, on a larger scale, of the stimulation experienced with the small formats. Stains, irregularities of the material, brushstrokes all help to create a "climate" that gives the artist a clear idea of the dimension of the work.

This first stage brought about the apparition of the form. Through direct graphic work Miró outlined signs and characters, and then he added the colours that define them and create a rhythm in the composition. The strength of the picture comes, in fact, from the directness of the line, a line we might almost call a rough draft, without the perfectionism that characterizes the earlier works.

The lack of elaboration was to be accentuated as time passed; indeed, the older the artist grew, the greater the strength and impact of his work. At the same time there was a progressive — though not definitive — disappearance of the figure, a disappearance that was to become increasingly evident and was finally to reserve the leading role entirely to the fields of colour.

Miró's output of pictures in 1954 continued this "spur-of-the-moment" approach to painting, with its direct, brutal expression, but the artist was soon to be absorbed by his work in ceramics, prolonged in the following years by the commission for the two great UNESCO murals. He did not give up painting, but with these very important pieces he took another step forward in his attempt to get closer to the masses of humanity, who were, as he said himself, so constantly in his thoughts.

Over a period of five years the artist devoted himself almost exclusively to ceramics, engraving and lithography. Moreover, his work was profoundly affected by his move to Palma in 1956. Now, for the first time in his life, he could work in the great studio he had always dreamed of. In the lower part of the garden surrounding his house in Cala Major, his friend, the architect Josep Lluís Sert, built him a fine, spacious studio with harmonious lines that blended perfectly into the surrounding landscape. But this studio, so large and beautiful, and perhaps a little too new, seemed to confuse and excite the painter at first. It lacked life. Gradually, however, he accumulated all sorts of objects that he found in his walks along the beach or in the country: roots, tree trunks, stones, shells, old farm implements. Everything interests Miró, everything can be used as a starting-point for creating a painting or a sculpture.

This move to Majorca, moreover, obliged the artist to carry out a great spring-cleaning and tidying of the numerous canvases — and even more numerous drawings, projects and sketch-books — that had been accumulating in Barcelona for forty years. And this inspection of his work led him to meditate and to begin to move in new directions. He became conscious of the need to break with some of the habits he had formed in the course of his career. Once again he saw that he had to set out on a new and unfamiliar road, eliminating an image of himself and his work that had become widely accepted through reproductions or postcards. Miró, however, sought to move in his new direction without cutting himself off from his deepest roots, the roots that bound him to the land where he lived and to the customs of his country.

The prolific output of 1959 and 1960 — over a hundred paintings, and a great many gouaches and watercolours — surprises us with a violence of expression that sometimes makes it difficult to recognize Miró's distinctive "handwriting" of signs. The painter lets himself be carried away by both the impetus of a graphic style arising out of a single gesture and the delicate lines that contrast with the materials and with the stains of colour. This apparently contradictory way of working is a response to the need he feels to get away from the formulas of his earlier vocabulary and to come closer to a purer state of painting, to immediate expression. This thick-lined writing, traced at one breath as it were, does not reject Miró's universe of forms, but simplifies it into a single gesture. Birds and women continue to appear in his pictures; not, however, with the same sensuous charm as before, but aggressively, discarding the presence of precision and detail. Of the birds, indeed, eventually nothing will remain but the ideogram of flight represented by its trajectory.

The heavenly bodies are undoubtedly the elements that have suffered least in the painter's rebellion against the figures of his universe. In *Red Disc* (Fig. 70), in which there are no human characters, the red disc which is the

principal feature of the composition stands out in the middle of a great white stain that spreads and diversifies into countless splashes on the black background. On this white we discover four discreet signs of the precise, simplified graphic style we have found on other occasions. Miró here has made the stain his starting-point — just as the artists of a later generation were to do, artists like Jackson Pollock, to give just one example — for creating a space in which to inscribe the powerful red disc so that, like the circle in the Japanese flag, it may attract the eye with all the force of its shape and its colour.

A very clear example of the break that took place in Miró's evolution at this time is the revamping of the 1937 *Self-portrait* (Fig. 53). In the original work the lead-pencil drawing on canvas created a portrait of the artist with an extraordinary profusion of lines which transfigured his face. In 1960 Miró wished to regard as finished this obsessive self-portrait with its total lack of colour. And for his purpose he commissioned an exact reproduction, on which he carried out a strange exorcism. A very thick black line emphasizes the essential features — the head with its hair, the eyes, the neck and the shoulders — as they contrast with some touches of pure colour.

With this transformation of the 1937 *Self-portrait,* Miró was unwittingly marking his definitive break with a whole period of definition and self-affirmation which, in the last two decades, moved steadily towards the supreme importance of gesture.

The years of maturity (1961-1970)

As the world moved into the sixties, Miró did not change his language but gradually refined and reduced it to the purely essential, without ever abandoning the themes that had always been his main concern: the earth, the sky and the heavenly bodies, women, birds... He was to show an increasingly firm and constant attitude to the roots that had led him to the point at which he now found himself; and everything he did was to show quite clearly the undeniable consistence that had presided over all his work from the very beginning of his career.

On some occasions the colour acquires a far greater importance than it had ever had before, and a single colour may be found occupying practically the whole of a canvas. In *Blue II* and *Blue III* (Figs. 68 & 69), the line of the horizon has disappeared, leaving the whole background of the composition for the colour of the sky. Miró does not dissimulate the brushwork but lets the gesture of the hand, in applying the colour, become evident through discontinuity. In *Blue II* a red touch in the vertical sense adds a dramatic note that contrasts with the softness of the blue, while in *Blue III* a very fine and delicate trajectory in black leads our eyes towards the enigmatic red point.

A letter that Miró received from Alexander Calder in 1964 is the starting-point for *Friend's Message* (Fig. 74). On the envelope Miró did the preparatory drawing for the painting, in which a great blackish mass spreads monstrously over the green background symbolizing friendship. The line of the horizon, that abiding reminiscence of the classes of Modest Urgell, separates the green of the sky from the black of the earth.

The line of the horizon will remain. We find it again in *The Wing of the Lark, Aureoled by the Blue of Gold, Reaches the Heart of the Poppy Sleeping on the Grass Adorned with Diamonds* (Fig. 85), very clearly delimited, done with a ruler and thickened in the upper part. It separates the two fields of colour: the yellow, which refers to the earth, and the green, which represents the sky. As though it were an almost obsessive constant, Miró never fails to make some allusion to the cosmic order, the

sky/earth duality, emphasized in this case by the presence of a red star and a black figure wrapped in a sort of purple nebula in the earth area.

In *Drop of Water on the Pink Snow* (Fig. 88), the broad field of orange is furrowed by a thick black brushstroke that seems to attack the delicate background of the canvas. The delicacy of the line defining the star contrasts with the black graphic writing, just as in the forties the slow figures served as a counterpoint to the rapid ones.

The backgrounds of the works of this period, however, are not always painted with pure colours. In *Painting I* (Fig. 71), the soft tones of the background go from various shades of red to yellow. On it appears a simple graphic sign that might be related to the series of *Circus Horses,* done in 1927. Taking up old themes afresh is another constant in Miró that can be seen very clearly in the sketches he gave to the Foundation that bears his name. For Miró never truly exhausts his themes; they may remain in a latent state, but are never dead.

The arrangement of the colours in chequered patterns, so frequent in the immediately preceding period, appears again in this decade. In the paintings the artist dedicated to his grandsons Emili and David (Figs. 76 & 77), however, we may observe how the little squares are growing larger and more elongated, losing something of the perfectionism they had in works of the preceding decade.

The Skiing Lesson (Fig. 79) is one of the apparently most complicated of the compositions painted during the sixties. The whitish grey background suggests the colour of the snow with its different tones. The black is used as a writing vehicle, a characteristic that was to become more and more accentuated — and one that possibly comes from the tradition of drawing in black on the white background of paper. The colours placed in the squares of the chequering indicate depth through the change from one register to another. In this canvas the movement is made evident through the trajectories, the arrows, the lines that finish in a ball or with a parenthesis. A feature particularly worth noticing is the stopping of the movement of the trajectories. One way of interrupting them is by means of the balls that prevent the irradiation from being lost in space. Another way of finishing a line is with a parenthesis, a graphic structure common in writing which Miró places at the end of many segments, as though to prevent his energy from escaping. The interruptions in the form of arrowheads indicate directions. All these components give an undeniable feeling of mobility to *The Skiing Lesson.*

Another example of movement in Miró's work can be found in *Woman and Birds in the Night* (Fig. 98), in which the principal features are the black colour of the night and the trajectory described by the flight of the birds.

In *Catalan Peasant by Moonlight* (Fig. 100), Miró again refers to this figure of the peasant, whom we find at the very beginning of his career and who has always been so familiar to him — and to the night, that time filled with magic which has always interested Miró. Here the artist has deliberately altered the colour of the sky, on which he has painted the green of the countryside, and the colour of the earth, on which he has painted the black of the night. As for the moon, that luminary of the night, it is partly black and partly yellow, and these cold colours give us all the tactile experience of this heavenly body which, unlike the sun, does not warm us but only gives us light.

Something similar occurs with *Woman and Birds in the Night* (Fig. 97), in which both the stroke representing the flight of the birds and the one that represents the woman are black, any colour in the work being reserved for

certain specific areas which, precisely because they are few in number, attract our attention all the more strongly.

Both women and birds have always been key pieces in the subject-matter of Miró's work. At the beginning of his career we find much more figurative women, though they may not always be realistic, while the birds are represented by themselves, not by the trajectories described in their flight. With the years Miró has come to pay more attention to ideas than to realities. What the artist reveals belongs to the innermost regions of his personality.

In the following year, 1968, Miró again painted a work with the title of *Woman and Birds* (Fig. 96), in which the arabesque traced by the flight of the birds blends into the complicated image of the woman.

References to the sky and the heavenly bodies have been another of the constants in Miró's work. In *The Gold of the Azure* (Fig. 90), the artist paints the whole background of the canvas gold, while a big blue stain refers us to the colour of space. In the lower left-hand corner a woman with full skirts gives us an idea of the reality of the earth — "its strength comes up through our feet" — in contrast to the star-filled outer space. We have already seen how Miró represented the stars in different ways when he was painting the *Constellations.* And from that time he had retained the simplification of the balls joined by a segment, like the weights used by weightlifters, and the star with eight points, formed by two perpendicular lines crossed by two diagonals.

In *Characters and Birds Rejoicing at the Coming of Night* (Fig. 89), the black colour of the night enfolds the characters, with their gaudy colours, and the trajectories of the birds, while a big eight-pointed star seems to preside over the festivities.

The moon, that creature of the night *par excellence,* is as familiar as the sun in the world of the peasant, which is the world of Mont-roig, where Miró first came into contact with reality. They are not familiar as astronomical phenomena, however, but as beings that rule meteorological and agricultural phenomena.

In Miró's work the moon is presented with certain distortions, as we may see, for instance, in the markedly pointed form in *Flight of Birds Encircling the Woman with Three Horses on a Moonlit Night* (Fig. 92), which is certainly not the shape of either the waxing or the waning moon, but seems to be, rather, a personification of the familiar nocturnal disc, which thus acquires a certain aggressiveness.

Traditionally the sun does not appear in paintings, unless it is at dawn or sunset, since it is impossible to look at it when it is in anything approaching a zenithal position. Miró, however, has represented the sun very frequently. Miró paints it because his work is not visual, and if he does so it is because he feels it through his skin, his experience of the sun is a tactile one. The suns Miró paints, usually rather swollen in outline, are always very bright red, a warm colour as befits the warmth it provides us with. In the sixties the sun appeared in many of Miró's works almost as the leading feature. As examples of this I might mention *Character before the Sun* (Fig. 93) and *The Flight of the Dragonfly before the Sun* (Fig. 91), this latter a composition of extreme elegance, in which the few elements used — the blue of the blackground, the red of the sun and the trajectory of the dragonfly — give it all the strength that is so characteristic of Miró's work.

In 1968 Miró felt the attraction of writing once more and painted a series of *Poems,* such as *Poem I* (Fig. 95), and the canvas entitled *Letters and Figures Attracted by a Spark* (Fig. 94). What differentiates these new works from the ones he had done in the twenties is that this time he dispensed with the meaning of the words and let himself be carried away by the charm of the letters habitually used by packers.

The pop artists have made almost too much use of the graphic content of advertising. Miró, limiting himself to everyday reality, lets the letters participate in the composition bereft of their literal meaning. The result is extraordinarily elegant and beautiful.

The year 1968 brought the holding of the great anthological exhibition of Joan Miró's work at the old Hospital of the Holy Cross in Barcelona. This was the first exhibition of its kind to be held in Spain. For the first time, too, the Catalan public was given an opportunity of getting to know the work of this artist who had always felt himself bound by such deep roots to his country, whether he was in Paris, New York or anywhere else.

In 1969 the Architectural Association of Catalonia organized the exhibition entitled *Miró otro* ("The other Miró") at its headquarters in Barcelona (Figs. 136 & 137). At this time the art world was beginning to feel that air of renewal that advocated such movements as *arte povera,* ephemeral art, non-commercial art. Miró's imagination was fired by these ideas and he painted the great glass frontage on the ground floor of the Association's building as though he were creating a vast mural — a work that was inevitably fated to disappear when the exhibition finished, and of which all that has remained is photographic evidence.

The most recent years and the Joan Miró Foundation (1971-1981)

In the nineteen-seventies Joan Miró's work largely followed the same guidelines as in the preceding decade. Once again we find the theme of woman, with the almond-shaped female emblem, in *Woman in the Night* (Fig. 108); the sun, in *Woman before the Sun* (Fig. 105); the moon, in *Woman before the Moon* (Fig. 107); birds, in *Woman and Birds in the Night* (Fig. 104).

The distinctive feature of these latest works is the abundant use of black and the considerable reduction of the other colours in proportion to that black. This characteristic, together with the artist's apparent nonchalance in applying the paint to the canvas, which led to the apparition of trickling, splashing and dripping, gives these most recent paintings great force and aggressiveness. An aggressiveness, however, that exists more in the form than in the content. These works should not be interpreted as a shout of protest, but as a sincere, spontaneous manifestation of the artist's feelings.

By the beginning of the seventies the work of Joan Miró was recognized and highly esteemed all over the world. It was just at the start of this decade, in fact, that the great International Exhibition of Osaka was held. Miró was invited to participate in this with a large painting and a ceramic mural. The Japanese public was greatly attracted by Joan Miró's work and identified with it in a very special way.

Important exhibitions of his work were now held everywhere in rapid succession. In 1972 the exhibition entitled *Magnetic Fields* was held at the Guggenheim Museum in New York, the same year saw *Miró bronzes* at the Hayward Gallery in London, and in 1974 there was the great retrospective exhibition in Paris, held simultaneously at the Grand Palais and the Musée d'Art Moderne. Finally, in 1978, the Spanish Government organized the first anthological exhibition of Joan Miró's painting at the Spanish Museum of Contemporary Art in Madrid. Mexico, Caracas, Milan...; but the list would be interminable. Without wishing to repeat tired clichés, we might say that Miró is really a "universal Catalan", a man of our land whose name and work are instantly recognized all over the world.

This recognition on the international scale, however, has not in any way deflected the love Miró has always felt

for his native land. And a telling proof of this is the example of generosity he gave when he decided to offer to the city of Barcelona the Joan Miró Foundation, which was opened to the public on 10 June 1975.

For many years before this, indeed, Miró and his friends, among whom special mention should be made of Joan Prats, had been making plans for what was eventually to become the Foundation. Joan Prats, unfortunately, died in October 1970, before he could see the fulfilment of the projects he had nursed with such enthusiasm. The first exhibition room in the building contains his private collection and bears his name, as a memorial and homage to one who was Miró's greatest friend and a prime mover in the avant-garde art of our country.

The building that houses the Joan Miró Foundation, in the Park of Montjuïc, was designed by Josep Lluís Sert, a great friend of Miró's who had worked with the artist before on the pavilion of the Spanish Republic at the Paris International Exhibition in 1937, and who had built Miró's studio in Majorca in 1956. For the Joan Miró Foundation Sert created an open architectural structure in which the interior space communicates with the exterior and achieves a perfect balance between the architecture and its setting.

From the beginning, of course, Sert had to face the double problem that affects all space intended for the exhibition of works of art: lighting and circulation. In order to take as much advantage of the natural light as possible, he decided to use a sort of clerestory-skylights in quarter-cylindrical form through which the sunlight, reflected, reaches the interior zenithally, in such a way that it does not produce shadows and does not permit any direct ray of light to fall on the works of art or meet the eyes of the viewer, regardless of the sun's height above the horizon as it varies according to the time of day or the season of the year.

The direction of the circulation of viewers is organized around the central patio, the origins of which are to be found in the *impluvia* of Roman villas and in medieval cloisters, and it is so arranged that the visitor is never obliged to pass through the same space twice.

The principal building material is reinforced concrete, which has been specially treated to change its characteristic grey colour to the white that is so typical of Mediterranean buildings. On the outside the marks of the concrete shuttering are combined with prefabricated plaques that have a grainy texture. The interior walls are simply whitewashed, a typically Catalan feature. This white colour creates a restful atmosphere that is very propitious to untroubled viewing. The other materials used also come from the demotic architecture of the Mediterranean: the red-tiled floors, the wooden thresholds, etc.

The forms, too, are typical of Sert's Mediterranean architecture: the central patio I have already mentioned, the openings communicating the interior and the exterior, the little vaults that form the ceilings, which create a greyish shading of the white. One of the distinctive shapes of the exterior of the building is the octagonal tower that contains the auditorium, the engraving and drawing archives, and the library. This prism, so characteristic of Catalan Gothic, seems to be the architect's homage to the buildings of an age of splendour in our country.

In the Miró Foundation Sert has created a place in which we Catalans can feel at home, a restful place that is perfectly suited to the contemplation of works of art, and a building that does not overawe us or make us feel ill at ease.

The Foundation contains the works donated by Joan Miró himself, which are exhibited on a rotation basis: 188 paintings, 145 sculptures, 9 textile works, the graphic work in its entirety and a collection of nearly five thousand drawings, which enable us to follow the artist's evolution from the first childhood drawings of 1901 down to the present.

The Foundation also possesses and periodically exhibits works by other artists, such as Adami, Alfaro, Braque, Calder, Chillida, Tàpies... But the Joan Miró Foundation is not a museum in the traditional sense. In accordance with the wishes of its founder, it has to be a place where contemporary art can live its life, a life made up of research and discoveries, which is what Joan Miró's own artistic career has always been. And so the Foundation constantly endeavours to offer the public everything that represents novelty, or a positive contribution, in the context of 20th-century art.

The most important activity of the Joan Miró Foundation is the organization of the temporary exhibitions held there, among which we might make particular mention of the following: Tantric Art (1975), Five Hundred Drawings by Joan Miró (1976), Antoni Tàpies (1976), America-America (1977), From Bonnard to Miró (1977), History of Catalan Culture (1977), Bauhaus (1978), Francis Bacon (1978), Images of Calder (1978), Olfactory Suggestions (1978), Architecture of Josep Lluís Sert (1979), Joan Miró: Graphic Work (1980), Paul Klee (1981), and Henry Moore (1981). Apart from this the Foundation organizes lectures, debates, round-table conferences, films, stage performances, children's entertainments and concerts, all of these activities being at all times linked to the artistic tendencies of our century.

The Foundation, moreover, has one exhibition room — Space 10 — pemanently devoted to the exhibition of works by young artists engaged in research work that they have not had an opportunity of showing in public.

Joan Miró has given yet another proof of his generosity by deliberately refusing to influence such decisions as may be taken regarding the Foundation's management or activities. To ensure this he decided to appoint a Board of Trustees with twenty-four members closely connected with the artist by family, professional or friendly ties.

Graphic work

Within the overall context of Joan Miró's creative output, his graphic work occupies a most important position, not only from the point of view of quantity but also from that of quality. If we take into account all the stencils, lithographs, etchings and woodcuts, whether made for themselves or to illustrate books, together with the considerable production of posters, the resultant figure would be well over a thousand works. Quantity, however, would be of no value if it were not accompanied by quality.

In 1928 Joan Miró, moved by that eagerness that has always characterized him to experiment with all the techniques that come within his ken, did his first eight stencils, which were intended to illustrate Lise Hirtz's *Il était une petite pie.* This technique, characterized by the use of a thin sheet of metal or cardboard, in which the fragments for colouring are cut, represents a tentative first step prior to embarking on the adventure of lithography and engraving.

One year later, in 1929, he did his first lithographs, in black and white only, as illustrations for Tristan Tzara's *L'arbre des voyageurs.* This was the first time, therefore, that he found himself working on that lithographic stone which, after the appropriate inking, reproduces the image desired on paper.

Four years after that, in 1933, Christian Zervos commissioned Miró to do three black-and-white etchings as illustrations for *Enfances,* a book of poems by Georges

Hugnet. Miró learned this technique at the Lacourrière atelier in Montmartre. Here for the first time he came to grips with the copper plate and was able to appreciate how the effect of the acids brings the drawing out in relief. He used this fascinating technique again to produce one of his most famous etchings, *Daphnis and Chloe*. Taking his inspiration from the mythological theme, Miró represents Daphnis playing pipes. The character, with his enormous feet, responds to the artist's long-held idea that the strength of the earth comes up in us through our feet. Breaking the line of the horizon in the background we see the figure of Chloe, as though she were drawn forth from the sea by the music Daphnis is playing. Near her a goat is trying to eat a leaf from a bush. The two principal heavenly bodies, the sun and the moon, seem to preside over the composition.

This etching gives us a very clear idea of what Miró's early engravings were like. The main protagonist in all of them is the artist's hand, which works the copper surface with a burin just as it might work with a pencil on paper. The result is a figurative work that illustrates a story.

In 1938 the Cubist painter Marcoussis, who was a friend of Miró's, taught him the technique of dry point. The result of their collaboration was the *Self-portrait* done jointly by the two artists, in which the portrait of our painter is lost among the linear acrobatics and the stars.

Meanwhile Miró had done other stencils: two in 1934 for the special number of the review "D'aci d'allà" devoted to twentieth-century art and, in 1937, the celebrated *Aidez l'Espagne,* which was to be used for collecting funds to help the Republican forces in the Spanish Civil War. In this work we see a man with his fist raised, who appears above an inscription that runs: "In the present conflict I see the decrepit forces of the Fascist faction, and on the other side the people, whose vast creative resources will give Spain a strength that will astonish the world." Signed: Joan Miró. This stencil, which first appeared in the review "Cahiers d'Art", was used for the publication of a poster that went all round the world.

In 1939, just after the Civil War, Miró began to work on the *Barcelona Series,* a sequence of fifty lithographs in black and white that he was not to finish until 1944, on account of the material difficulties involved at that time in embarking on a task of such importance. Joan Prats was the publisher of this work, which may well be regarded as Miró's plastic comment on the disasters of war. Aggressive characters with their teeth ground down to points, grotesque characters with noses like elephant's trunks, arms like hooks and sharp-pointed tongues, all make very plain the contempt the artist felt for the war that had just concluded.

When Miró was in New York in 1947 he renewed his acquaintance with Hayter, the engraver from whom he had first learnt the technique of the burin in Paris. With him he did the dry-point etchings for Tristan Tzara's book *L'Antitête,* which he illustrated jointly with Yves Tanguy and Max Ernst.

Until 1948 Miró had not done any engraving in colour. But from that year on he was to use colour with ever increasing fluency; colour, indeed, was gradually to become the main feature, black being reserved for outlining the shapes against the white of the paper, which is its traditional role in drawing.

Miró did not try his hand at woodcuts (a technique that consists in printing from reliefs cut in boxwood blocks suitably inked) until 1950, when he illustrated a book written on him and his work by the Brazilian diplomat João Cabral de Melo. He made use of this technique again in 1958 for the eighty woodcuts illustrating Paul Éluard's book *À toute épreuve.* The artist himself later

said that the gouge had given him open sores on the hand; this, however, could not be an excuse for giving the wooden blocks to somebody else to cut, for Miró has always considered that he himself must be wholly responsible for both the work and the results obtained.

His first etchings in colour, entitled *Series I,* were done in 1952. Around this time Miró was beginning to collaborate closely with quite a number of poets and writers, illustrating books by Prévert, Ribemont-Dessaignes, René Crevel, Michel Leiris, René Char, Paul Éluard, André Breton and Joan Brossa, as well as writers rescued from oblivion by the Surrealists, such as Jarry and Lautréamont.

In an extensive interview with Georges Raillard, which was later published in book form, Miró explained his approach to book illustration: "My starting-point is the architecture of the book, the typography, which I consider very important. Then I try to enter deeply into the spirit of the poet; I devote an enormous amount of thought to this. Two things simultaneously: the architecture of the book and the spirit of the text. Then I do a lot of drawings, but really a lot of them, and very quickly, on any old piece of paper that comes to hand. That is the second stage. After that I go on to the third: having got well into the spirit of the text and the architecture of the book, I do a series of drawings in colour on paper in a large format. When this is finished I begin to engrave on the copper with the acid. Very freely, hardly paying any attention to the sketch. For the sketch, more than anything else, is a study for avoiding mistakes and for helping to familiarize the engraver with the spirit in which I want him to work. When I start on the copper I consult the sketch very little, if at all, just enough to avoid losing touch."

By the end of the nineteen-sixties Miró had totally mastered the techniques of traditional engraving; what interested him now was to find new possibilities that would give new textures. In the engravings he did in 1968 we find relief prints in cement, which is replaced in those of the following year by carborundum. This way of working was a response to new approaches to material paint, gesture and stain. The lines become concretions of matter, the backgrounds sets of colour stains. Gesture makes its contribution through all sorts of impulsive graphic marks, which on occasion become so important that they may even determine the whole composition. Joan Miró's most recent lithographs and engravings, therefore, have come a long way from *Daphnis and Chloe,* which beside them might be simply a drawing. Again we see how Miró's restless spirit has led him to reject all possibilities of paralysis or of letting himself be carried away by a too easy success.

In the last few years Miró has fitted out important engraving workshops at Son Boter, beside his own studio at Son Brines, near Palma, and in these he works assiduously with Joan Barbarà on engravings and with Damià Caus on lithographs. These studios are intended to be used by young artists interested in these techniques who have nowhere to practise them. This gesture is yet another proof of Joan Miró's boundless generosity.

Ceramics

In 1915 Joan Miró first made the acquaintance of the ceramist Josep Llorens Artigas. They met at the Agrupació Courbet, founded by Artigas himself, and they still met frequently and shared the same aspirations when they were both living in Paris. In 1940 Artigas returned to Barcelona and set up his studio in the Carrer Juli Verne. One day he asked his friend Reguant, also a ceramist, to prepare some stoneware clay for him according to a

formula he gave him. Unfortunately, the whole firing was lost, because the materials used were not of the same quality as Artigas usually worked with; he left the useless pieces in a heap in the corner of his studio, intending to destroy them when he had a moment.

Miró and Artigas met again in Barcelona in 1944. The painter was greatly interested in ceramics and he asked his friend to prepare some enamels for him to test. On the day appointed for this test, Miró arrived at Artigas' studio, where he happened to see the pieces from the spoilt firing. "What do you do with this stuff?", he asked. "Oh, nothing really," answered Artigas. "I just use it for tests." Miró's interest was at once aroused by these pieces, in which chance had introduced a new and unexpected factor: fragments of clay from pieces that had been beside them in the kiln, eruptions, roughnesses, etc.: he used them as supports for painting with the enamels, which would be fixed by the action of the fire.

This, then, was how Miró first made contact with ceramics: in a totally anticonventional way, endeavouring to attain that extreme spontaneity and free creative activity that always characterize him, and letting himself be guided by the vigour and aggressiveness communicated to him by the irregular fragments of fire clay and the defective pieces.

Apart from the pieces that came from the spoilt firing, Miró also worked on a series of small-sized plaques — about two hundred altogether — that Artigas prepared for him. Very few of these survived, for Miró was not at all satisfied; the results seemed to be closer to easel painting than to ceramics.

The third attempt of this first stage came nearer to what he wanted. One day he came across some pieces of fire clay from an old, half-destroyed kiln. He took these irregular fragments, which chance had helped to turn into shapes that recalled nothing known to him, and decorated them on both sides. The subject-matter was the same as in the plaques, but with greater complexity in the drawing.

Also dating from this first stage are some sculptures in terracotta, which opened up new directions for Miró's output in ceramics. The subject was always a human character, a character and a bird, or a head. These sculptures reveal a vision of mankind that is full of humour.

The year 1953 marked the beginning of a new stage, the stage we may regard as a period of maturity and total mastery of the materials used. It was at this time that Miró and Artigas created what they called the *Terres de grand feu*, the origin of which is to be found in the plaster sculptures Miró did between 1950 and 1953. Artigas and his son, Joan, visited Miró in Mont-roig, where he showed them his latest sculptural pieces. They were at once struck by the possibility of working together again. The technical difficulties facing them, however, were far from negligible. How could they transform newsprint, straw or wire into ceramics? In the end they decided to do the most difficult pieces separately and then put them together. Finally came the firing processes: first the biscuit firing, then that for stoneware and, lastly, the one that would fix the colours of the enamels applied by Miró.

On 25 February 1954 the first firings started; it took seventy-five firings altogether, and sixty tons of wood were consumed. And the result was 234 pieces, all of them forms arising out of the observation of nature.

During this second stage Miró seemed to be devoting himself above all to large-scale pieces, but he also did some smaller ones which have an exotic beauty, like *The Little Owl* (Fig. 109).

Both the materials and the technique, during this stage, were also more complex. Artigas, who had now established his studio definitively in Gallifa, always prepared his own clays. He used two types: the stoneware type, consisting of clay, feldspar and kaolin, and fire clay, which is a mixture of ordinary clay and terracotta reduced to a very fine powder. Sometimes both types are used for a single piece: the second, less heat-resistant but very easily moulded, is used to produce the form, and over it is placed a layer of stoneware clay to give a hard surface. Nor is it unusual to find a piece covered by a layer of fine clay glaze placed on top of the rough, sandy fire clay. Miró scrapes the surface with a punch or burin, as though he were doing an engraving, to remove the glaze and reveal the clay underneath with its different quality and texture.

The enamels are carefully chosen to ensure a result that will faithfully reproduce Miró's habitual colours. Their composition must include a fusible element: feldspar or red lead, depending on whether the firing is to be at a low or a high temperature. Also used are colouring agents, such as cobalt, copper, iron or manganese, which will give different colours according to the type of firing. Copper, for instance, becomes red with reduction, whereas oxidising turns it green or black, depending on the quantity used. Miró always waited eagerly for the surprise of seeing the colour appear after the fire of the kiln had had its effect.

The artist explored all the technical variations during the period 1953-1956, much more than during other stages. That is why we may describe these years as the most specifically ceramic period.

Miró's ceramic output between 1960 and 1963 is characterized by its monumental nature. The most representative pieces of this period are those in the gardens of the Maeght Foundation in Saint-Paul-de-Vence.

Special mention should be made of the murals done by Joan Miró in collaboration with Artigas and his son. In 1955 Miró was commissioned to do two great murals for the UNESCO building in Paris, the *Wall of the Sun*, which measures 3 by 15 metres, and the *Wall of the Moon*, measuring 3 by 7.5 metres. In an article entitled *Ma dernière œuvre est un mur*, published in 1958, Miró writes: "Detail elements of the building, such as the design of the windows, inspired the compositions in the shape of a chessboard and the forms of the characters. I was trying to produce a brutal expressiveness in the larger wall, a more poetical suggestion in the smaller one. Inside each composition I wanted to establish a contrast, confronting dynamic, brutal graphic symbols with serene, coloured forms in flat areas or in chequering."

Shortly before starting work on these murals, Miró and Artigas visited Santillana and its famous Collegiate Church, where they were much struck by "the extraordinary beauty of the material of an old wall eroded by damp", to quote Miró's own words.

But when the 250 pieces that were to make up the *Wall of the Sun* were ready, neither the painter nor the ceramist was satisfied with the work done. Technically speaking, everything was perfect, but the tiles lacked the living irregularity of the old wall in the Collegiate Church of Santillana. Without hesitating for a moment, they began again. Miró later spoke of Artigas holding his breath when he saw the artist painting with a broom on the ceramic surface, an action that could not be rectified later.

The last firing took place on 29 May 1958. They had needed 35 altogether, in the course of which they had used 25 tons of wood, 4,000 kilos of clay and 200 kilos of enamel — to which must be added the 4,000 kilos of clay used in the first attempt, together with 250 kilos of enamel and 10 tons of wood.

In 1958 Miró was awarded the Grand Prix of the Guggenheim Foundation, which is eloquent testimony to the international success obtained by these ceramics.

In 1961 Harvard University asked Miró to do a ceramic to replace a mural painting that he himself had painted

ten years earlier, and which had been moved to the Fogg Art Museum.

The artist was fully aware of the impossibility of re-creating in ceramic something he had painted earlier in his career. His writing and his style had both evolved since then. So he set to work directly on the ceramic, without any preliminary maquette. And the result was in perfect consonance with the pictorial solutions that characterized this moment in his career, when the enormous force of the black line was dominating his compositions.

Between 1964 and 1972 Miró received five other commissions for murals: from the Handelhochschule of St. Gall in Switzerland (1964), the Solomon R. Guggenheim Museum (1966), the Barcelona Airport Authority (1970) (Fig. 115), the Kunsthaus in Zürich (1971) and the Ciné-mathèque in Paris (1972). They were all for murals of different sizes, with different problems of adaptation to the wall, whether exterior or interior. Miró succeeded in finding the most suitable solution for each case and, with that "divine discontent" that is so characteristic of him, made use of every possible resource to give each of these works its own personality and differentiate it from the others.

Sculpture

All the techniques in which Miró has worked — from painting to engraving, and including ceramics, tapestry and, of course, sculpture — have helped to enlarge his field of expression. They have never been mere amusements, the pastimes of an ingenious artist, but rather the results of that urge to advance ever further that has characterized the whole of Joan Miró's work. If we review his career as a painter, we will see how he has always maintained a constant search for solutions that have always been new. The contrasts between slow and quick working, softness and aggressiveness, careful detailing and tachisme, respond to this determination on Miró's part never to let easy success tempt him into stagnation. This desire of the artist's was to become even plainer when it came to using new techniques that would present new problems and offer new solutions. Ceramics enabled Miró to put colour in relief, sculpture gave him a total mastery of form and volume.

The earliest antecedents of Miró's sculpture should be sought in the classes of Francesc Galí. When the teacher blindfolded the pupil and made him discover objects through his sense of touch, he was opening up the way that would lead to the discovery of volume and, indirectly, to sculpture.

In December 1931 Miró exhibited his object-sculptures at the Galerie Pierre in Paris. Seen as sculptures, they had the relief of that art but not its volume. They might be described, rather, as a sort of collages made with the most varied objects: on a piece of wood — whether in its natural state, or subjected to some manual process, or painted — he placed some nails, a set square, a piece of iron or any chance-found object. The inherent humour or sarcasm was as important in these works as the objects themselves. The whole show, in fact, was a kind of protest, a final consequence of the Dada and Surrealist movements, and one that came at the time when Miró himself was talking about the need to murder painting.

Between 1944 (coinciding with his first attempts at ceramics) and 1950, Miró did his first sculptures in terracotta and bronze. Their forms have their origin in those of nature, but the artist shows his personal accent quite clearly in his treatment of one very specific theme that has always been present in his work: woman. Woman appears here in all her exuberant maternal fullness, like a new version of the mother goddess, a figure so important in primitive Mediterranean cultures.

A few years later, in 1954, Miró did some maquettes for monuments in which the imagination played an essential role. In them bronze and paper were combined with the most widely-varying objects: bones, porcelain hooks, old telephone bells, bits of leather... Bearing in mind that this was a series of maquettes, we can imagine the effect that these instruments would have produced if they had been carried out in monumental dimensions.

The year 1966 may be regarded as the first year of Miró's real concentration on sculpture, which lasted until 1971. It is very easy to identify the objects he used in constructing his sculptures. On the one hand, everything that nature offered him: stones worn away by wind and water, roots drying on the beaches, cactus spines... On the other hand, the tools of everyday life: a fork, a piece of iron from some agricultural machine, kitchen utensils, clay whistles... All these objects, whether straight from nature or man-made, belong to a world that is opposed to industrialization, a world that has not yet emerged from the craft age. This is the world that interests Miró, the one that remains wedded to authenticity. The artist combines these objects in whatever way he finds most suitable for creating a new form on the basis of forms already known. As his friend Joan Prats said: "When I pick up a stone, it's a stone; when Miró picks up a stone, it's a Miró." For Miró invents from the starting-point of the real world, and in direct relation to it. As though in allusion to Chaplin's famous phrase, "Reality has more imagination than we have," he lets a piece of a beehive, a broken pitcher, a basket or any other object reveal a new reality to us. At the same time, in choosing the objects Miró shows us that there is no such thing as a vulgar material, that poetry can be made out of everything and that the most insignificant tool can reveal an apparently hidden beauty. That is why, during his walks along the beach in Majorca, he is always on the look-out for anything he may find. "It is reality that gives me the impact, the ideas," he says.

The material chosen by Miró to prolong the life of his everyday objects, as though he wished to immortalize them, is bronze — though this is not his only material. The two birds, Sun Bird (Fig. 120) and Moon Bird (Fig. 121), were first cast in bronze and later sculpted in Carrara marble.

In the course of many centuries bronze has gradually acquired the reputation of being a "noble" material. It has been used for casting the most solemn of equestrian monuments and also for bells and cannons. It cannot be denied, either, that the most abjectly academic sculptors have always been very fond of bronze. And the patinas — often faked — have helped to enhance the material and the effects desired. The real prestige of bronze, in fact, has been seriously impaired by the ill-treatment it has so often suffered. Its use unquestionably entails problems for any sculptor.

Miró decided openly in favour of bronze and succeeded in obtaining new effects from it, changing all its negative connotations by resorting to highly positive solutions. As the grandson of a cabinet-maker in Palma and a blacksmith in Cornudella, and the son of a jeweller, Miró had lived very close to the transformation of materials by the hand of the craftsman; and that is why he wanted to preserve his objects by using an enduring material, but working it in that most traditional way, the lost-wax process. By taking a mould from the original work, a positive plaster model is produced from which the founder can obtain as many negative plasters as he wants to make. The melted wax, poured into this mould, takes on the form of the sculpture and solidifies. Then a heat-resistant material is introduced into the hollow interior. When the whole is exposed to a high temperature, the wax melts and the metal in a state of fusion is poured into

its place through holes left open for the purpose. All that remains to be done is to remove the heat-resistant material in order to obtain the sculpture in bronze.

Miró always follows all these operations very closely; not to do so, indeed, would seem to him to be hardly ethical, though the one who really carries out the operations is the craftsman, in this case the founder. Miró feels a very great respect and admiration for all those who collaborate with him in his various craft-assisted activities, whether sculpture, ceramics, engraving or tapestry, as we can see from a letter he wrote to Pierre Matisse on the occasion of an exhibition of sculptures, engravings and lithographs which was held at the latter's gallery in New York in 1970. In this letter he establishes precise distinctions, saying, for instance, that the pieces cast by Susse in Paris "have a noble patina that goes from black to dull red, passing through broad areas of a greenish tone," while those cast by Clémenti "possess a rich and very personal patina, full of magic"; as for the pieces cast by Parellada, "their patina has that purity that contains the power of suggestion and the primitive strength of the sculptures. It is impossible to imagine these pieces otherwise."

Most of Miró's sculptures retain the patina given them by the founder; but in some cases the artist has covered the bronze with his characteristic colours.

Painting has enabled Miró to develop a whole language of signs that began with some very tentative "feelers" that were still quite close to reality. And sculpture has enabled him to underline certain essential aspects of his work. We can easily see, for instance, that there is one theme that appears very frequently: woman.

In sculpture the female body is one of those cases that can admit the most ambivalent treatments. Practically any object can be used for the purpose: a pumpkin, a root, a loaf, a length of piping with a large perforation symbolizing the woman's sex... In order to achieve this effect, Miró subjects his objects to a degree of tension, a reorganization. Objects by Miró do not function as objects, but as pretexts, as starting-points. Placed in a certain way, they acquire intentionality.

The subject-matter of sex appears as a constant throughout Miró's work and this is accentuated in his sculpture, with a certain touch of humour on occasion. Thus, for instance, when we look at *Man and Woman* (Fig. 123) we may be surprised by the apparent lack of any connection between the title and the two stools. The solution is easy enough, however. The rounded shape of one of the stools suggests a woman, while the stool with a square seat refers to a man in its straight, angular lines.

In Miró's sculpture we can also find allusions to heavenly bodies, sometimes through an object and at other times thanks to an incision made by the artist, or to birds, as in *Sun Bird* (Fig. 120), *Moon Bird* (Fig. 121) and the humorously conceived *Woman and Bird* (Fig. 126), which consists of a combination of a very straight-standing stool, a lid or cover, a Spanish civil guard's tricorne, some weightlifter's weights and a stone.

More recently Miró has used new materials, such as synthetic resin, for the definitive form of monumental sculptures, like the ones that stand in the revamped quarter of La Défense in Paris, the maquette for which is now in the Joan Miró Foundation (Fig. 128). In this case the artist dispensed with natural or crafted objects and created new ones intended to look like equivalents of his pictorial forms seen in three dimensions.

Tapestry

In 1972 and 1975 Miró did his first textile works, the overweaves and the sacks.

An overweave is produced by passing threads — weaving on a canvas base — to form a drawing. Miró's overweaves do not conform exactly to this definition, since he does not confine himself to adding threads to a base or background, but the idea is perfectly valid.

The starting-point for the overweaves is a man-made reality: the neutral tapestry prepared by Josep Royo, the craftsman working with Miró. On a warp of jute he prepares a varied weft: jute woven in the "millet-grain" pattern, greenish esparto knotted with the white fibre of cotton, great loops of hemp cord and twisted or plaited string. On this basis, which represents an age-old tradition in the history of mankind, Miró brings chance to bear. He pours petrol over the weave, lights it and then attacks the resultant fire, at those points that seem most suitable, with a broom drenched in water. The result is a new tapestry, enriched by the traces of fire, by the torn fibres, by the holes... The next stage is that of the distribution of the colours. Miró cuts out pieces of brightly-coloured felt, which he then sews, as though they were patches, over the holes, in the furrows or on the edges scorched by the fire. These patches may be placed in the upper part, revealing their roughly-cut outlines, or in the lower area, as mysteriously hinted-at presences; or they may hang from the background weft, adding a touch of colour.

Miró adheres to a very rigorous order in his placing of the colours. First he cuts out the red, the colour which establishes a contrast with the black of the burnt parts; then he looks for the most suitable place for the blue; and this latter colour will then demand green and, finally, yellow.

After the weaving, burning and patching comes the operation of adding objects to the overweave. Miró had already done collages in which he had used feathers, cartons, pieces of cork and wires: all of them objects that served to build up an idea. In the present case the elements he uses are authentic testimonies to the creative act, documents that help to familiarize us with the process carried out: the plastic buckets that contained the water or the paint, the scissors used for the cutting-out, the brooms, cords, skeins of coloured wool, and even the pot that held the nails. These objects represent themselves; theirs is not a surrealist metamorphosis but an objective presence.

The following stage consists in tracing great graphic symbols in black in and out among all these burnt parts, patches of felt and objects. With a sweeping gesture of his arm, Miró draws a stroke that sometimes turns back on itself, forming an enclosed area that demands a note of colour in the centre. The colours are applied to the work in splashes, letting them trickle freely, or else by simply using a paintbrush in the traditional way. Not infrequently we find ribbon lettering, of the sort used on packing cases, painted on the overweaves.

In the sacks the reality of man is very much present, for the sacks in question are specific, "historical" sacks, imbued with all the reality of their context, economic and political. For Miró has used clearly identifiable sacks: from the cotton sacks that have carried "Caribbean" flour, with their red and blue lettering, to the jute sacks used for the transport of sugar from Almería. Miró salvages these sacks, breathing whole chapters of experience, and gives them a sense of permanence by giving them transcendence. He adds an object, a skein of wool, stains of colour, with which they take on a new meaning that saves them from the rejection that would have been their inevitable fate.

In 1974 Miró set out on a new path in this adventure of tapestry when he was commissioned to do a very large one (Fig. 135) for the lobby of a skyscraper in New York. Starting with a small-format maquette, he let Josep Royo interpret the colours and the texture, collaborating as in

the case of the great ceramic murals. In 1977 he received another tapestry comission, this time from the National Gallery of Art in Washington, for a tapestry to measure 11 by 7 metres (Fig. 134). Finally, in 1979 he did the great tapestry intended for the Joan Miró Foundation in Barcelona.

Theatre

Joan Miró's first contact with the world of the theatre was as long ago as 1926, when in collaboration with Max Ernst he painted the décor for the Russian Ballet's production of *Romeo and Juliet*. From the maquettes preserved in the Wadsworth Atheneum in Hartford, Connecticut, it may be deduced that the two parts of the décor painted by Miró were in line with his easel painting at that time.

In December 1931, Miró exhibited the paintings on paper and objects created in Mont-roig the previous summer. All these pieces, particularly the objects, appealed enormously to the dancer and choreographer Léonide Massine when he saw the exhibition, and he immediately made it his business to get in touch with Miró, who he thought might be the ideal person to do the décor for his ballet *Jeux d'enfants*. The fantastic objects shown by Miró seemed to him to be in the very line that he wanted to give his choreography.

When Massine explained his plans to the painter, the latter was delighted with the idea and set to work hard on his designs during the first three months of 1932. Miró was responsible, not only for the décor but also for the costumes and the toys.

The décor was carried out in accordance with the style of Miró's 1931 paintings on paper. The motifs appearing in it are two great astral figures, a white sphere and a sort of cone ending in a circle. The décor was completed by a series of movable screens and, of course, the toys: swords, shields and horses. In designing the costumes Miró was very careful to bear in mind the movements the dancers would have to make. These designs were based on very simple shapes, in which colour played a fundamental role.

On 14 April 1932 the Ballets Russes de Montecarlo presented the first performance of *Jeux d'Enfants,* with music by Bizet and a libretto by Boris Kochno, at the Grand Théâtre de Montecarlo.

Miró did not do any more work for the theatre until 1978, when he did the characters of *Mori el Merma* (Figs. 138-140) for the Claca Teatre company. Actually, although this show was not presented until 1978, Miró — without any thought of the theatre — had already been working for quite a long time on this theme, the origin of which is Alfred Jarry's *Ubu roi*.

Among the drawings, sketches and notes donated by Miró to the Foundation, we have found a copy of *Ubu roi* published in Paris in 1921. In the margins of its pages, now yellowed by age, there is a series of drawings and annotations made by Miró when he read the text.

Through the grotesque character of Ubu, in whom the visceral functions predominate over the intellectual, Jarry intended to give a satirical image of any tyrant who imposes his will on his people by the use of force. And Miró, in his interview with Georges Raillard, said: "Now everybody sees quite clearly that what Alfred Jarry imagined was really somebody like Franco and his gang. That is why Ubu fascinated me all through the years of Franco's dictatorship, and that is also why I have drawn this character so often." In 1966 a bibliophile's edition of *Ubu roi* was published, with thirteen lithographs by Joan Miró illustrating the thirteen most important passages in the work. In 1963 *Ubu aux Baléares* was published, and in 1975 *L'enfance d'Ubu,* the former with illustrations

and texts by Joan Miró and the latter with illustrations by Miró and texts made up of popular Majorcan and Catalan sayings, some of them in rather piquant or even salacious language. Around 1970, moreover, Miró did a detailed illustration of the work which has never been published. All this material, which is preserved in the Joan Miró Foundation, was used as their starting-point by the Claca Teatre group in giving theatrical shape and volume to the Mironian characters taken from the flat surface of the paper. Miró endowed the characters with greater force by applying colour to them.

From this close collaboration between the Claca company and Joan Miró came a theatrical performance — which was, after all, what Jarry's work was in the first place — thanks to which we were enabled to see the characters of Miró's universe actually moving.

More recently, in late September of 1981, Joan Miró's last work for the theatre was presented in Venice. This work, *Miró, l'uccello luce* ("Miró, bird of light"), is a ballet with music by Sylvano Bussotti and a script by the French poet and art critic Jacques Dupin, who is an authority on Miró's work.

The work is divided into three parts, each of which alludes to a key moment in the development of Miró's work. The first is a dance representing the artist's awakening and his journey in search of a language of his own, the second refers to the dream period in Miró's work, and in the third we see the crystallization of the images in signs, when the artist has reached his fullest powers.

Miró, l'uccello luce offers us a poetic and symbolical reading of the work of Joan Miró expressed through dance.

Epilogue

We cannot finish this journey through the life and work of Joan Miró without mentioning his latest great work, *Woman and Bird* (Fig. 141), which stands in the park laid out on the land formerly occupied by the Barcelona slaughterhouse. This work, which, paradoxically, is not a painting — though the art of painting is the richest, most widely disseminated and best known of all aspects of Joan Miró's work — is a cement construction almost entirely covered with shards of pottery, and it is as it were a synthesis of all the elements that have gone to make up Miró's contribution to art.

In *Woman and Bird* we find once again the constantly recurring theme of woman, represented by the great black incision, like an immense wound, that traverses the piece from top to bottom, and birds, represented by the cylindrical form resting on the upper part of the sculpture.

The contribution of the craftsman — and for craftsmen Miró has always felt and expressed great respect — is in this case of fundamental importance. Joan Gardy-Artigas prepared the colours before firing in such a way that they would reflect Miró's characteristic tones exactly after firing; it was also he who shaped the edges of the hundreds of ceramic shards of different colours that cover almost the whole surface of the piece. This form, however, in accordance with Miró's express wishes, recalls the irregular outlines of the ceramic shards that cover the benches in the Güell Park, the work of Antoni Gaudí, that architect always so greatly admired and appreciated by Miró — even at times when Art Nouveau was despised as over-elaborate and baroque — who was an assiduous attendant at the drawing classes in the Cercle de Sant Lluc, where he was observed at a respectful distance by his young fellow pupils, among them Joan Miró.

BIOGRAPHY

1893 20 April. Birth of Joan Miró, at No. 4 in the Passatge del Crèdit, Barcelona, at nine o'clock in the evening.

1900 Lessons with Senyor Civil at his school in the Carrer de Regomir. From now on all Miró's childhood summers are spent in Cornudella and in Majorca.

1901 Earliest drawings still extant.

1907 Attends the Barcelona Commercial School. Has classes with Modest Urgell and Josep Pascó at the Exchange School of Fine Arts.

1910 Finds employment as an apprentice accountant in the firm of Dalmau i Oliveras, but fails to adapt to this milieu.

1911 Falls seriously ill. Convalescence in Mont-roig. Decides to devote himself to painting.

1912 Studies at Francesc Galí's Art School. Becomes friendly with the ceramist Llorens i Artigas and the painter E. C. Ricart. Visits the Cubist and Fauvist exhibitions at the Galeries Dalmau. First oil paintings.

1915 Leaves the Galí School. Studies drawing at the Cercle Artístic de Sant Lluc. Makes friends with Joan Prats and J. F. Ràfols. Rents a studio with E. C. Ricart in the Carrer de Sant Pere més Baix.

1916 Reads French poetry and avant-garde reviews. First contact with the art dealer Dalmau. Visits the exhibition of French art organized in Barcelona by Vollard.

1917 Meets Francis Picabia. Paints *Nord-Sud, Hermitage de Sant Joan d'Horta, Siurana, Prades* and the portraits of *E. C. Ricart* and *J. F. Ràfols.*

1918 First one-man show, at the Galeries Dalmau (No. 18, Carrer de la Portaferrissa, Barcelona). Paints *Still Life with Coffee Mill,* portraits of *H. Casany, Juanita Obrador, R. Sunyer* and the *Little Girl,* and the landscapes *The House with the Palm Tree* and *Kitchen garden with Donkey.*

1919 First visit to Paris. Meets Picasso and Maurice Raynal. Shows in Barcelona with the Agrupació Courbet, founded by J. Llorens i Artigas. Paints *Mont-roig, the Church and the Village, Vineyards and Olive Groves of Mont-roig, Self-portrait* and *Nude with Looking-glass.*

1920 Settles in Paris. Meets Reverdy, Tzara, Max Jacob. Attends Dada manifestations. Summer in Mont-roig. Paints *The Table.*

1921 Has a studio in Paris, at 45, rue Blomet. First one-man show in Paris, at the Galerie La Licorne. Preface to catalogue by Maurice Raynal. Summer in Mont-roig. Paints *Portrait of Spanish Dancer* and *Standing Nude,* and starts *The Farm-house.*

1922 Becomes a member of the "Groupe de la rue Blomet", with André Masson, Artaud, Leiris, Limbour, Salacrou and Tual. Summer in Mont-roig. Paints *The Farmer's Wife* and *Flowers and Butterfly,* and finishes *The Farmhouse.*

1923 Exhibits at the "Salon d'Automne" in Paris. Meets Hemingway, Ezra Pound, Henry Miller, Prévert. Summer in Mont-roig. Paints *Ploughed Earth, Pastorale* and *Catalan Landscape (The Hunter).*

1924 Becomes very friendly with Breton, Éluard and Aragon. Summer in Mont-roig. Paints *Portrait of Senyora K., Maternity, The Bottle of Wine* and *The Carnival of Harlequin.*

1925 Has a very successful one-man show at the Galerie Pierre Loeb. Preface to catalogue by Benjamin Péret. Takes part in the exhibition of the Surrealist group. Paints *The Dialogue of the Insects* and *Head of Catalan Peasant.*

1926 Collaborates with Max Ernst on the décor for the Russian Ballet's production of *Romeo and Juliet.* Paints *Dog Howling at the Moon, Horse on the Seashore, Character Throwing a Stone at a Bird* and various *Imaginary Landscapes.*

1927 Settles in the rue Tourlaque, in Montmartre, with Max Ernst, Éluard, Arp and Magritte. Paints the series of the circus and the white backgrounds.

1928 Visits Holland. Exhibition at the Galerie Georges Bernheim in Paris. Paints the *Dutch Interiors* and *The Potato.*

1929 12 October. Marries Pilar Juncosa, in Palma. They move into a flat at No. 3, rue François Mouthon, Paris. Paints *Queen Louise of Prussia, Portrait of Mrs. Mills in 1750* and *La Fornarina.*

1930 Exhibitions at the Galerie Pierre in Paris and the Galerie Goemans in Brussels. First exhibition in the United States, at the Valentine Gallery, New York. First lithographs, as illustrations for Tristan Tzara's *L'arbre des voyageurs.*

1931 17 July. Birth of his daughter, Maria Dolors, in Barcelona. Exhibition of object-sculptures at the Galerie Pierre in Paris.

1932 Settles in Barcelona. Décor, backdrop and costumes for the ballet *Jeux d'enfants.* Exhibitions at the Galerie Pierre in Paris, the Pierre Matisse Gallery in New York and, with the Surrealists, at the "Salon des Surindépendants" in Paris.

1933 3 May. First performance of *Jeux d'enfants* at the Liceu, Barcelona's opera house. Does his first etchings. Exhibition at the Galerie Bernheim in Paris.

1934 Living in Barcelona. Large-scale works in pastel and on sandpaper. Paints *Snail, woman, flower, star.*

1935 Living in Barcelona. Takes part in the Surrealist exhibition in Tenerife. "Savage paintings" on cardboard.

1936 Takes part in the exhibition "L'art contemporain" at the Jeu de Paume in Paris. Paints in tempera, on copper plates and on fibrocement.

1937 Moves to Paris. Paints *The Reaper* (for the Pavilion of the Spanish Republic at the Paris Universal Exhibition) and *Still Life with Old Shoe.*

1938 Spends the summer at Varengeville-sur-Mer, in Normandy. Paints *A Star Caresses the Breast of a Black Woman.*

1939 Settles in Varengeville-sur-Mer. Paintings on sacking.

1940 20 January. Begins the series of the *Constellations.* Returns to Paris. In view of the German advance, returns to Spain and settles in Majorca. Finishes the *Constellations.*

1941 First large-scale retrospective, at the Museum of Modern Art, New York. First monograph on his work, by J. J. Sweeney.

1942 Returns to Barcelona and moves back into the flat at No. 4, Passatge del Crèdit, where he was born. Paintings on paper.

1944 First ceramics in collaboration with Llorens i Artigas. Printing of the 50 lithographs of the *Barcelona Series* (drawn on report paper in 1939).

1945 Exhibition entitled "Ceramics and Constellations" at the Pierre Matisse Gallery, New York.

1947 First visit to the United States. Takes part in the Surrealist Exhibition at the Galerie Maeght in Paris. Mural measuring 3 by 10 metres for the Terrace Plaza Hotel, Cincinnati.

1948 Returns to Paris. Does an important series of lithographs at the Mourlot atelier. Exhibition at the Galerie Maeght. Paints *The Red Sun Gnaws at the Spider.*

1949 Exhibition of 57 of his works from Barcelona collections, at the Galeries Laietanes, Barcelona. Retrospective at the Kunsthalle, Bern.

1950 Does his first woodcuts. Mural painting for Harvard University.

1952-1953 Paints a great number of canvases in a freer, more brutal style, the most important among them being the one now in the Guggenheim Museum. Exhibitions at the Kunsthallen of Basel (1952) and Bern (1953). Second stage of his ceramic work in collaboration with Llorens i Artigas. Between 1953 and 1956 does 386 of these pieces in Gallifa.

1954 Grand Prix for Engraving at the Venice Biennale. Except for the small paintings on cardboard done in 1955, Miró gives up painting until 1959.

1956 Settles near Palma, where Josep Lluís Sert has built him a studio. Exhibition of the *Terres de grand feu* at the Galerie Maeght and at the Pierre Matisse Gallery.

1958 In collaboration with Llorens i Artigas, does the *Wall of the Sun* and the *Wall of the Moon* for the UNESCO building in Paris.

1959 Second visit to the United States. Retrospectives at the Museum of Modern Art, New York and in Los Angeles. Grand Prix of the Guggenheim Foundation.

1960 Ceramic mural for Harvard University. Numerous engravings and lithographs at the Maeght atelier.

1961 Third visit to the United States. Exhibitions at the Galerie Maeght in Paris and at the Pierre Matisse Gallery in New York. Exhibition of graphic work in Geneva.

1962 Large anthological exhibition at the Musée National d'Art Moderne in Paris. Creation of the "Joan Miró Prize for Drawing" in Barcelona.

1964 Important retrospective at the Tate Gallery in London and the Kunsthaus in Zürich. Opening of the Maeght Foundation in Saint-Paul-de-Vence (France) and its *Labyrinth* decorated entirely with ceramics and sculptures by Miró.

1965 Exhibition, "Cartons 1959-1965", at the Pierre Matisse Gallery. Cover for the Catalan children's weekly, "Cavall Fort".

1966 Important retrospective in Tokyo and Kyoto.

1967 Carnegie Prize for Painting. Paints *The Gold of the Azure.*

1968 Large exhibition at the Maeght Foundation in Saint-Paul-de-Vence. Paints *Triptych for the Cell of a Loner.* Important exhibition, with a retrospective section, at the old Hospital of the Holy Cross, Barcelona.

1969 Exhibition, "Miró otro", at the Architectural Association of Catalonia, Barcelona.

1970 Ceramic mural for the Osaka International Exhibition.

1971-1972 Exhibitions of sculpture at the Art Institute of Chicago, the Hayward Gallery in London and the Kunsthaus in Zürich. Creation of the Joan Miró Foundation — Centre of Contemporary Art Studies.

1973 Exhibition of "overweaves" at the Galerie Maeght. Important exhibition of sculpture and ceramics at the Maeght Foundation, Saint-Paul-de-Vence.

1974 Double exhibition in Paris: painting, sculpture and ceramics (with an important retrospective section) at the Grand Palais, and the graphic work in its entirety at the Musée d'Art Moderne.

1975 10 June. Opening of the Joan Miró Foundation — Centre of Contemporary Art Studies, in the building designed by Josep Lluís Sert in the Park of Montjuïc, Barcelona. Anthological exhibition (1914-1974) at the Galeria Maeght, Barcelona.

1976 Exhibition of small-scale sculpture and graphic work at the Galería Mas, Madrid. 18 June: formal inauguration of the Joan Miró Foundation, with an exhibition of 475 drawings (1901-1975) selected from the almost five thousand donated by Joan Miró to the Foundation.

1977 Exhibition of graphic work at the Centre de Lectura, Reus. Exhibition of painting, sculpture and graphic work at the Museum of Céret (France). Ceramic mural for the University of Wichita (United States).

1978 The Council of Europe awards the 1977 "Special Prize for a Museum" to the Joan Miró Foundation. Anthological exhibitions in Madrid: painting at the Spanish Museum of Contemporary Art and graphic work in the exhibition rooms of the Directorate General of the National Trust, Archives and Museums. Anthological exhibition of painting at Sa Llotja (the old Exchange Building), Palma. Exhibition, "Dessins de Miró", at the Centre Georges Pompidou, Paris. Exhibition, "Cent Sculptures 1962-1978", at the Musée d'Art Moderne de la Ville de Paris, in Paris. Exhibition, "Joan Miró: recent paintings, gouaches and drawings from 1969 to 1978", at the Pierre Matisse Gallery, New York.

1979 Exhibition, "Drawings by Miró", at the Hayward Gallery, London. Retrospective exhibition of paintings at Orsanmichele, Florence. Exhibition of graphic work at the Museo Civico, Siena. Retrospective exhibition of paintings, sculptures, drawings and watercolours at the Maeght Foundation, Saint-Paul-de-Vence. Exhibition, "Homenatge a Gaudí", at the Galeria Maeght, Barcelona. Miró is awarded an honorary doctorate by the University of Barcelona.

1980 Retrospective exhibition at the Museo de Arte Moderno de México, Mexico City. Retrospective exhibition at the Museo de Bellas Artes, Caracas. Exhibition of paintings at the Hirshhorn Museum, Washington. Travelling exhibition of paintings and drawings in Japan: Isetan Museum in Tokyo, Nagoya Museum in Nagoya, Fukuoka Museum in Fukuoka and Osaka Museum in Osaka. Unveiling of the ceramic mural in the new Palacio de Congresos, Madrid.

1981 Unveiling of a twelve-metre-high monumental sculpture in Chicago. Exhibition, "Miró a Milano": a great retrospective of paintings, sculptures, drawings, ceramics, tapestries and graphic work by Miró, shown in various public and private buildings in Milan.

1982 Execution, in collaboration with Joan Gardy-Artigas, of *Woman and Bird,* a sculpture in cement covered with ceramic shards which now stands in the park that has been laid out on the land formerly occupied by the Barcelona slaughterhouse. Exhibition, "Joan Miró: painting, sculpture, ceramics, graphic work, posters, tapestry and theatre", at the Joan Miró Foundation, Barcelona.

BIBLIOGRAPHY

1934 ZERVOS, CHRISTIAN: *L'œuvre de Joan Miró de 1917 à 1933*. Paris. "Cahiers d'Art", Vol. 9, Nos. 1-4.

1941 SWEENEY, JAMES JOHNSON: *Joan Miró*. New York. The Museum of Modern Art.

1949 CIRICI, ALEXANDRE: *Miró y la imaginación*. Barcelona. Ed. Omega.

CIRLOT, JUAN EDUARDO: *Joan Miró*. Barcelona. Ed. Cobalto.

GREENBERG, CLEMENT: *Joan Miró*. New York. Quadrangle Press.

1954 ELGAR, FRANK: *Miró*. Paris. Hazan éditeur.

1956 PRÉVERT, JACQUES & RIBEMONT-DESSAIGNES, GEORGES: *Joan Miró*. Paris. Maeght éditeur.

VERDET, ANDRÉ & HAUERT, ROGER: *Joan Miró*. Geneva. Kister.

1957 HUTTINGER, EDUARD: *Miró*. Bern-Stuttgart-Vienna. Ed. Scherz.

Joan Miró. Madrid-Palma. "Papeles de Son Armadans", Year II, Vol. VII, No. XXI.

SCHEIDEGGER, ERNST: *Joan Miró*. Zürich. Arche.

TEIXIDOR, JOAN: "Joan Miró i el seu temps" (text dated in 1956 and included in the volume *Entre les lletres i les arts*). Barcelona.

VERDET, ANDRÉ: *Joan Miró*. Nice. Galerie Matarasso.

WEMBER, PAUL: *Miró: das graphische Werk*. Krefeld. Kaiser Wilhelm Museum.

1958 HUNTER, SAM: *Joan Miró: das graphische Werk*. Stuttgart. Hatje. Spanish translation by J. E. Cirlot, entitled *Joan Miró, Su obra gráfica*. Barcelona, 1959. Ed. Gustavo Gili.

1959 ERBEN, WALTER: *Joan Miró*. Munich. Prestel. Spanish translation. Mexico, 1961. Ed. Hermes.

GOMIS-PRATS: *Atmósfera Miró* (text by J. J. Sweeney). Barcelona. Ed. R. M.

SOBY, JAMES THRALL: *Joan Miró*. New York. The Museum of Modern Art. Spanish translation. Puerto Rico. Universidad de Río Piedras.

1961 DUPIN, JACQUES: *Joan Miró: la vie et l'œuvre*. Paris. Flammarion.

WEELEN, GUY: *Miró* (2 volumes). Paris. Hazan éditeur. Spanish translation. Barcelona, 1960. Ed. Gustavo Gili.

1962 GOMIS-PRATS: *Creació Miró* (text by Yvon Taillandier). Barcelona. Ed. Polígrafa, S. A.

1963 GASCH, SEBASTIÀ: *Joan Miró*. Barcelona. Alcides.

LASSAIGNE, JACQUES: *Miró*. Lausanne. Skira.

1964 BONNEFOY, YVES: *Miró*. Milan. Silvana Editoriale d'Arte.

PENROSE, ROLAND: *Joan Miró*. London. The Arts Council of Great Britain.

1966 GOMIS-PRATS: *Joan Miró: creación en el espacio* (text by Roland Penrose). Barcelona. Ed. Polígrafa, S. A.

1967 DUPIN, JACQUES: *Miró*. Milan. Unione Generale d'Edizioni. Spanish translation. Mexico-Buenos Aires. Ed. Hermes.

1968 BUCCI, MARIO: *Joan Miró*. Florence. Sadea-Sansoni Editori. Spanish translation. Barcelona, 1970. Ed. Nauta. *Miró*. Barcelona. Town Hall of Barcelona.

1970 PENROSE, ROLAND: *Miró*. London. Thames & Hudson. Spanish translation. Barcelona, 1976. Daimon - Manuel Tamayo.

PERUCHO, JOAN: *Joan Miró i Catalunya*. Barcelona. Ed. Polígrafa, S. A.

TAPIÉ, MICHEL: *Joan Miró*. Milan. Fratelli Fabbri Editori. French edition. Paris. Ed. Hachette-Fabbri.

CATALÀ-ROCA, GOMIS, JOAQUIM & PRATS, JOAN: *Joan Miró* (text by J. J. Sweeney). Barcelona. Ed. Polígrafa, S. A.

1971 CIRICI, ALEXANDRE: *Miró llegit*. Barcelona. Edicions 62. Spanish translation entitled *Miró en su obra*. Barcelona. Editorial Labor.

CHILO, MICHEL: *Miró, l'artiste et l'œuvre*. Paris. Maeght éditeur.

CORREDOR-MATHEOS, JOSÉ: *Miró*. Madrid. Directorate General of Fine Arts.

ROWELL, MARGIT: *Miró*. New York. Abrams.

1972 CATALÀ-ROCA & PRATS, JOAN: *Miró escultor* (text by Jacques Dupin). Barcelona. Ed. Polígrafa, S. A.

KRAUSS, ROSALIND & ROWELL, MARGIT: *Miró, Magnetic Fields*. New York. The Solomon R. Guggenheim Museum.

LEIRIS, MICHEL & MOURLOT, FERNAND: *Joan Miró litógrafo I*. Paris. Maeght éditeur. Barcelona. Ed. Polígrafa, S. A.

1973 JOUFFROY, ALAIN & TEIXIDOR, JOAN: *Miró Sculptures*. Paris. Maeght éditeur.

PIERRE, JOSÉ & CORREDOR-MATHEOS, JOSÉ: *Céramiques de Miró et Artigas*. Paris. Maeght éditeur.

RUBIN, WILLIAM S.: *Miró in the collections of the Museum of Modern Art*. New York. The Museum of Modern Art.

1974 *Miró*. Bilbao. "Maestros actuales de la pintura y escultura catalana", No. 22. Ed. La Gran Enciclopedia Vasca.

Joan Miró. Paris. Ed. des Musées Nationaux.

1975 LEIRIS, MICHEL & QUENEAU, RAYMOND: *Joan Miró litógrafo II*. Paris. Maeght éditeur. Barcelona. Ed. Polígrafa, S. A.

1976 ROWELL, MARGIT: *Joan Miró, peinture-poésie*. Paris. Éditions de la Différence.

PICON, GAETAN: *Carnets catalans*. Geneva. Skira. Catalan translation. Barcelona, 1980. Ed. Polígrafa, S. A.

1977 CIRICI, ALEXANDRE: *Miró-Mirall*. Barcelona. Ed. Polígrafa, S. A.

RAILLARD, GEORGES: *Joan Miró. Ceci est la couleur de mes rêves*. Paris, Éditions du Seuil. Spanish translation entitled *Conversaciones con Joan Miró*. Barcelona, 1978. Granica editor.

1978 GIMFERRER, PERE: *Miró: colpir sense nafrar*. Barcelona. Ed. Polígrafa, S. A. Spanish translation by the author, entitled *Miró y su mundo*. Barcelona. Ed. Polígrafa, S. A.

TEIXIDOR, JOAN: *Joan Miró litógrafo III*. Paris. Maeght éditeur. Barcelona. Ed. Polígrafa, S. A.

Joan Miró: pintura. Madrid. Directorate General of the National Trust, Archives and Museums.

Joan Miró: obra gráfica. Madrid. Directorate General of the National Trust, Archives and Museums.

Dessins de Miró. Paris. Centre National d'Art et de Culture Georges Pompidou. Musée National d'Art Moderne.

1981 CALAS, NICOLAS: *Joan Miró litógrafo IV*. Paris. Maeght éditeur. Barcelona. Ed. Polígrafa, S. A.

CORREDOR-MATHEOS, JOSÉ: *Los carteles de Miró*. Barcelona. Ed. Polígrafa, S. A.

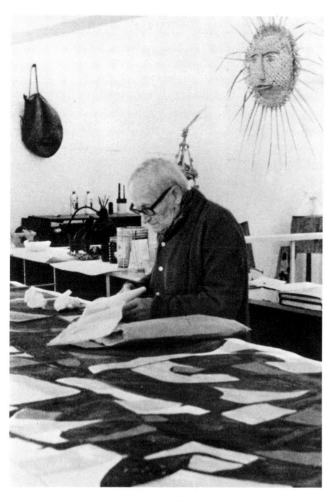
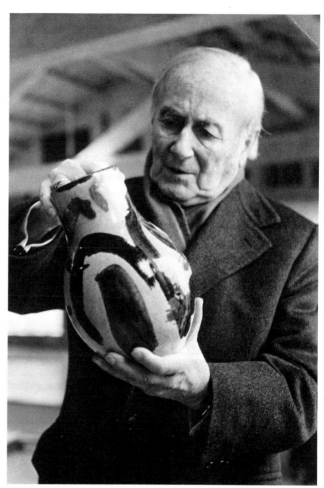
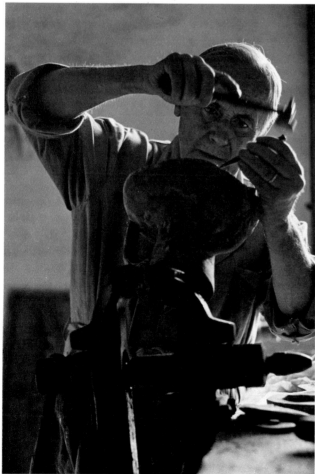

Joan Miró at work.

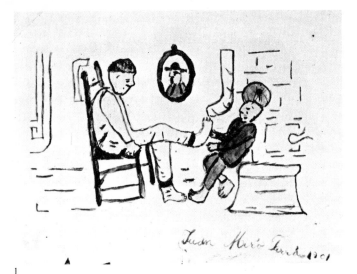

1

2

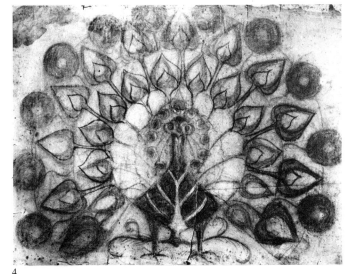

4

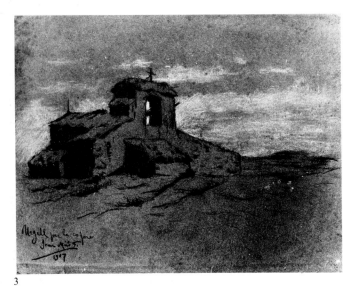

3

5

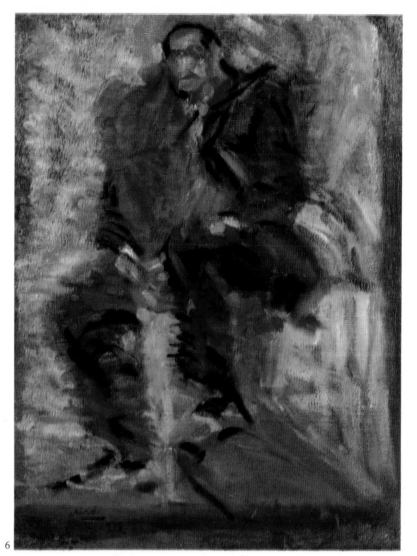

6

7

1. & 2. Earliest drawings by Joan Miró.
 Both done before he entered the Exchange
 School of Fine Arts.

3. *Drawing*. 1907. Copy of a work by Modest Urgell.
 Charcoal and white pencil on paper, 24.1×31.1 cm.

4. *The Peacock*. *c*. 1908.
 Charcoal on paper, 49.5×63.6 cm.

5. Sketch of a street. 1915. Lead pencil.

6. *The Peasant*. 1914.
 Oil on canvas, 65×50 cm.
 Galerie Maeght, Paris.

7. *The Reform*. 1916.
 Oil on paper, 56×42 cm.
 Galerie Maeght, Paris.

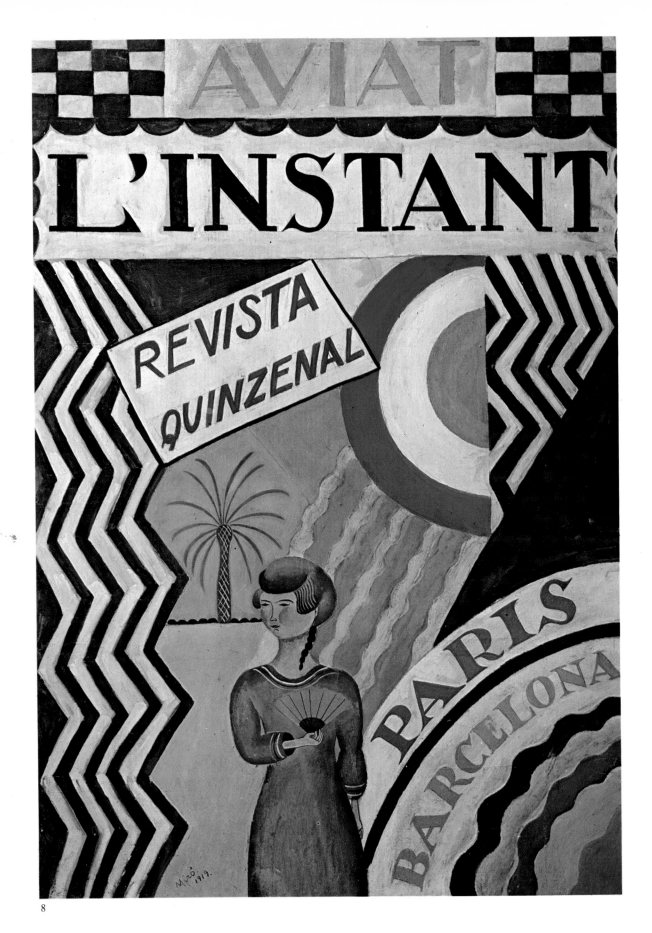

8

8. Sketch for a poster by Joan Miró for the review *L'instant*. Barcelona, Paris. 1919.
Oil on cardboard, 107 × 76 cm.
Joaquim Gomis Collection, Barcelona.

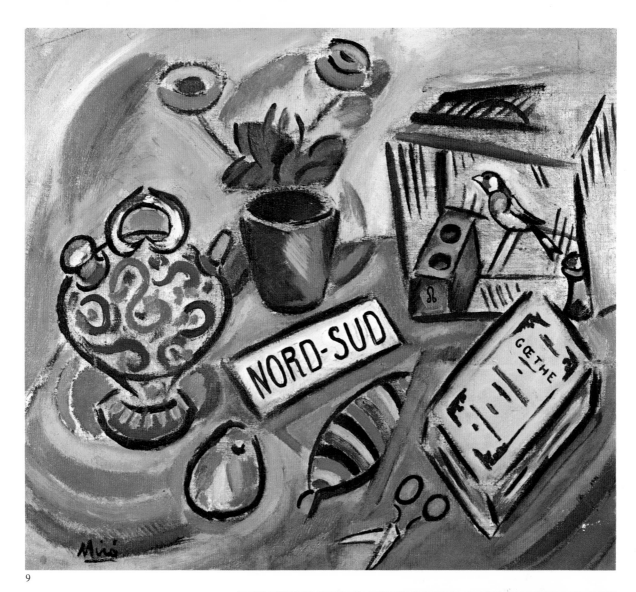

9

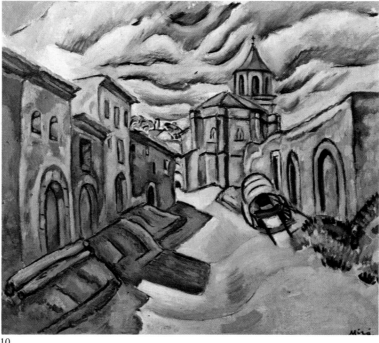

10

9. *Nord-Sud*. 1917.
 Oil on canvas, 62×70 cm.
 Galerie Maeght, Paris.

10. *Prades, a Street*. 1917.
 Oil on canvas, 49×59 cm.
 Pilar Juncosa de Miró Collection, Palma.

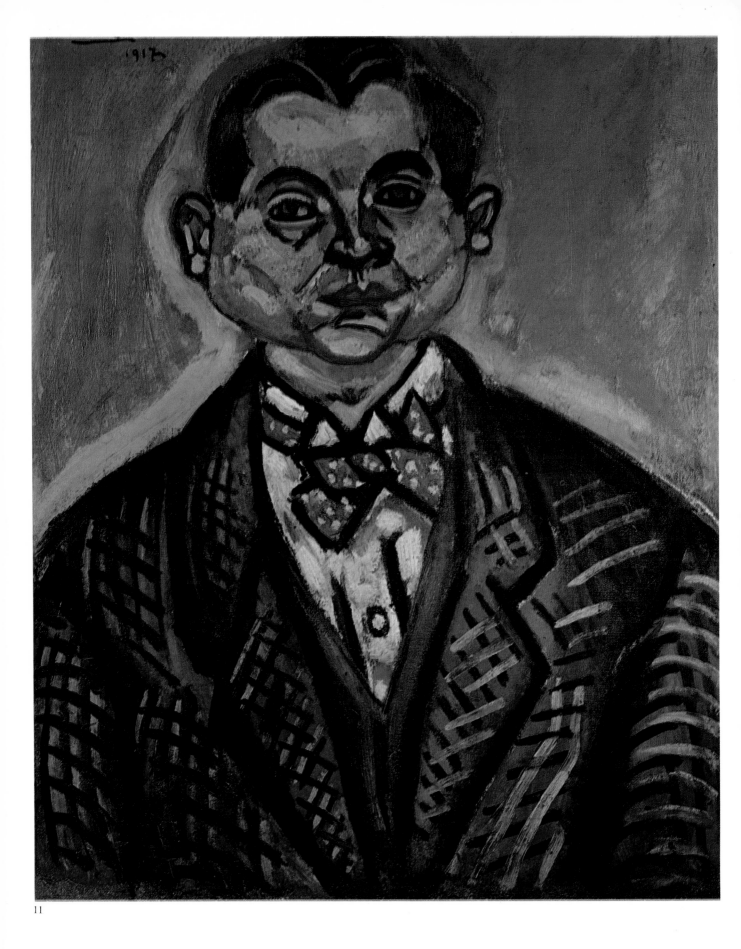

11

11. *Self-portrait.* 1917.
 Oil on canvas, 61×50 cm.
 Mr Edward A. Bragaline Collection, New York.

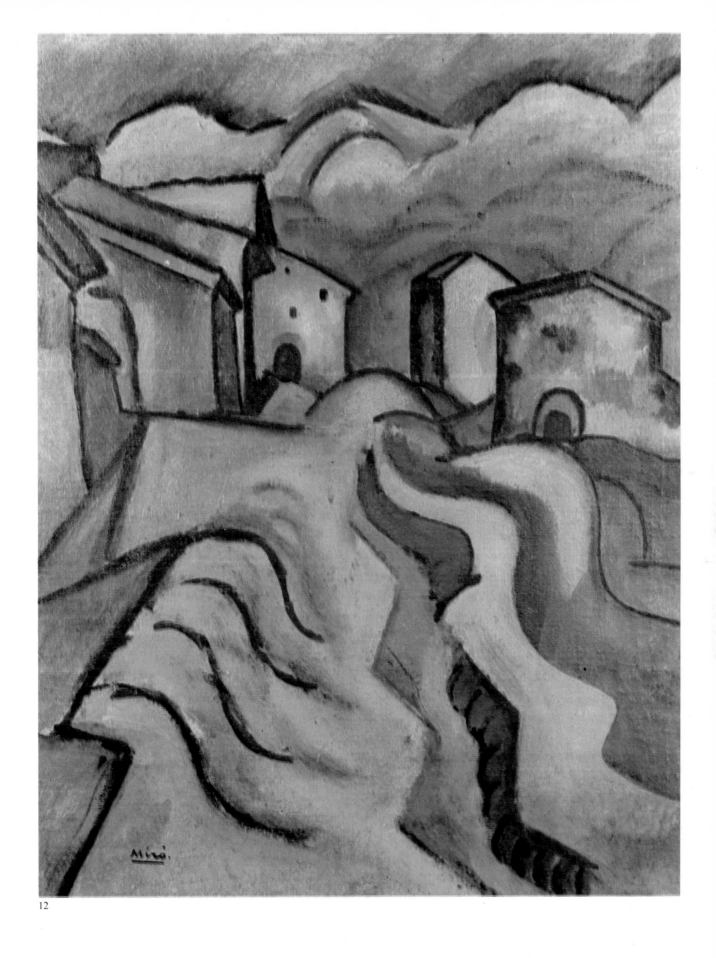

12

12. *Siurana, the Village.* 1917.
Oil on canvas, 39 × 49 cm.
Joaquim Gomis Collection, Barcelona.

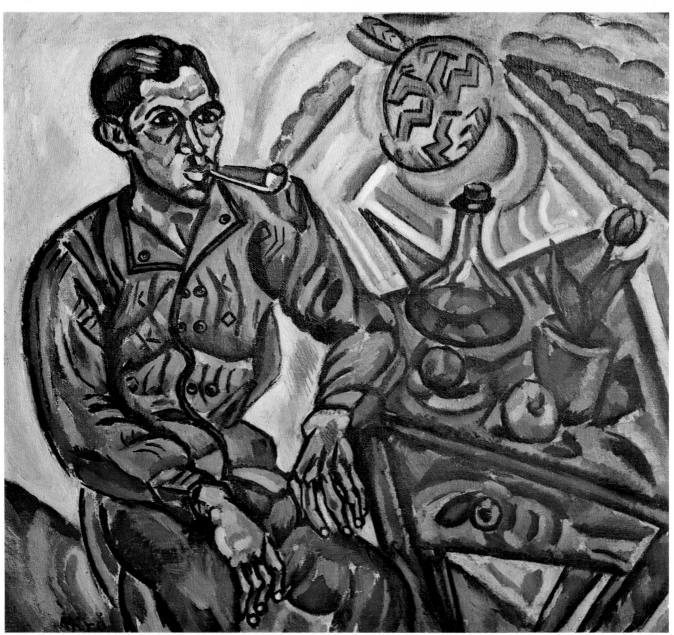

13

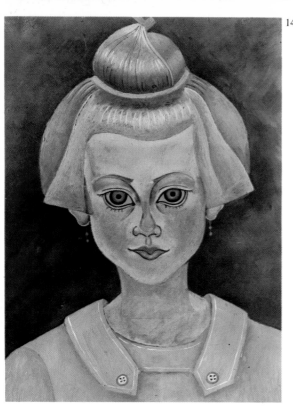

14

13. *Portrait of V. Nubiola.* 1917.
 Oil on canvas, 104 × 113 cm.
 Folkwang Museum Collection, Essen.

14. *Portrait of a Little Girl.* 1918.
 Oil on canvas, 33 × 28 cm.
 Joan Miró Foundation, Barcelona.

15. *Young Man in Red Cardigan (Self-portrait).* 1919.
 Oil on canvas, 73 × 60 cm.
 Musée du Louvre, Paris (Picasso Collection).

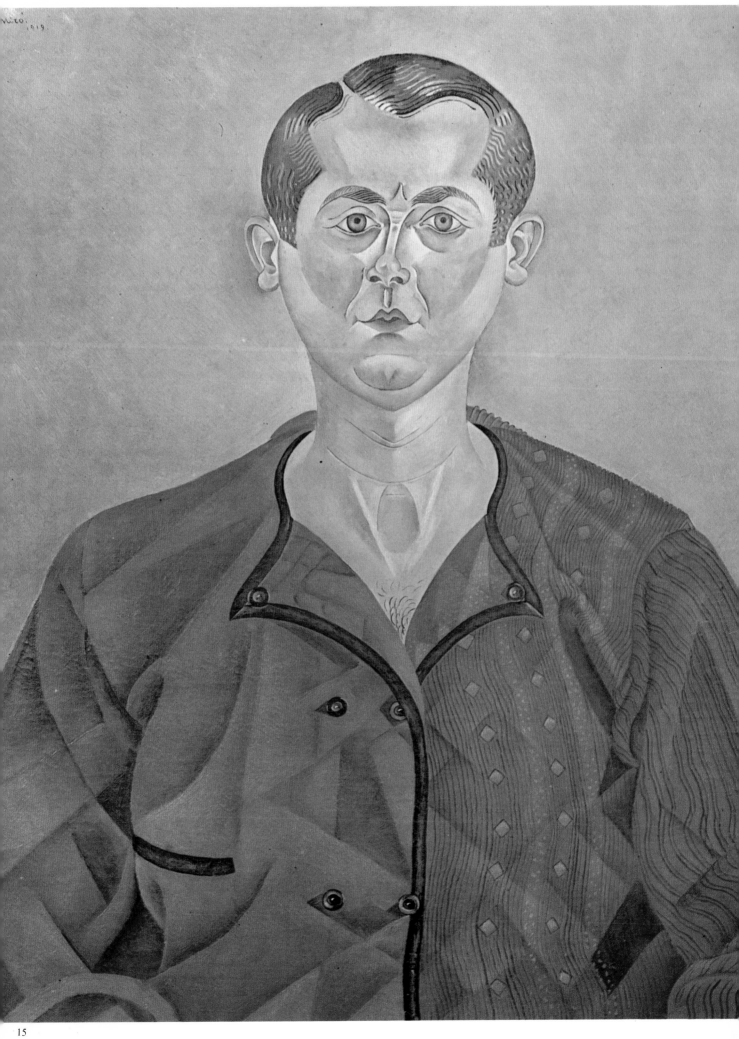

15

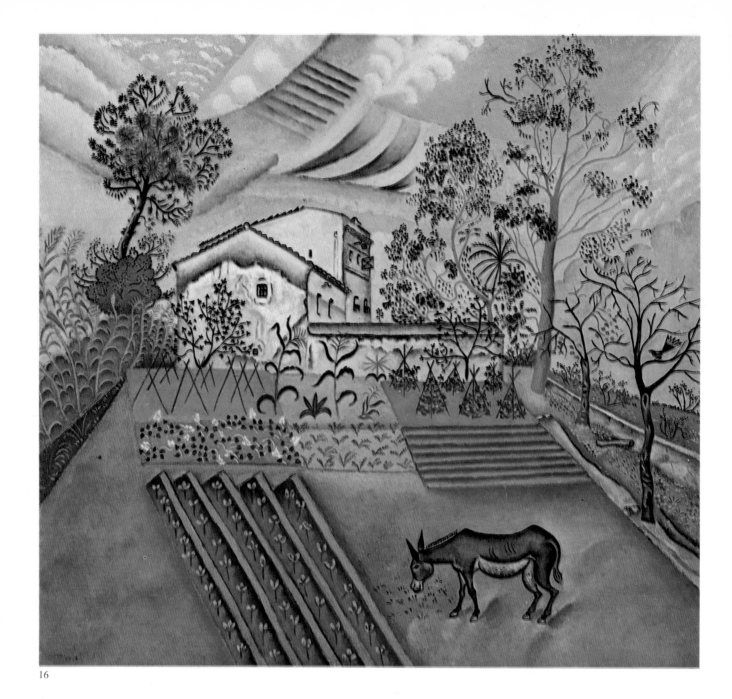

16

16. *Kitchen Garden with Donkey.* 1918.
 Oil on canvas, 60 × 70 cm.
 Nationalmuseum, Stockholm.

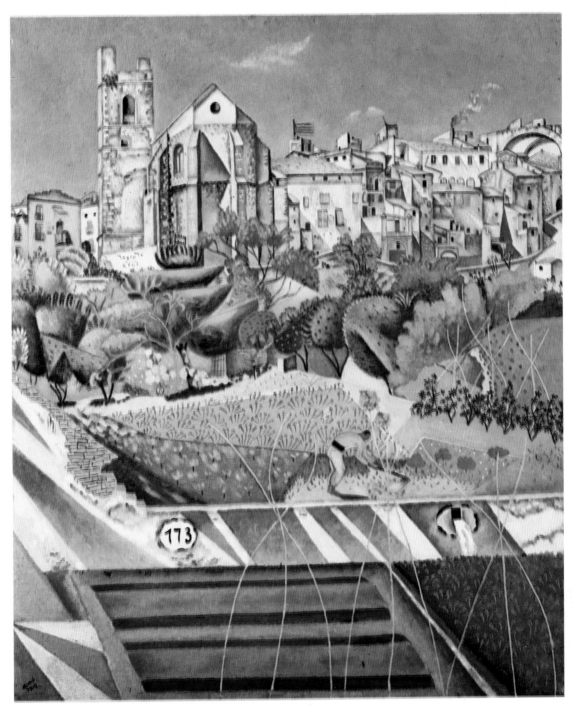

17

17. *Mont-roig, the Church and the Village.* 1919.
Oil on canvas, 73 × 61 cm.
Maria Dolors Miró Collection, Palma.

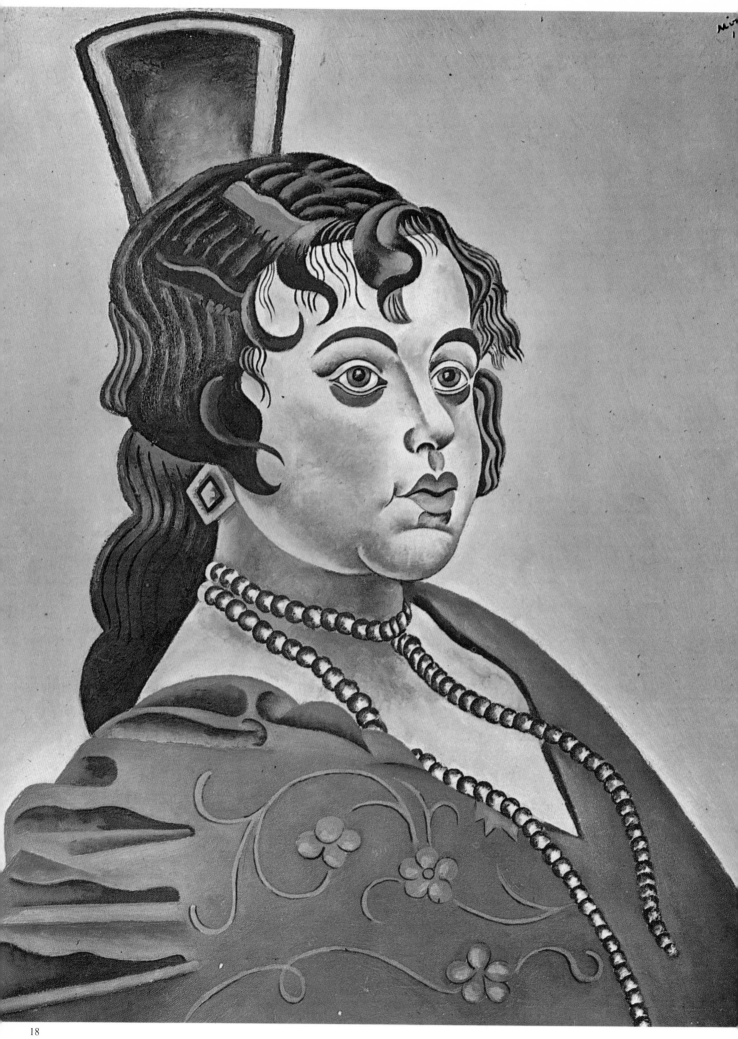

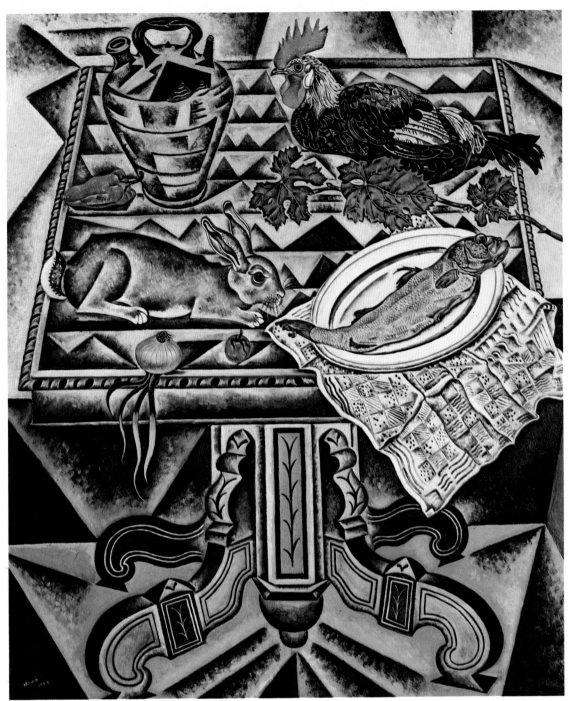

19

18. *Portrait of Spanish Dancer*. 1921.
 Oil on canvas, 66 × 56 cm.
 Musée du Louvre, Paris (Picasso Collection).

19. *The Table*. Mont-roig, 1920.
 Oil on canvas, 130 × 110 cm.
 Private collection, Zürich.

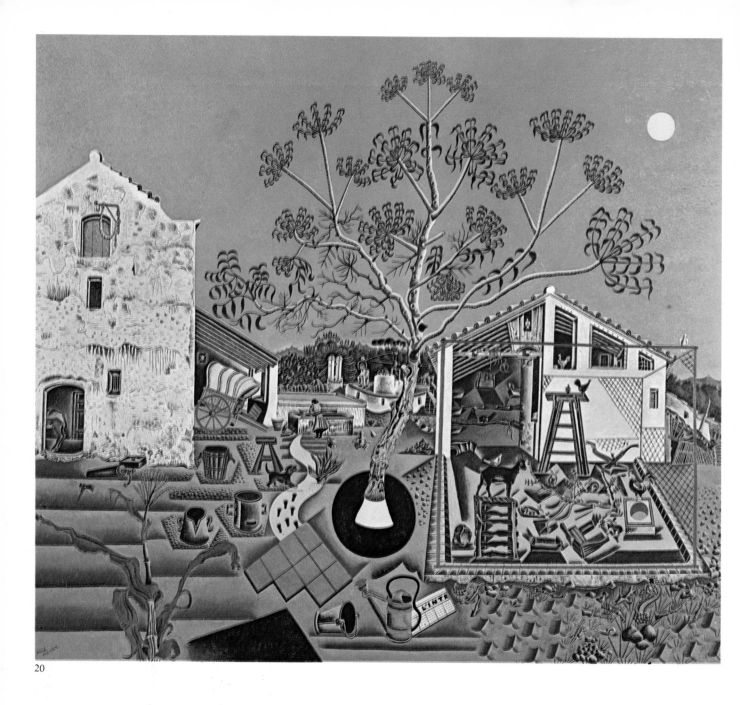

20

20. *The Farmhouse. Mont-roig.* Barcelona-Paris, 1921-1922.
 Oil on canvas, 132 × 147 cm.
 Mrs Ernest Hemingway Collection, New York.

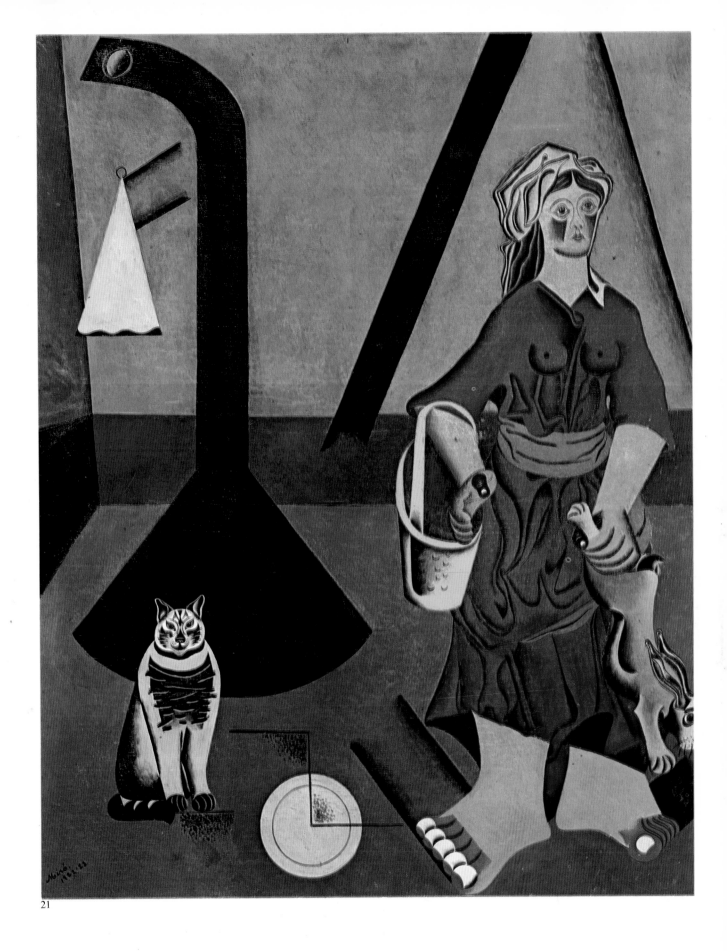

21

21. *The Farmer's Wife*. Mont-roig and Paris, 1922-1923.
Oil on canvas, 81 × 65 cm.
Mme Duchamp Collection, Fontainebleau, Paris.

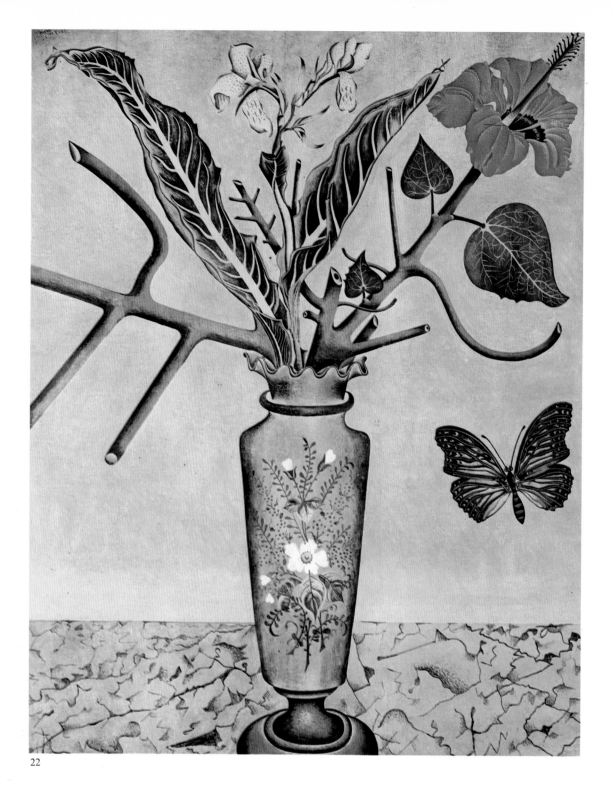

22

22. *Flowers and Butterfly*. 1922-1923.
 Egg tempera on hardboard, 81×65 cm.
 Private collection, Los Angeles.

23. *The Carnival of Harlequin*. 1924-1925.
 Oil on canvas, 66×93 cm.
 Albright-Knox Art Gallery, New York.

24. *Ploughed Earth*. Mont-roig (Tarragona), 1923-1924.
 Oil on canvas, 66×94 cm.
 The Solomon R. Guggenheim Museum, New York.

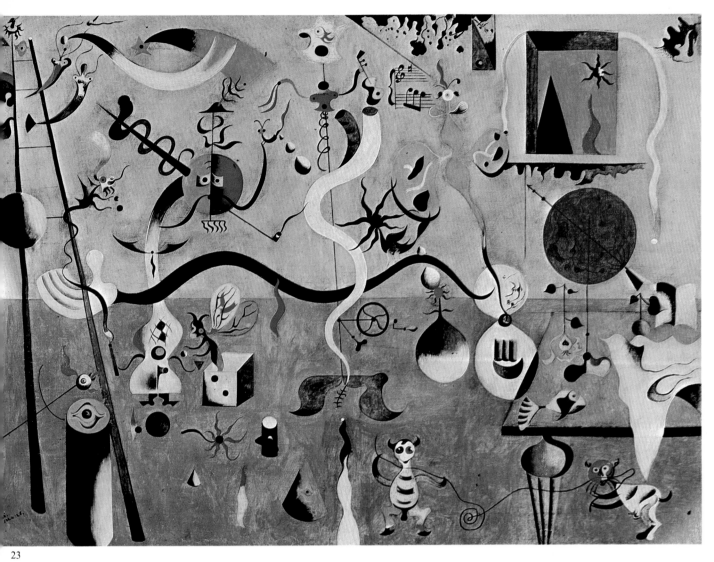

23

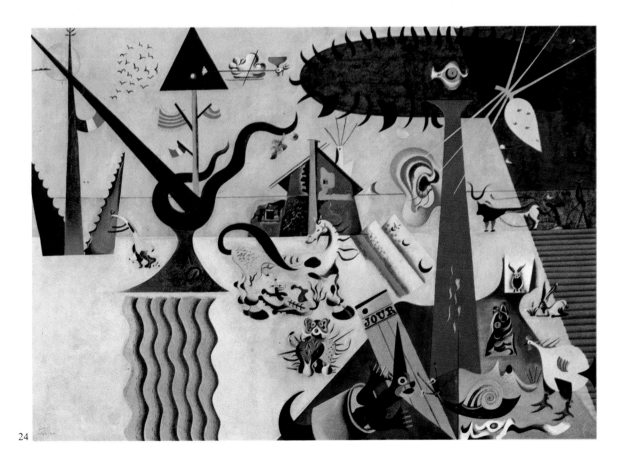

24

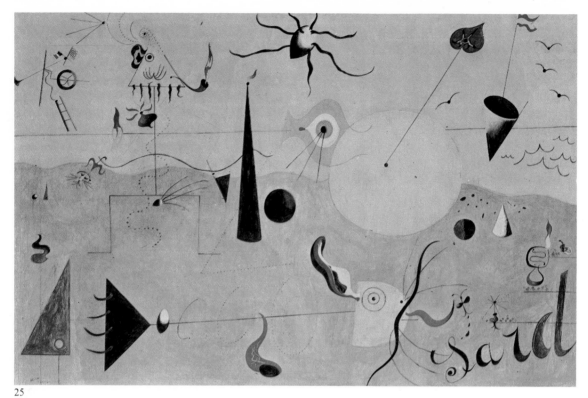

25

26

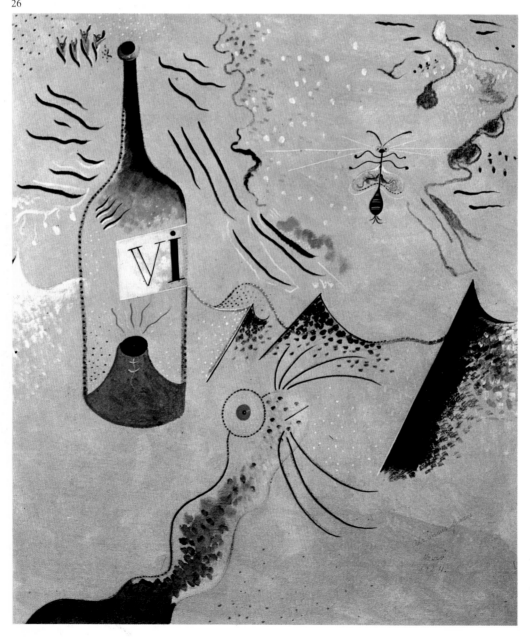

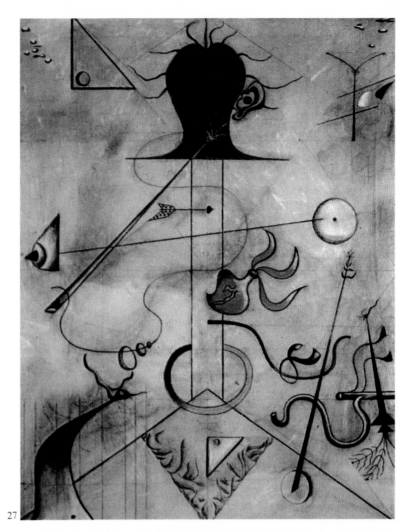

27

28

25. *Catalan Landscape (The Hunter)*. 1923-1924.
 Oil on canvas, 65 × 100 cm.
 The Museum of Modern Art, New York.

26. *The Bottle of Wine*. 1924.
 Oil on canvas, 73 × 65 cm.
 Joan Miró Foundation, Barcelona.

27. *Portrait of Senyora K*. 1924.
 Oil and charcoal on canvas, 115 × 89 cm.
 M. René Gaffé Collection, Cannes.

28. *Oh! un de ces messieurs qui a fait tout ça*
 (Oh, one of those gentlemen who has done all this). 1925.
 Poem picture. Oil on canvas, 195 × 130 cm.
 Galerie Maeght, Paris.

29

30

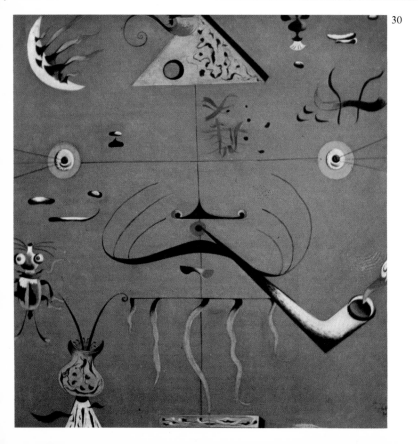

29. *Head of Catalan Peasant*. 1925.
Oil on canvas, 91 × 73 cm.
Private collection, London.

30. *Head of Catalan Peasant*. 1924-1925.
Oil on canvas, 47 × 45 cm.
Private collection, England.

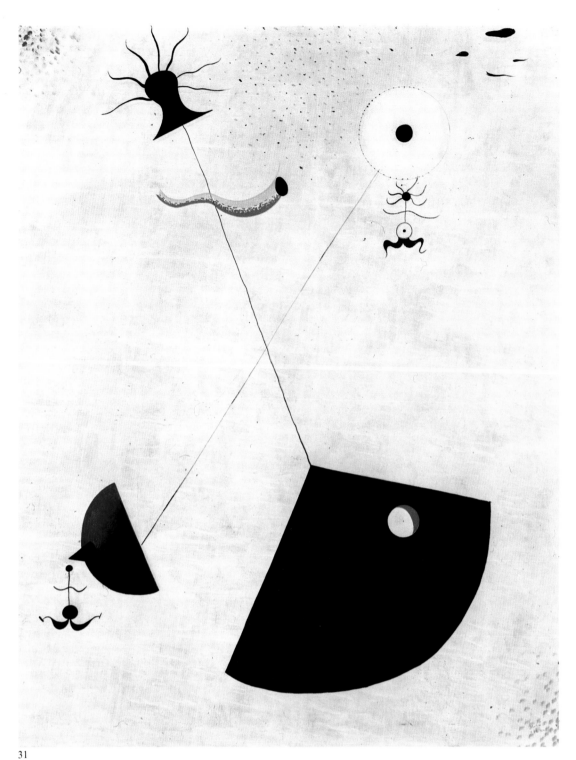

31

31. *Maternity*. 1924.
 Oil on canvas, 92 × 73 cm.
 Private collection, London.

32

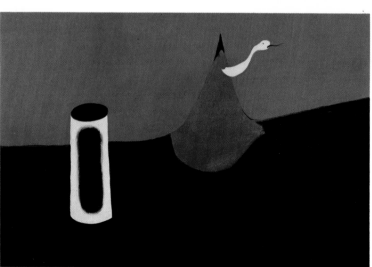

33

32. *Smoker's Head.* 1925.
Oil on canvas, 64 × 49 cm.
Roland Penrose Collection, London.

33. *Landscape with Serpent.* 1927.
Oil on canvas, 130 × 195 cm.
Mme Natalie de Noailles Collection,
Fontainebleau, Paris.

34. *The Siesta.* 1925.
Oil on canvas, 97 × 146 cm.
Musée National d'Art Moderne, Paris.

35. *Archer.* 1927.
Oil on canvas, 116 × 89 cm.
Private collection, London.

36. *Painting (The White Glove).* 1925.
Oil on canvas, 116 × 89 cm.
Private collection, London.

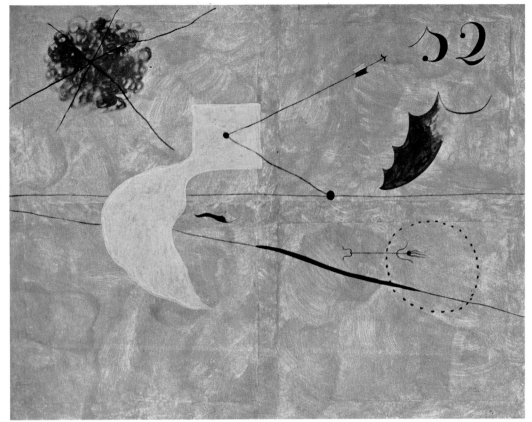

34

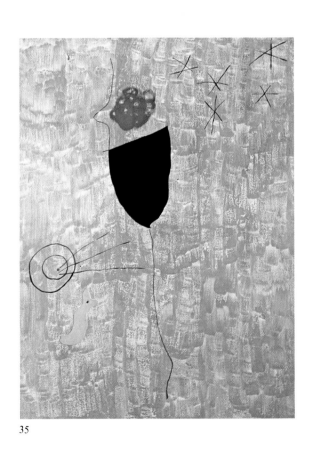

35

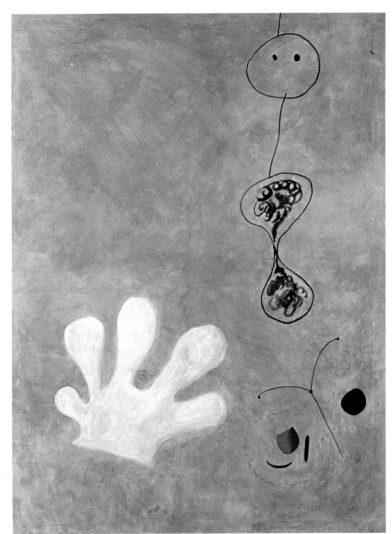

36

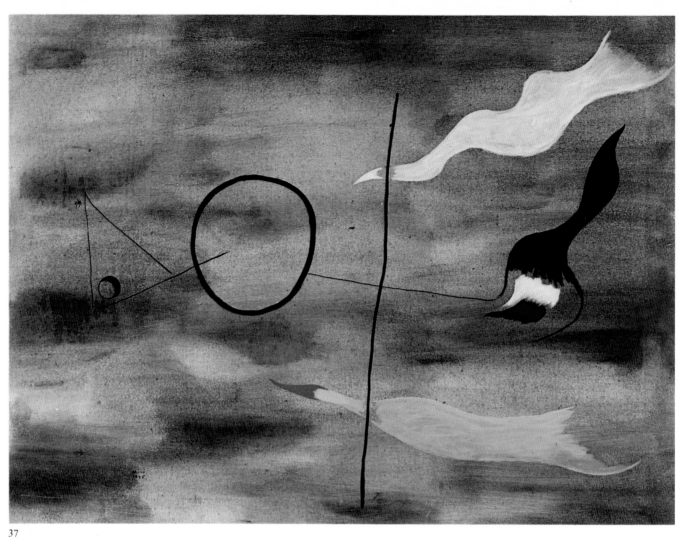

37

38

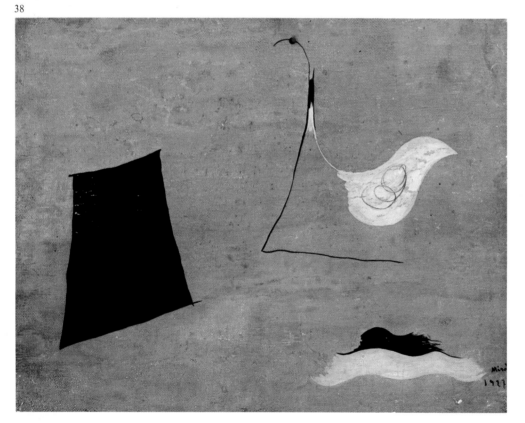

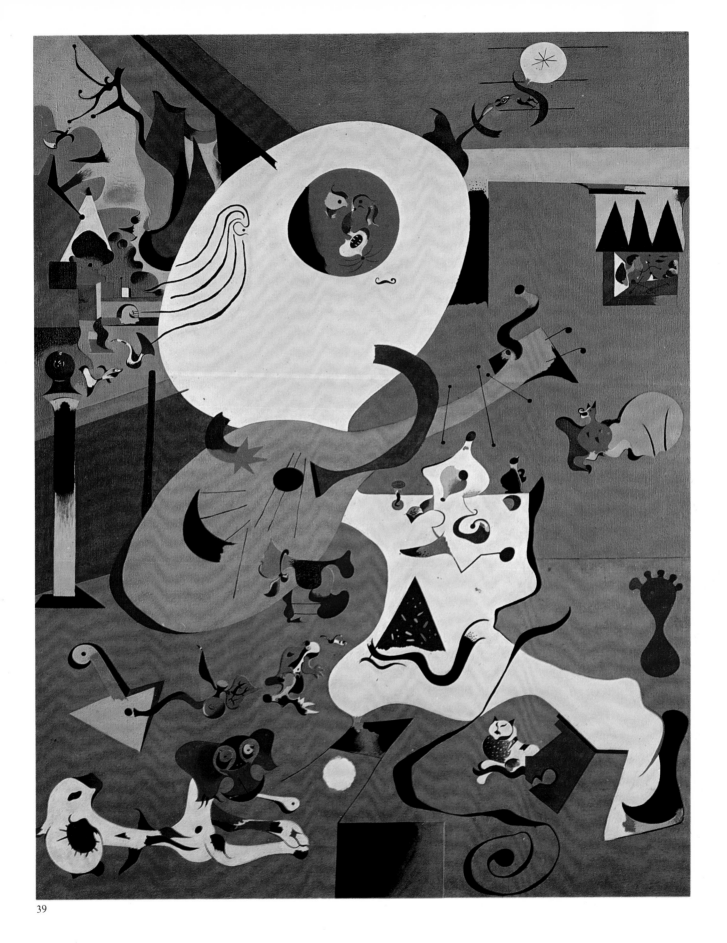

39

37. *Painting*. 1925.
 Oil on canvas, 72 × 99 cm.
 Joan Miró Foundation, Barcelona.

38. *Composition*. 1927.
 Oil on wood, 19 × 25 cm.
 Private collection.

39. *Dutch Interior I*. 1928.
 Oil on canvas, 92 × 73 cm.
 The Museum of Modern Art, New York.

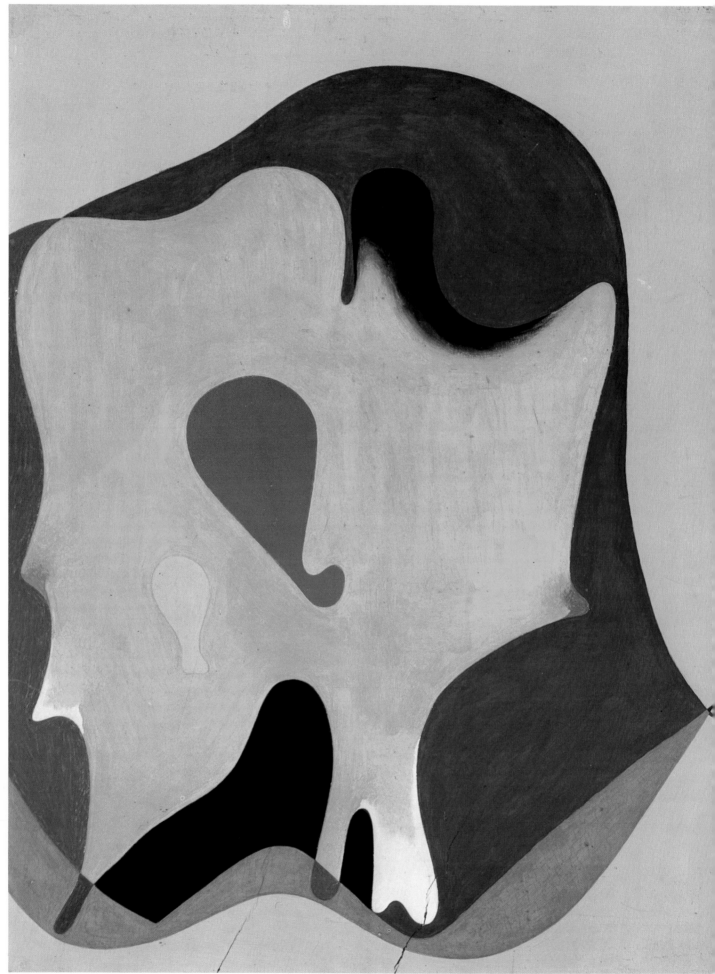

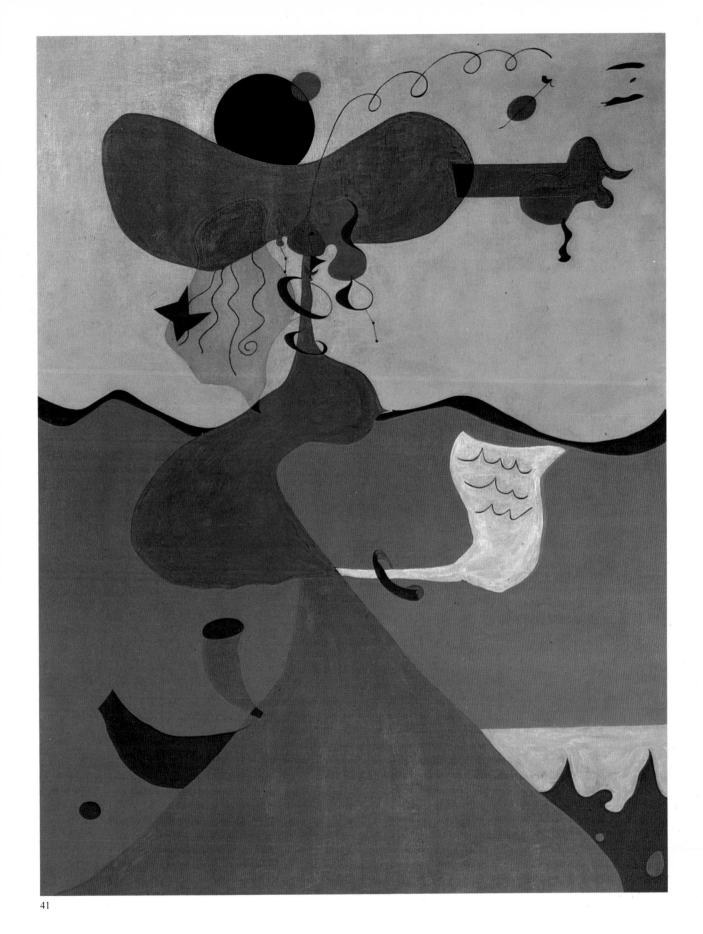

41

40. *Man's Head*. 1932.
 Oil on wood, 35×27 cm.
 Galerie Maeght, Paris.

41. *Portrait of Mrs. Mills in 1750 (after George Engleheart)*. 1929.
 Oil on canvas, 116×89 cm.
 The Museum of Modern Art, New York.

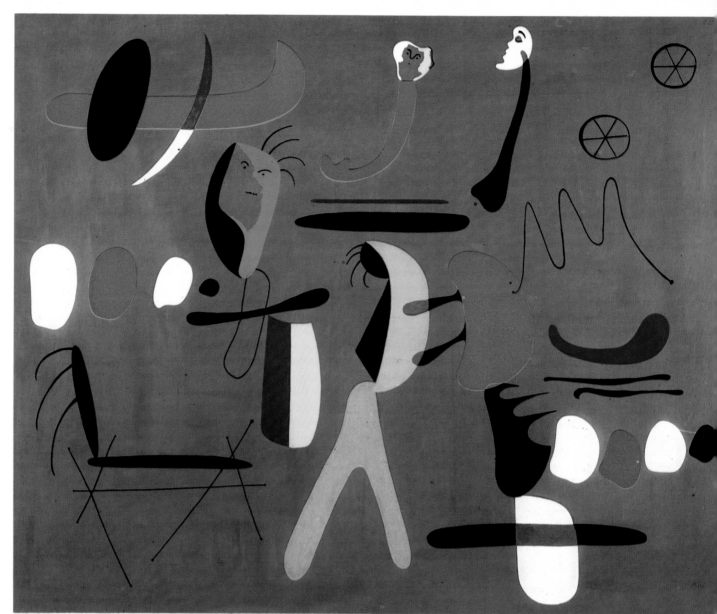

42

43

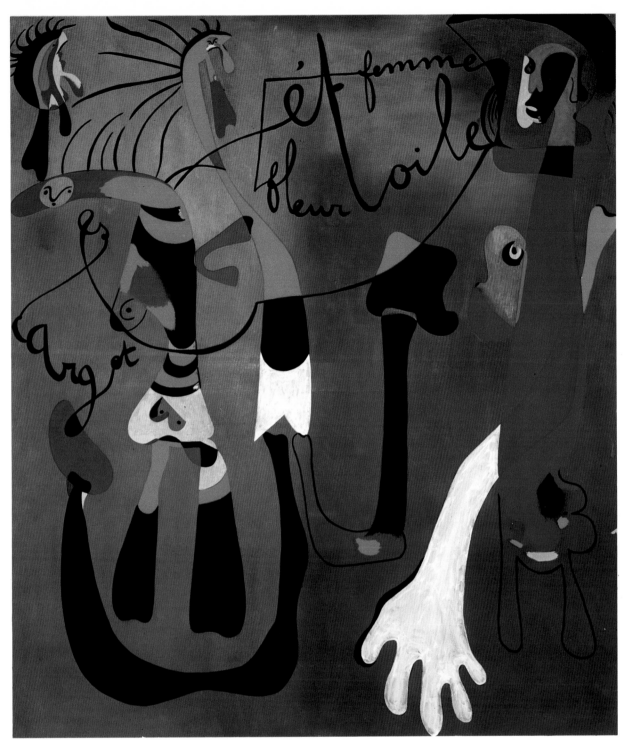

44

42. *Painting According to a Collage*. 1933.
 Oil on canvas, 130 × 162 cm.
 Joan Miró Foundation, Barcelona.

43. Preparatory collage for *Painting* (Fig. 42). 1933.
 Paper stuck on paper, 47 × 63 cm.
 Joan Miró Foundation, Barcelona.

44. *Snail, Woman, Flower, Star*. 1934.
 Oil on canvas, 195 × 172 cm.
 Joan Miró Foundation, Barcelona.

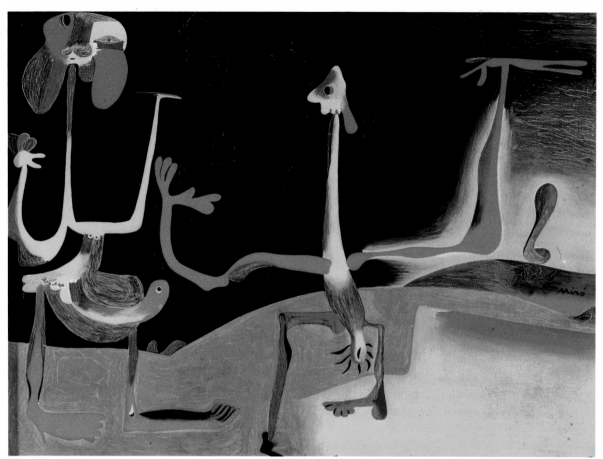

45

46

45. *Man and Woman before a Heap of Excrement.* 1935.
Oil on copper, 23.2 × 32 cm.
Joan Miró Foundation, Barcelona.

46. *Three Women.* 1935.
Oil on cardboard, 106 × 75 cm.
Alexander Calder Collection, Saché (France).

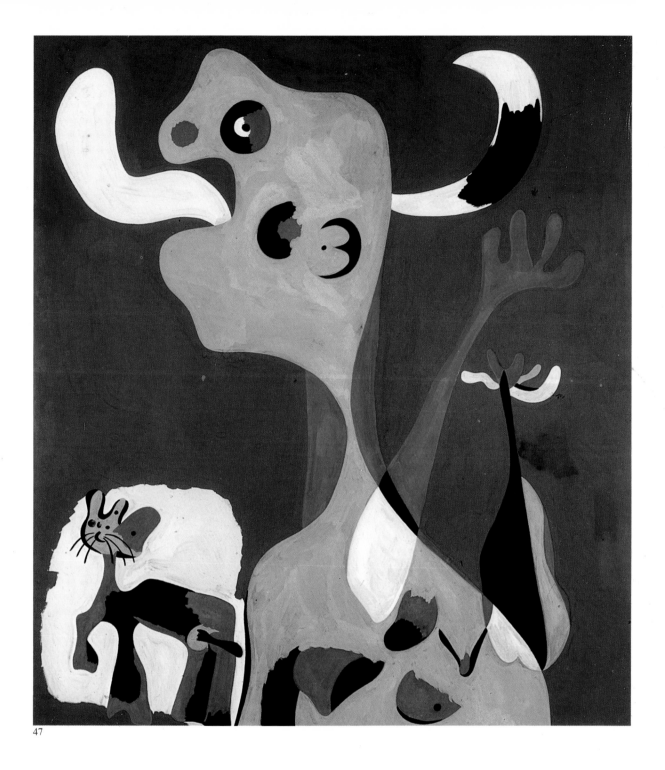

47

47. *Woman and Dog before the Moon*. 1936.
Gouache, 50 × 44.5 cm.
Mercè Torres Collection, Barcelona.

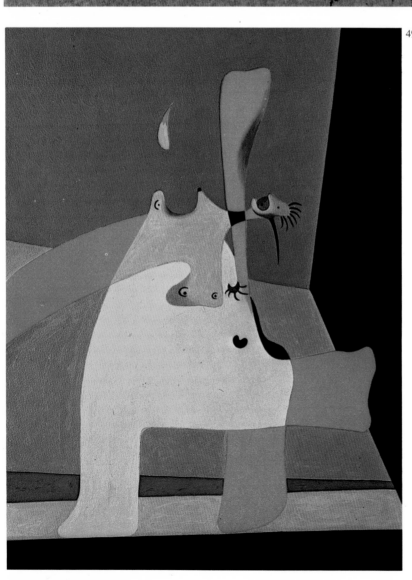

48

49

48. *Painting on Masonite*. 1936.
 Oil, tar, casein and sand on conglomerate,
 78 × 108 cm.
 Joan Miró Foundation, Barcelona.

49. *Flame in Space and Nude Woman*. 1932.
 Oil on wood, 41 × 32 cm.
 Joan Miró Foundation, Barcelona.

50. *A Star Caresses the Breast of a Black Woman*.
 Poem painting, 1938.
 Oil on canvas, 130 × 196 cm.
 Pierre Matisse Gallery, New York.

51. *Still Life with Old Shoe*. 1937.
 Oil on canvas, 81 × 116 cm.
 The Museum of Modern Art, New York.

50

51

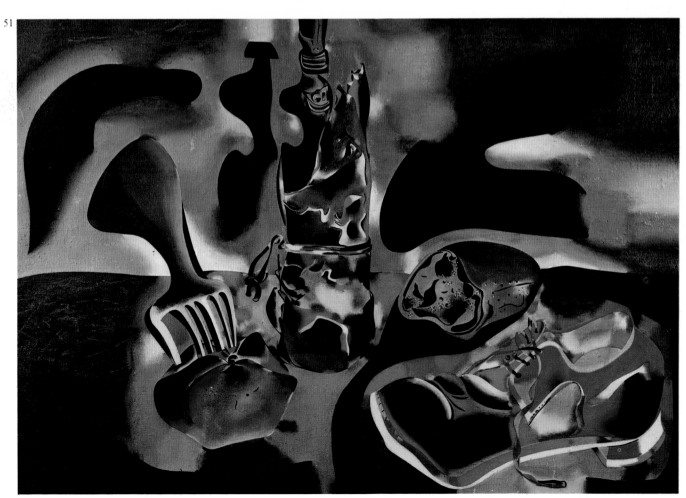

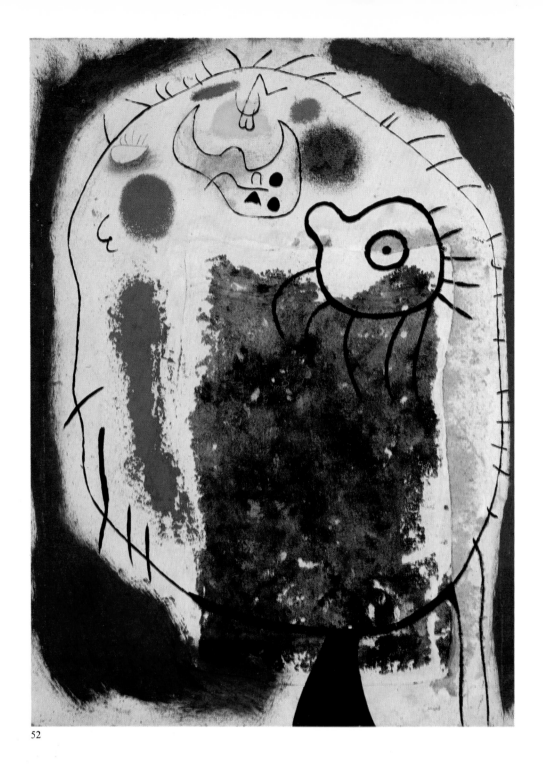

52

52. *Head*. 1937.
 Oil with glued towel and paint on plywood, 121 × 91 cm.
 Joan Miró Foundation, Barcelona.

53. *Self-portrait I*. 1937-1960.
 Oil and pencil on canvas, 146 × 97 cm.
 Joan Miró Foundation, Barcelona.

54. *Gouache*. 1933.
 49 × 65 cm.
 Joan Miró Foundation, Barcelona.

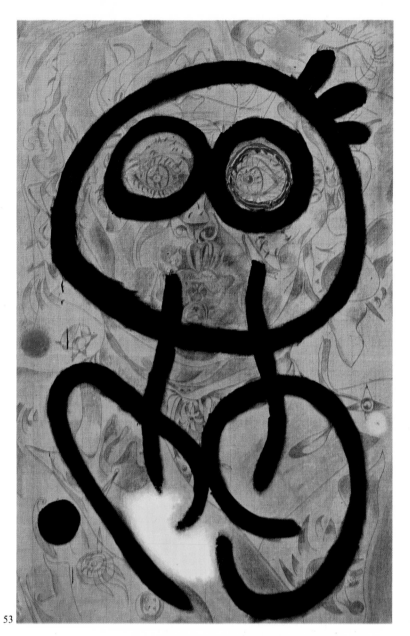

53

54

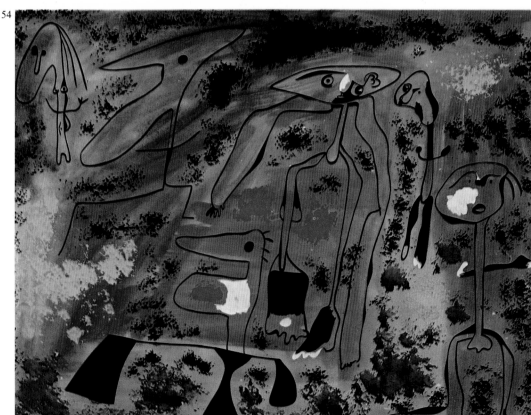

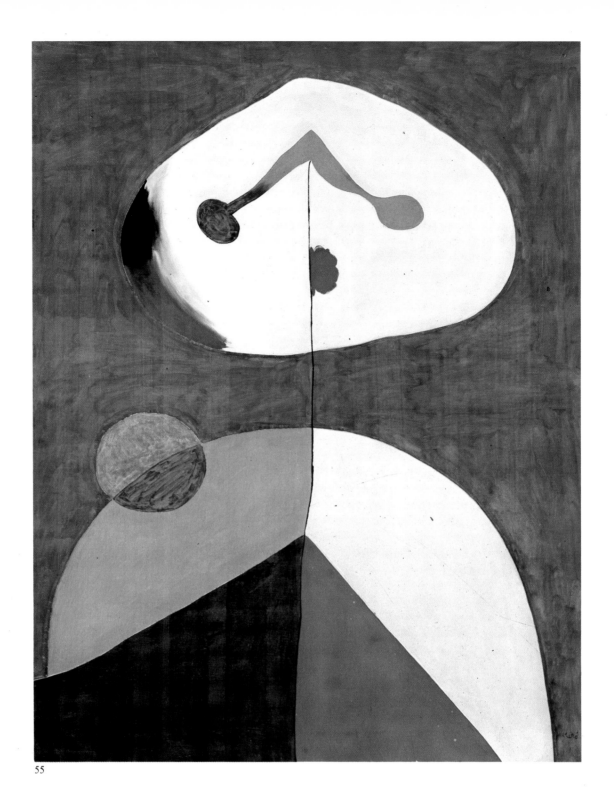

55

55. *Portrait II*. 1938.
 Oil on canvas, 162 × 130 cm.

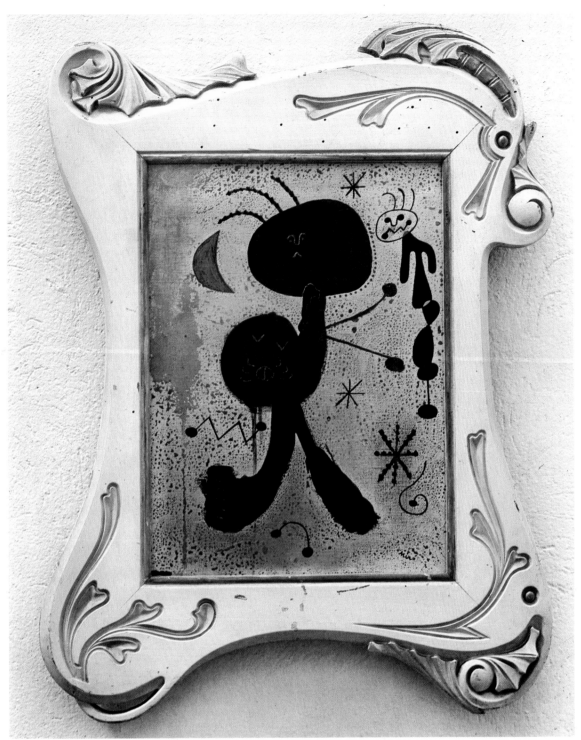

56

56. *Painting with Art-Nouveau Frame.* 1943.
Oil on canvas, 40×30 cm.
Joan Miró Foundation, Barcelona.

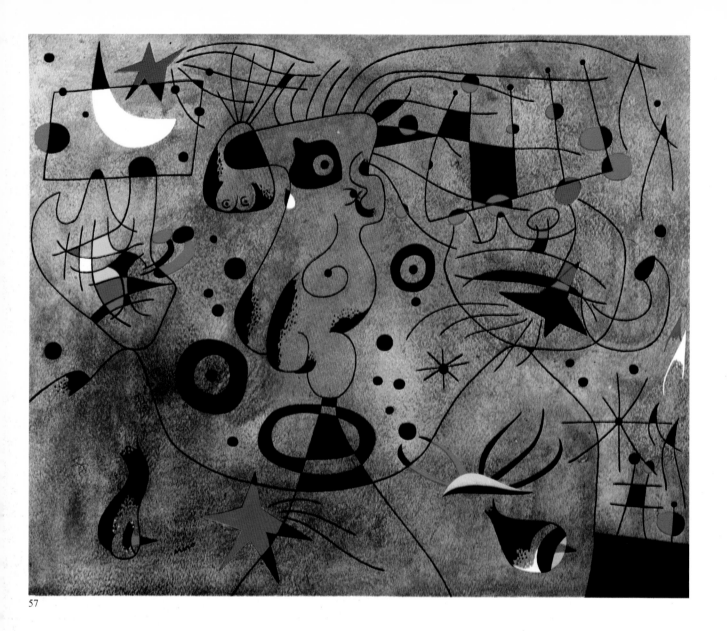

57

57. *Woman with Fair Armpit Dressing her Hair by the Light of the Stars.*
(From the *Constellations* series). Varengeville, 1940.
Gouache and paint in turpentine on paper, 38 × 46 cm.
The Cleveland Museum of Art, Cleveland.

58. *Women Surrounded by the Flight of a Bird* (From the *Constellations* series). 1941.
Gouache and paint on paper, 46 × 38 cm.
Elisa Breton Collection, Paris.

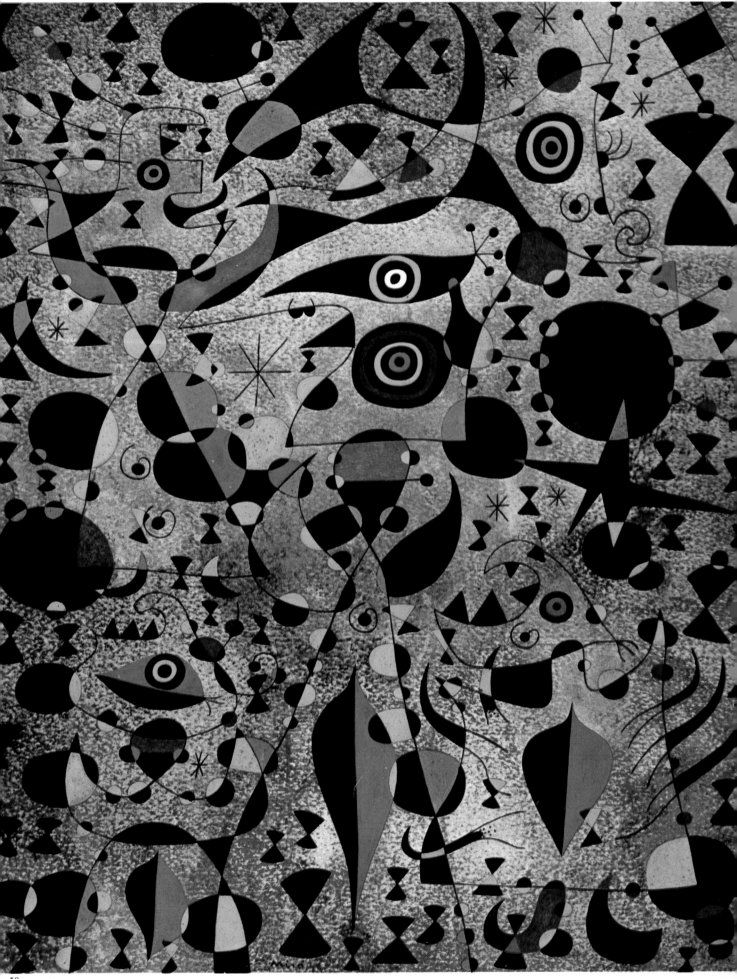

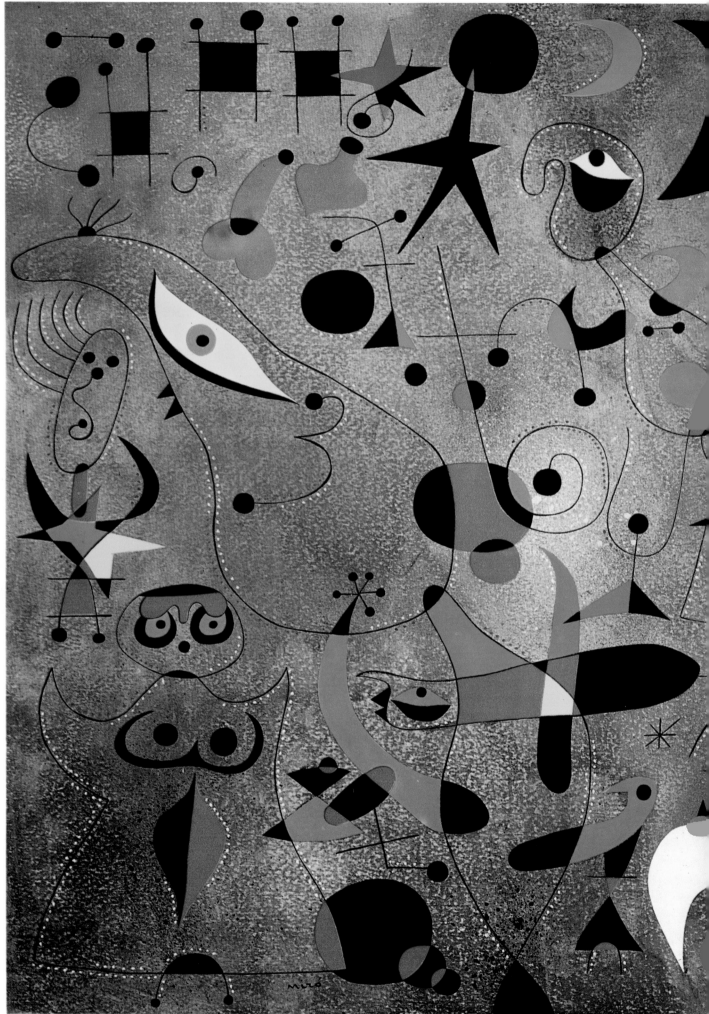

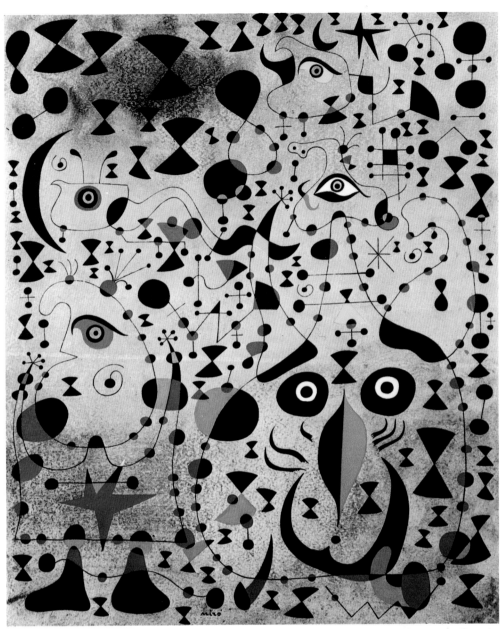

60

59. *The Day's Awakening* (From the *Constellations* series). 1941.
Gouache and paint on paper, 46×38 cm.
Mr and Mrs Ralph F. Colin Collection, New York.

60. *The Beautiful Bird Deciphering the Unknown to the Pair of Lovers*
(From the *Constellations* series). 1941.
Gouache and paint in turpentine on paper, 33×41 cm.
The Museum of Modern Art, New York.

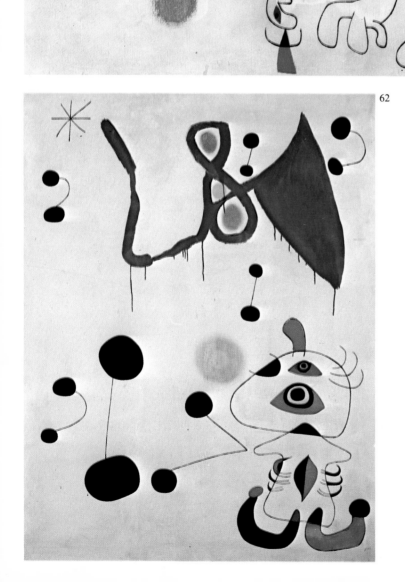

61

62

61. *Woman and Birds at Sunrise.* 1946.
Oil on canvas, 54 × 65 cm.
Joan Miró Foundation, Barcelona.

62. *Woman and Bird in the Night.* 1945.
Oil on canvas, 146 × 114 cm.
Joan Miró Foundation, Barcelona.

63. *The Red Sun Gnaws at the Spider.* 1948.
Oil on canvas, 76 × 96 cm.
Private collection, Belgium.

64. *Mural Painting for Joaquim Gomis.* 1948.
Oil on fibrocement, 125 × 250 cm.
Joaquim Gomis Collection, Barcelona.

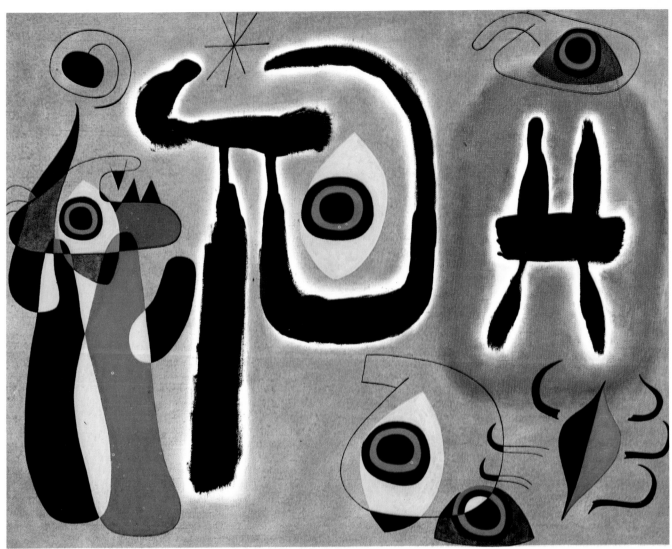

63

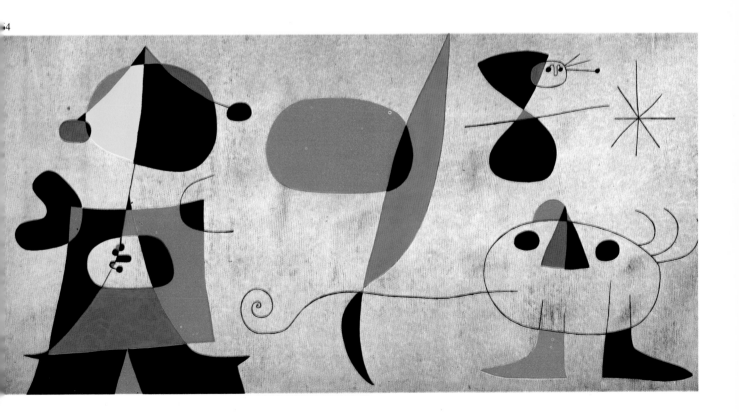

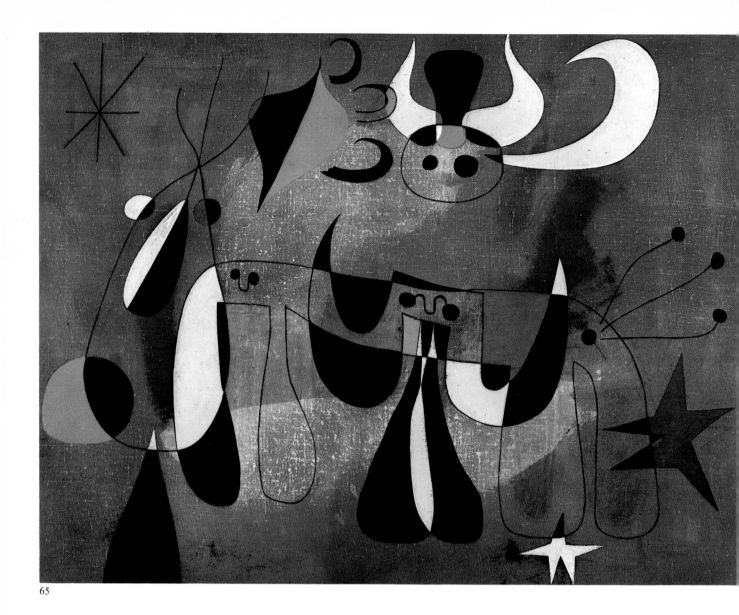

65

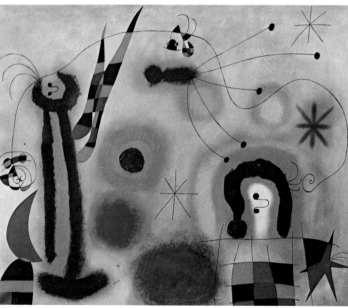

66

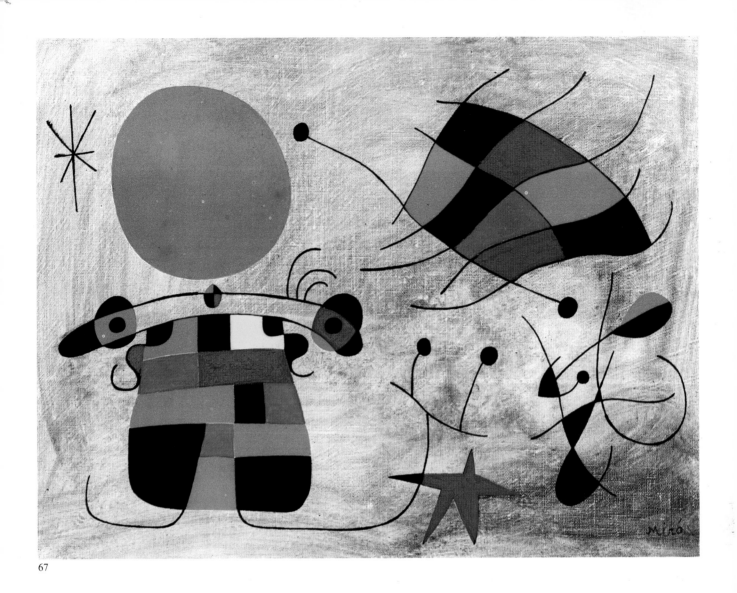

67

65. *Characters in the Night.* 1950.
 Oil on canvas, 89 × 115 cm.
 Genia Zadok Collection, New York.

66. *Dragonfly with Red Wings Pursuing a Serpent Gliding Spirally towards the Comet-Star.* 1951.
 Oil on canvas, 81 × 100 cm.
 Joan Miró Foundation, Barcelona.

67. *Smile of the Blazing Wings.* 1953.
 Oil on canvas, 33 × 46 cm.
 Pilar Juncosa de Miró Collection, Palma.

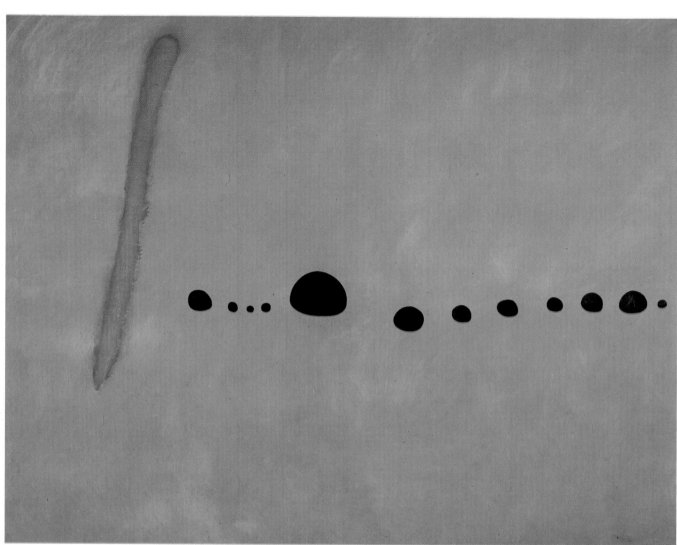

68

69

68. *Blue II*. 1961.
 Oil on canvas, 270×355 cm.
 Galerie Maeght, Paris.

69. *Blue III*. 1961.
 Oil on canvas, 270×355 cm.
 Pierre Matisse Gallery, New York.

70

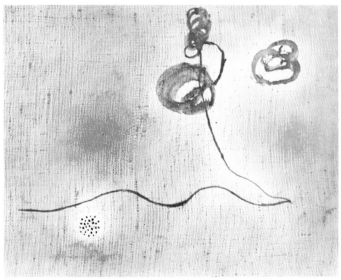

71

70. *Red Disc*. 1960.
 Oil on canvas, 130×165 cm.
 Mr and Mrs Victor K. Kiam Collection, New York.

71. *Painting I*. 16-10-65.
 Oil on canvas, 19×25 cm.

72. *Character and Bird*. 1963.
 Oil on cardboard, 75×105 cm.

73. *Character and Bird*. 1963.
 Oil on cardboard, 75×105 cm.

72

73

74

74. *Friend's Message.* 1964.
 Oil on canvas, 264 × 275 cm.
 Galerie Maeght, Paris.

75

75. *Women and Birds*. 1967.
Oil on wrinkled paper, 91 × 74 cm.

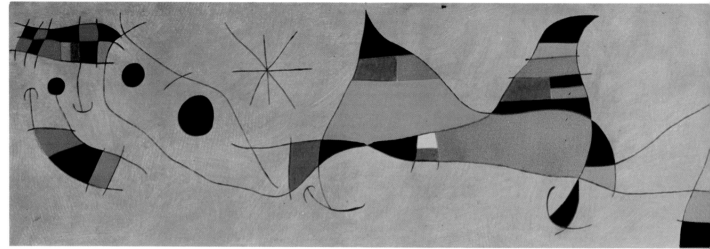

76

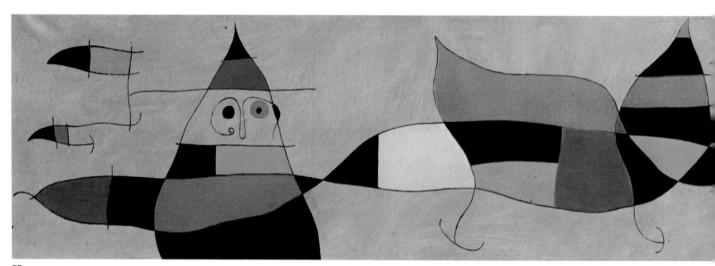

77

76. *For Emili Fernández Miró*. 1963.
 Oil on canvas, 75 × 280 cm.
 Emili Fernández Miró Collection, Palma.

77. *For David Fernández Miró*. 1964.
 Oil on canvas, 75 × 280 cm.
 David Fernández Miró Collection, Palma.

78. *Woman III*. 1965.
 Oil on Canvas, 116 × 81 cm.
 Joan Miró Foundation, Barcelona.

79. *The Skiing Lesson*. 1966.
 Oil on canvas, 193 × 324 cm.
 Galerie Maeght Collection, Paris.

78

79

80

81

82

80. *Song of the Vowels*. 1967.
 Oil on canvas, 350×144 cm.
 The Museum of Modern Art, New York.

81. *Woman and Bird in the Night*. 1967.
 Oil on canvas, 78×60 cm.
 Private collection, Paris.

82. *Bird in the Night*. 1967.
 Oil on canvas, 190×277 cm.
 Galerie Maeght, Paris.

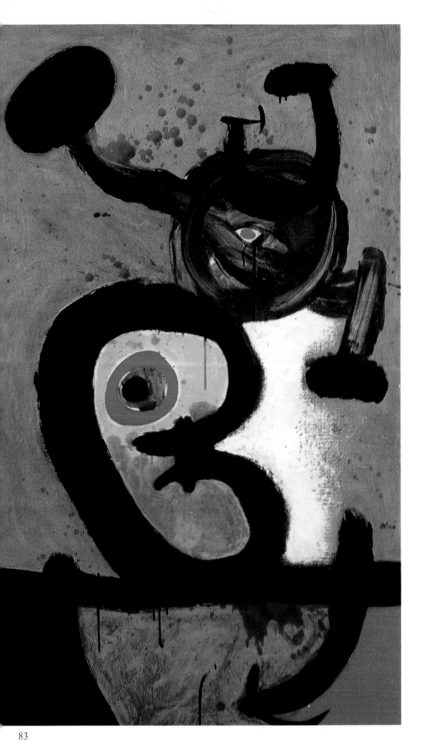

83

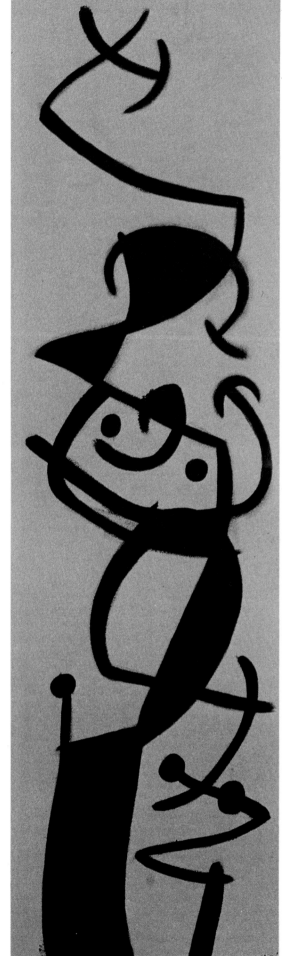

83. *Character and Bird in the Night.* 1967.
 Oil on canvas, 115 × 73 cm.

84. *Woman and Bird.* 1967.
 Oil on canvas, 203 × 60 cm.
 Galerie Maeght, Paris.

84

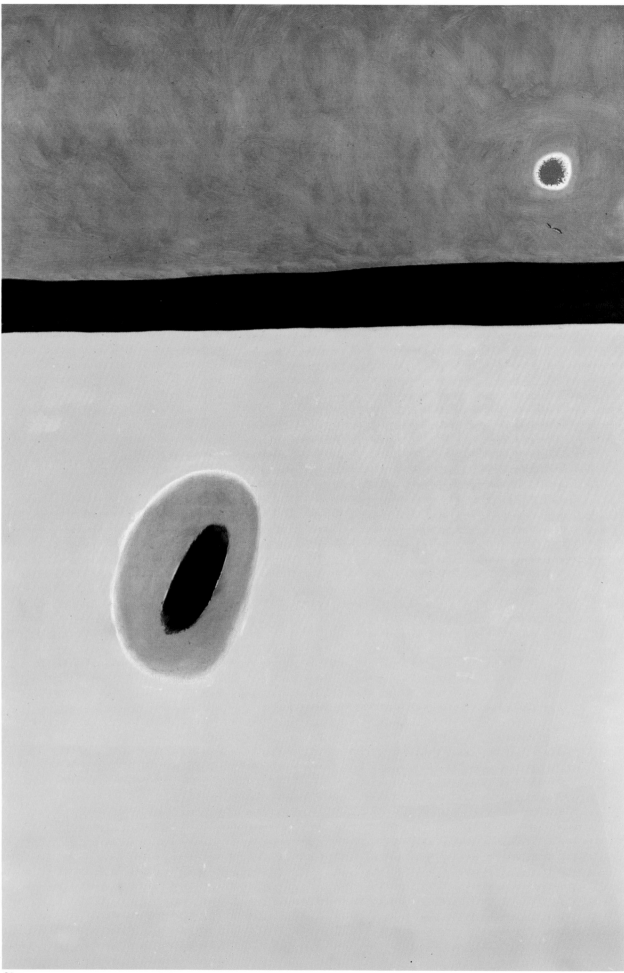

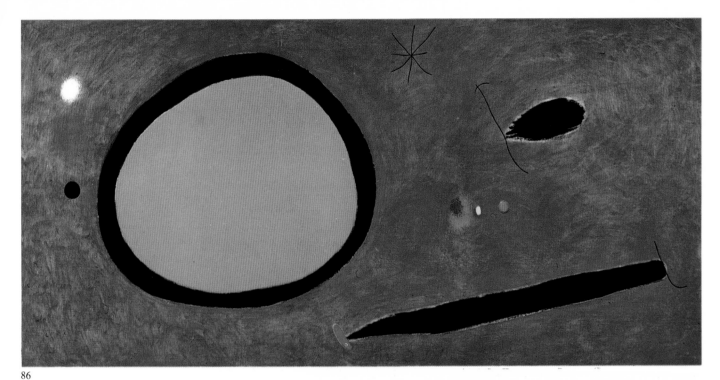

86

87

85. *The Wing of the Lark, Aureoled by the Blue of Gold, Reaches the Heart of the Poppy Sleeping on the Grass Adorned with Diamonds.* 1967.
Oil on canvas, 195 × 130 cm.
Pierre Matisse Gallery, New York.

86. *Bird's Flight by Moonlight.* 1967.
Oil on canvas, 130 × 260 cm.

87. *Hair Pursued by Two Planets.* 1968.
Oil on canvas, 195 × 130 cm.

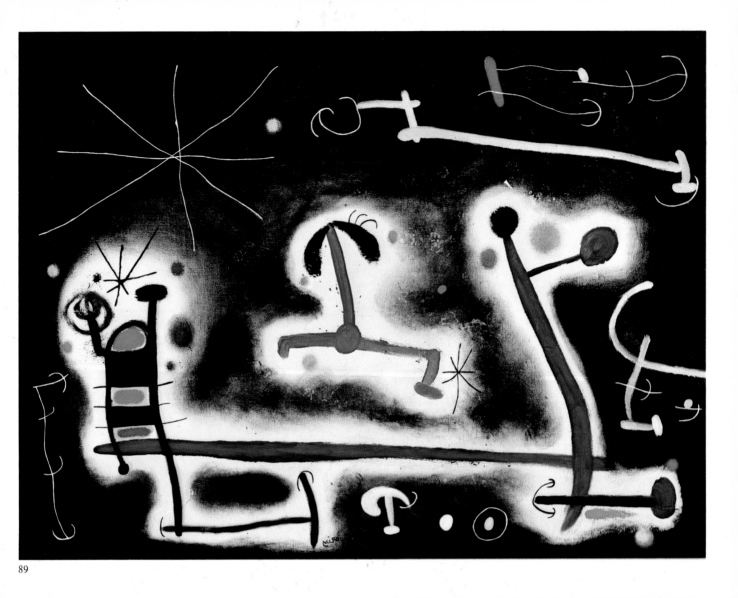

89

88. *Drop of Water on the Pink Snow.* 1968.
 Oil on canvas, 195 × 130 cm.
 Galerie Maeght, Paris.

89. *Characters and Birds Rejoicing at the Coming of Night.* 1968.
 Oil on canvas, 96 × 130 cm.
 Antoni Tàpies Collection, Barcelona.

90. *The Gold of the Azure.* 1967.
 Oil on canvas, 205 × 175 cm.
 Joan Miró Foundation, Barcelona.

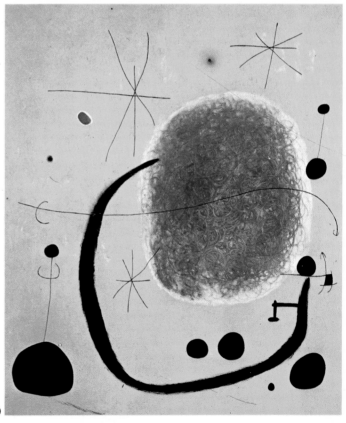

90

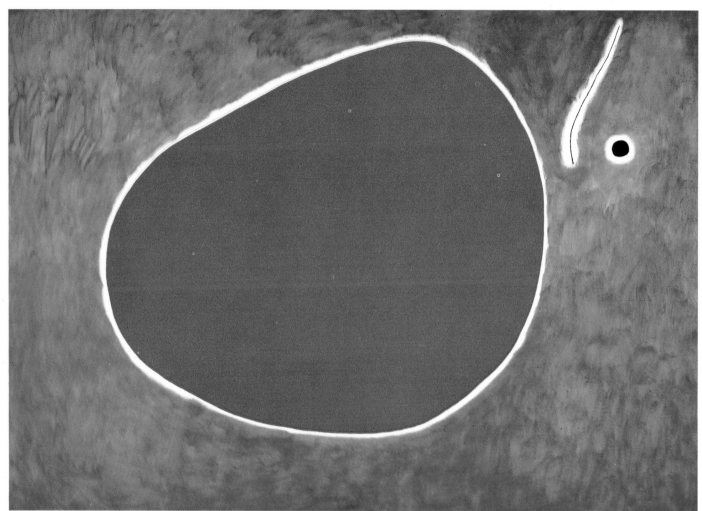

91

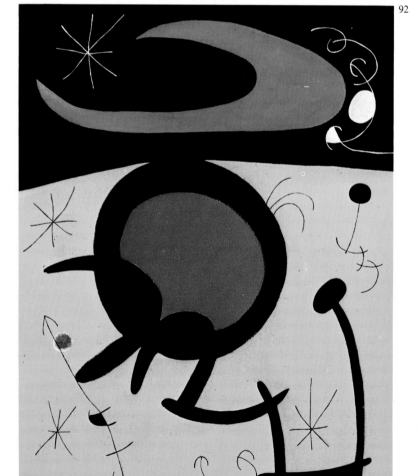

92

91. *The Flight of the Dragonfly before the Sun*. 1968.
 Oil on canvas, 174 × 224 cm.

92. *Flight of Birds Encircling the Woman with Three Horses
 on a Moonlit Night*. 1968.
 Oil on canvas, 92 × 72 cm.

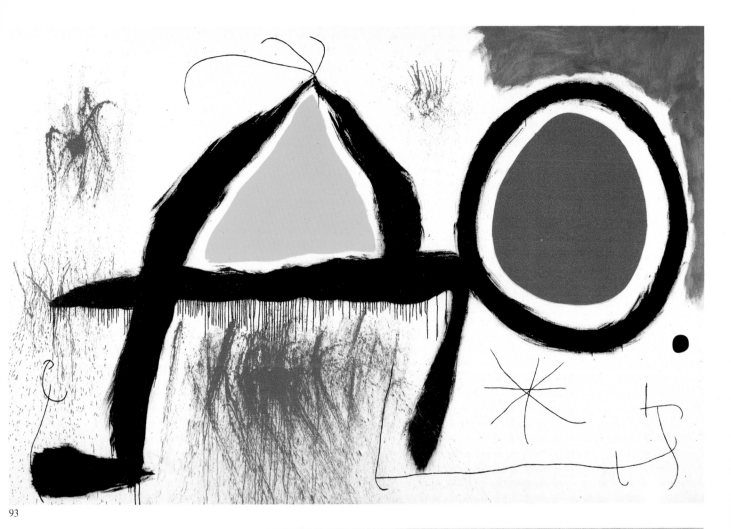

93

94

93. *Character before the Sun*. 1968.
Oil on canvas, 174×260 cm.
Joan Miró Foundation, Barcelona.

94. *Letters and Figures Attracted by a Spark*. 1968.
Oil on canvas, 146×114 cm.
Joan Miró Foundation, Barcelona.

95

95. *Poem I*. 1968.
 Oil on canvas, 205 × 174 cm.
 Joan Miró Foundation, Barcelona.

96

96. *Woman and Birds.* 1968.
Oil on canvas, 195 × 130 cm.
Joan Miró Foundation, Barcelona.

97

97. *Woman and Birds in the Night*. 1968. Oil on canvas, 205 × 195 cm.

98. *Woman and Birds in the Night*. 1968. Oil on canvas, 146 × 115 cm.

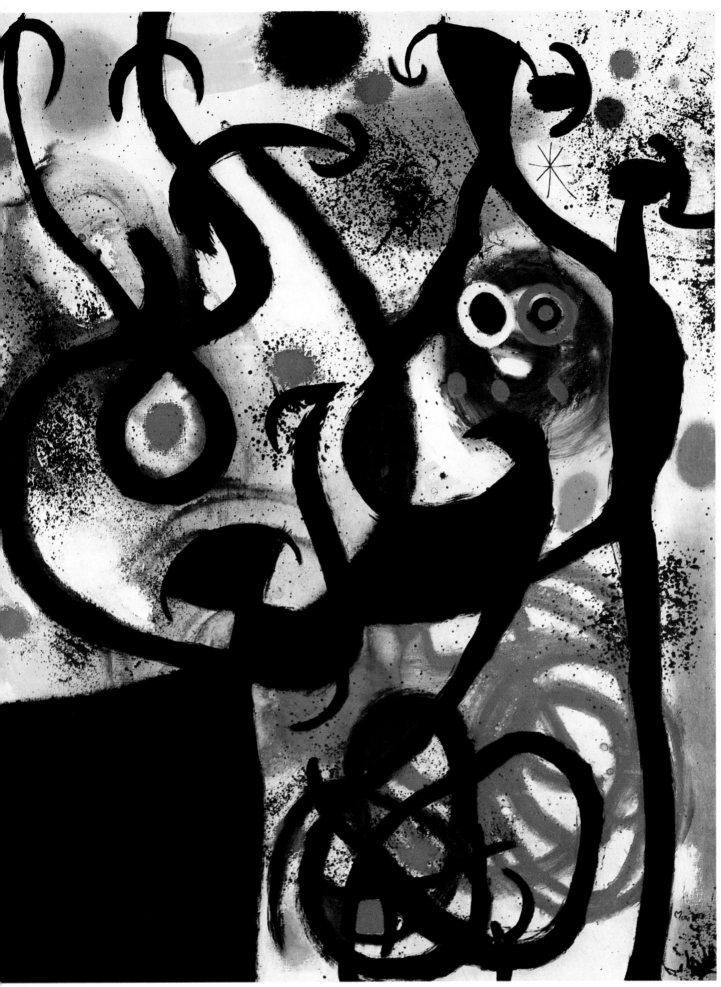

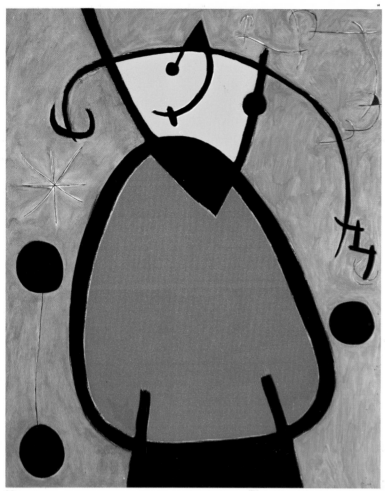

99

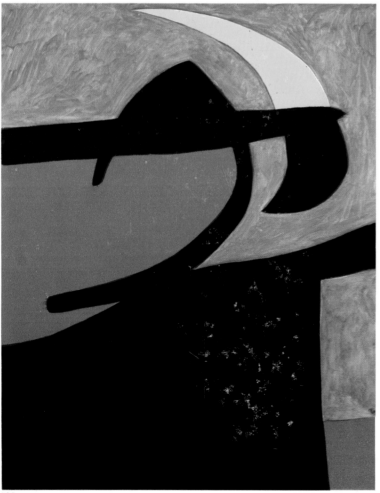

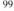

100

99. *The Break of Day*. 1968.
 Oil on canvas, 162 × 130 cm.
 Private collection.

100. *Catalan Peasant by Moonlight*. 1968.
 Oil on canvas, 162 × 130 cm.
 Joan Miró Foundation, Barcelona.

101

101. *Fascinating Character.* 1968.
Oil on canvas, 106 × 73 cm.

103

104

104. *Woman and Birds in the Night*. 1969-1974.
Oil on canvas, 244 × 174 cm.
Joan Miró Foundation, Barcelona.

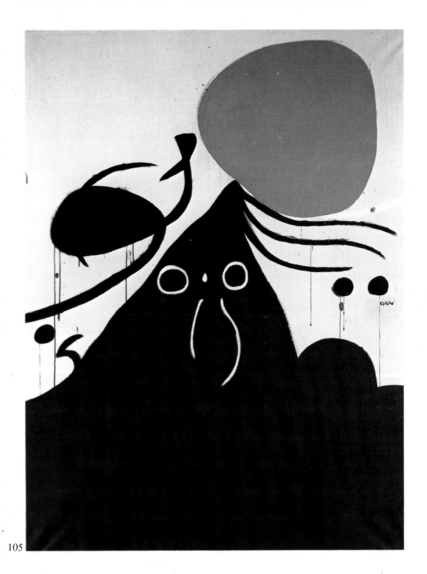

105

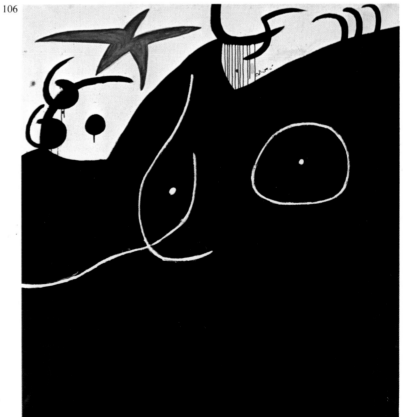

106

105. *Woman before the Sun*. 1974.
Oil on canvas, 260 × 195 cm.
Joan Miró Foundation, Barcelona.

106. *Woman before the Shooting Star*. 1974.
Oil on canvas, 205 × 195 cm.
Joan Miró Foundation, Barcelona.

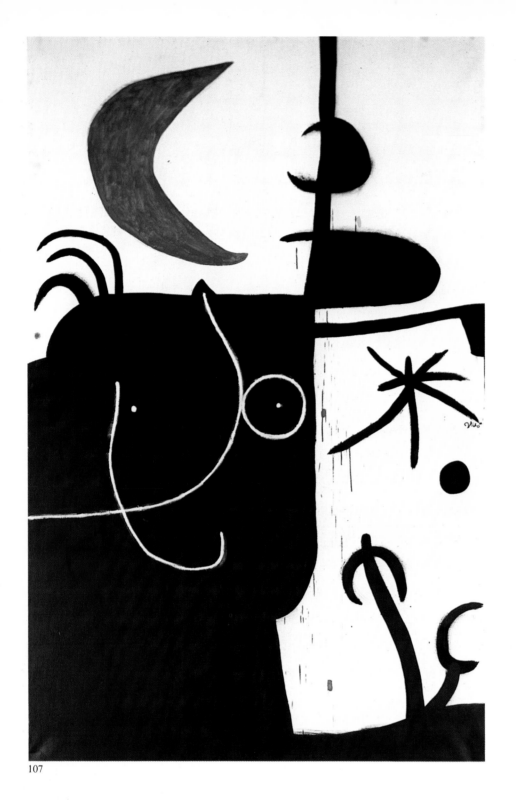

107

107. *Woman before the Moon.* 1974.
 Oil on canvas, 269 × 174 cm.
 Joan Miró Foundation, Barcelona.

108. *Woman in the Night.* 1974.
 Oil on canvas, 194 × 130 cm.
 Museum of the Provincial Council of Alava, Vitoria.

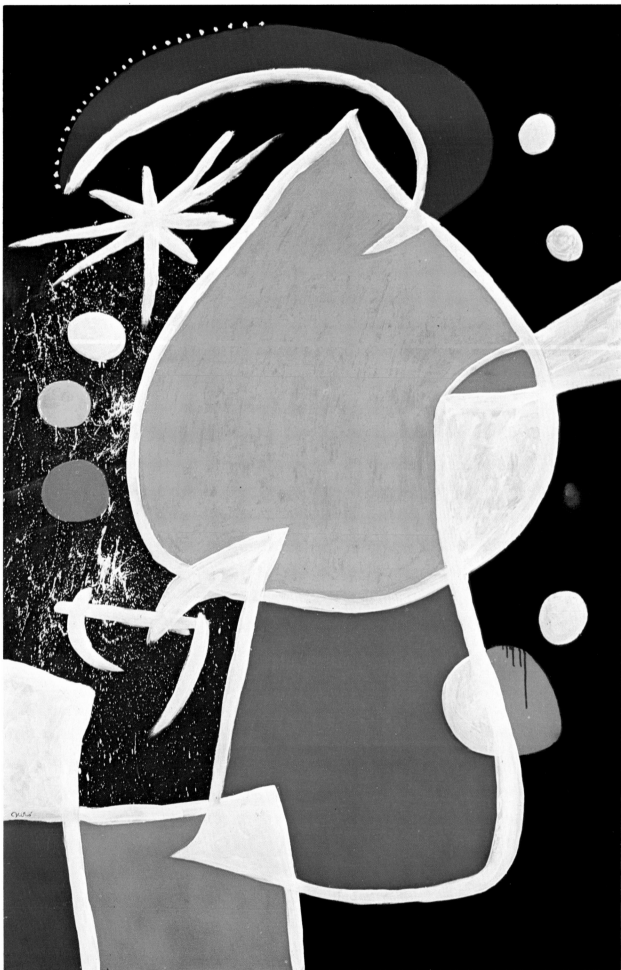

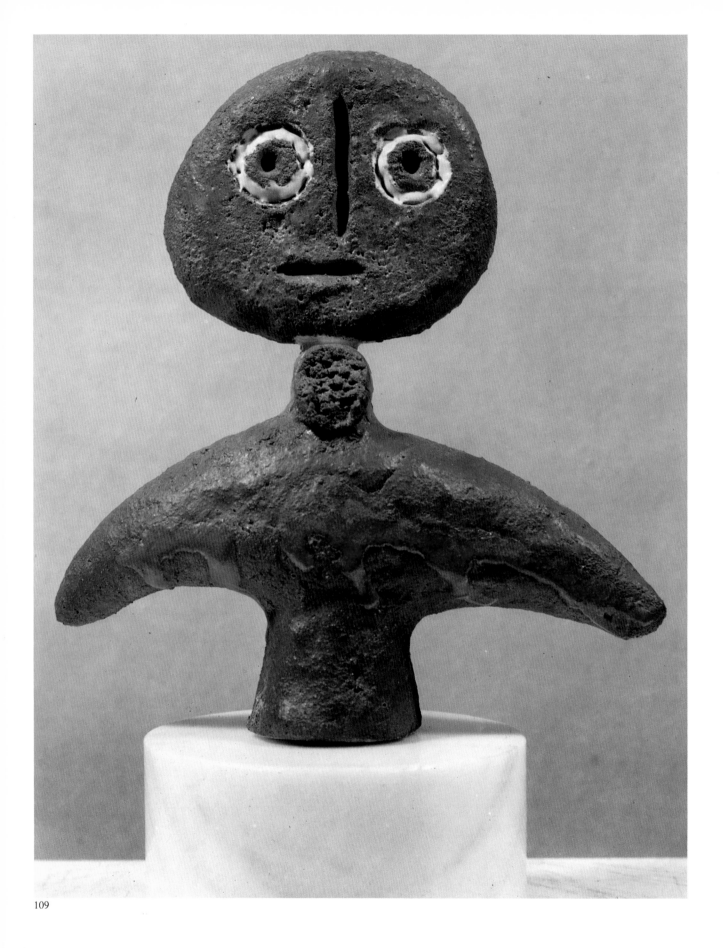

109

109. *The Little Owl.* 1954.
 Ceramic sculpture, 19×17 cm.

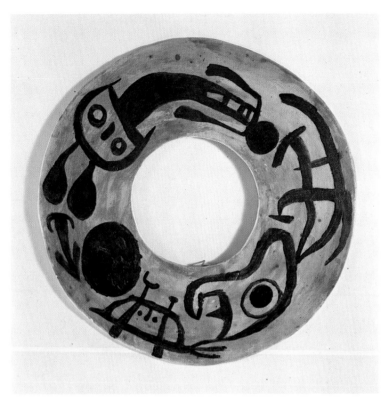

110

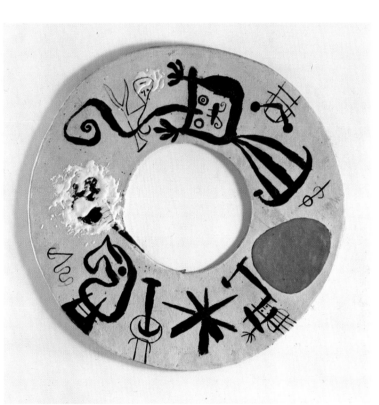

111

110. Antiplate, double-faced. 1956.
 Ceramic, diameter 50 cm.

111. Antiplate. 1956.
 Ceramic, diameter 50 cm.

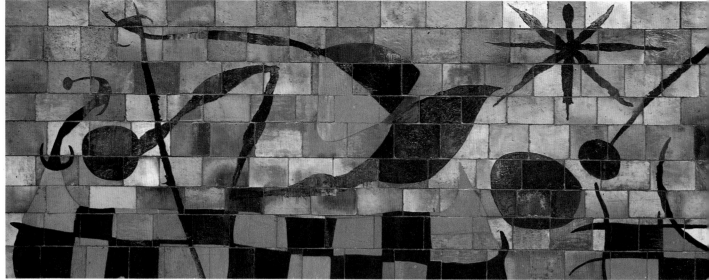

112

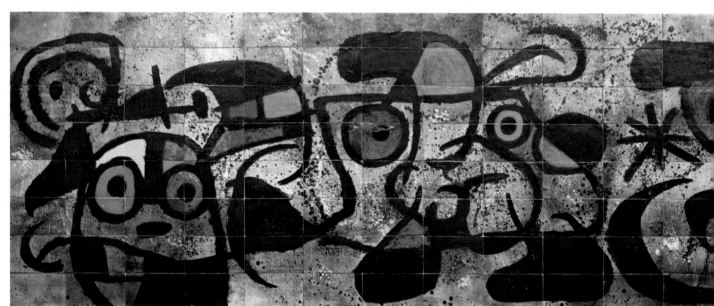

113

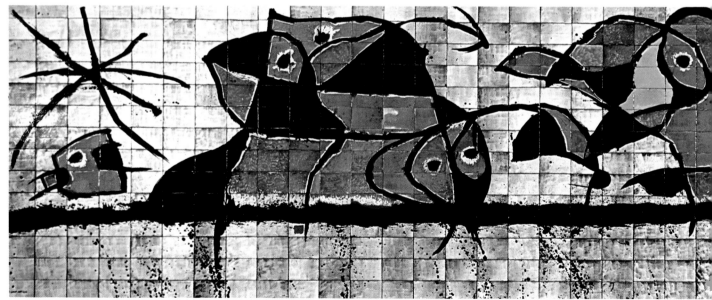

114

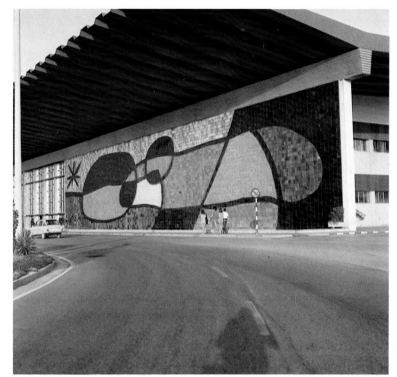

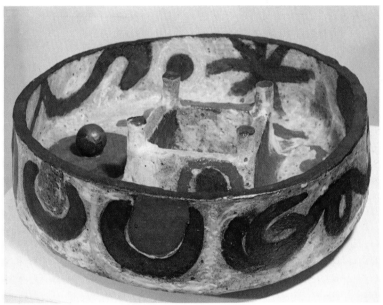

115

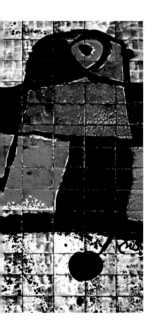

116

112. *Wall of the Moon.* 1957.
Ceramic, 3 × 7.5 m.
UNESCO Building, Paris.

113. Mural for Harvard University. 1960.
Ceramic, 2 × 6 m.

114. Ceramic mural at the IBM offices, Barcelona. 1976.
2.80 × 8.70 m. Ceramic plaques. Fire clay. Work executed
by Joanet Gardy Artigas, Gallifa.

115. Ceramic mural at Barcelona Airport. 1970.

116. *Architecture.* 1962.
Ceramic, 15 × 62.5 cm.

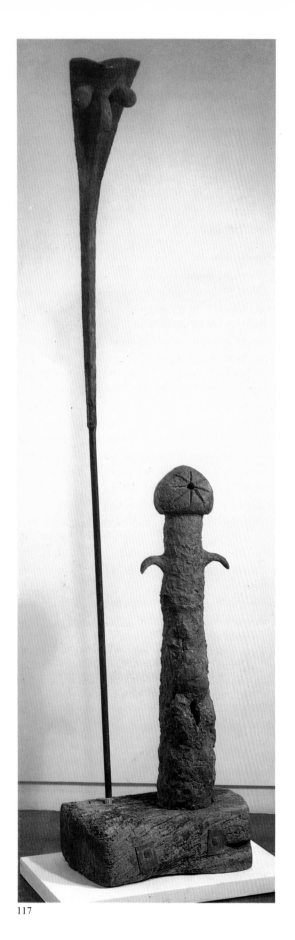

117

118

117. *Man and Woman*. 1962.
 Ceramic, wood and iron, 270 × 59 × 25 cm.

118. *Mask*. 1962.
 Ceramic and wood, 176 × 57 cm.

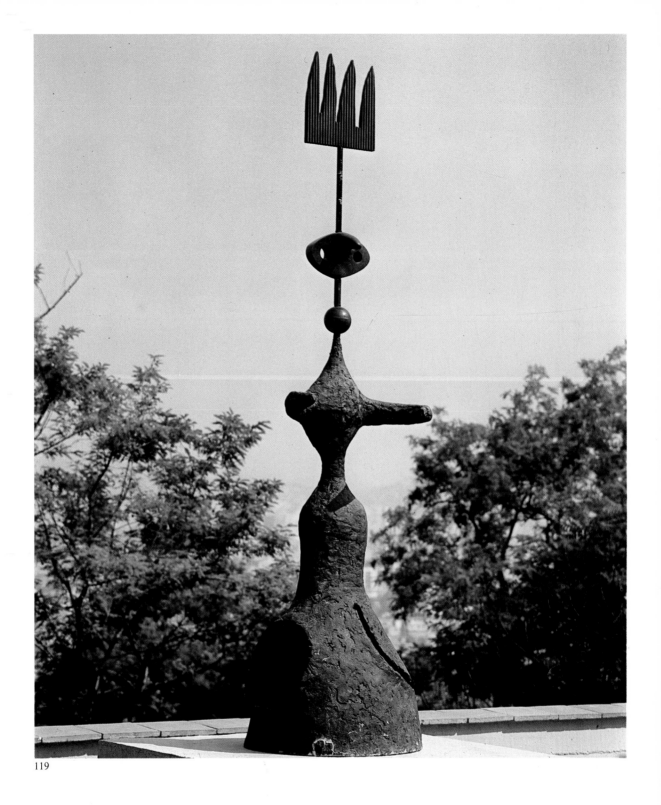

119

119. *Moon, Sun and a Star.* 1968.
Bronze and cement, 380 × 100 × 100 cm.
Joan Miró Foundation, Barcelona.

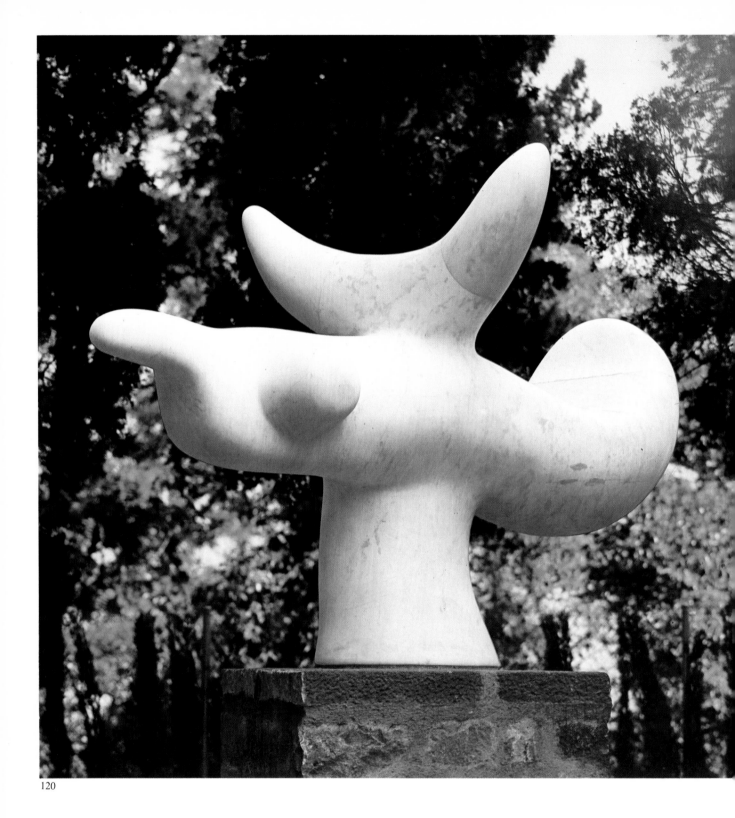

120

120. *Sun Bird*. 1968.
Carrara marble, 122 × 180 × 102 cm.
Joan Miró Foundation, Barcelona.

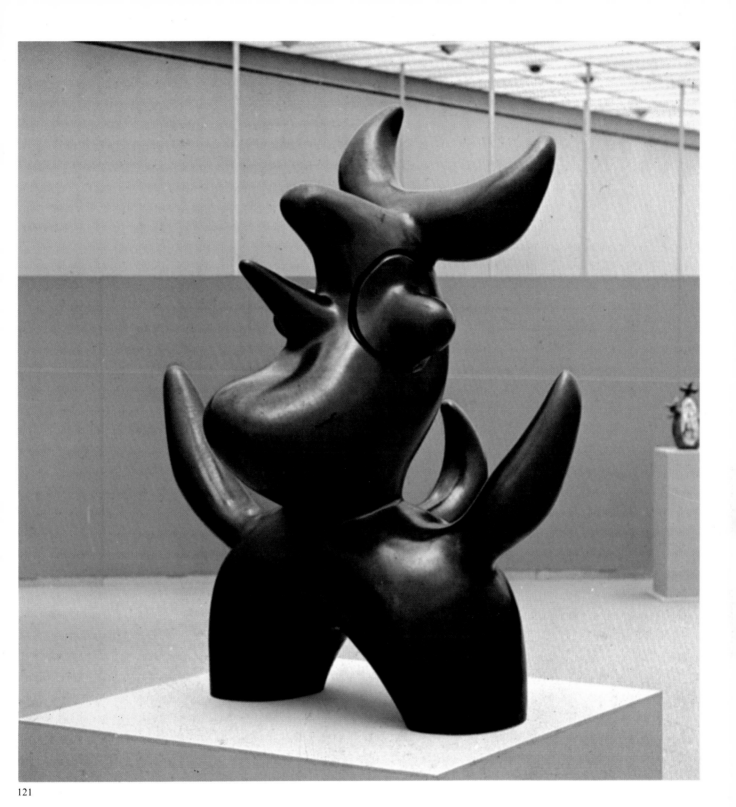

121

121. *Moon Bird.* 1966.
 Bronze, 230 × 205 × 147 cm.
 The Museum of Modern Art, New York.

122

123

122. *Character with Three Feet*. 1967.
Cast at the T. Clémenti foundry, Meudon.
Painted bronze, 215 × 55 × 50 cm.
Joan Miró Foundation, Barcelona.

123. *Man and Woman*. 1967.
Cast at the T. Clémenti foundry, Meudon.
Painted bronze, 68 × 38 × 38 cm.
Joan Miró Foundation, Barcelona.

124. *Woman and Bird*. 1967.
Painted bronze, 260 × 85 × 48 cm.
Private collection, Paris.

125

125. *Maternity*. 1969.
 Cast at the Parellada foundry, Barcelona.
 Bronze, 83 × 45 × 27 cm.
 Joan Miró Foundation, Barcelona.

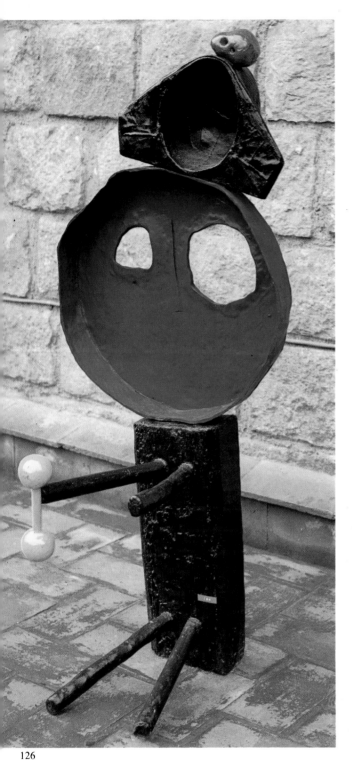

126

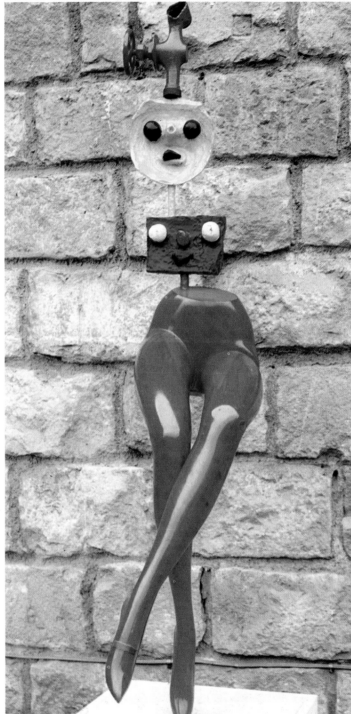

127

128

126. *Woman and Bird.* 1967.
 Cast at the T. Clémenti foundry, Meudon.
 Painted bronze, 135×50×42 cm.
 Joan Miró Foundation, Barcelona.

127. *Girl Running Away.* 1968.
 Cast at the Susse foundry, Arcueil.
 Painted bronze, 135×60×35 cm.
 Joan Miró Foundation, Barcelona.

128. Working maquette of sculptures intended for
 La Défense, Paris. 1976.
 Painted polyester. Right: height 480 cm; left: height 320 cm.
 Joan Miró Foundation, Barcelona.

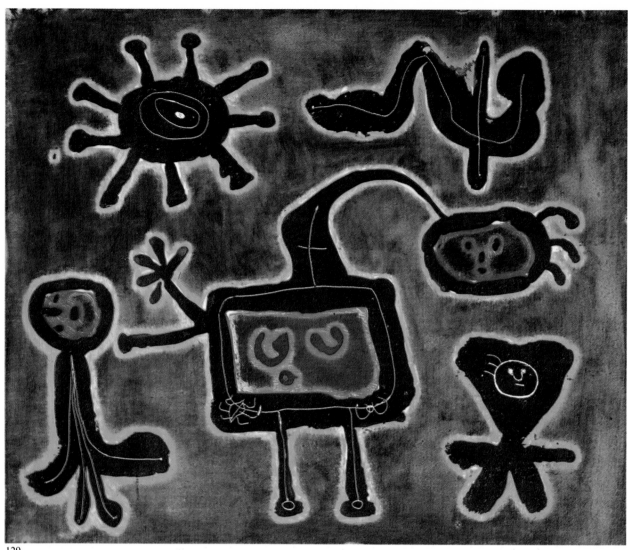

129

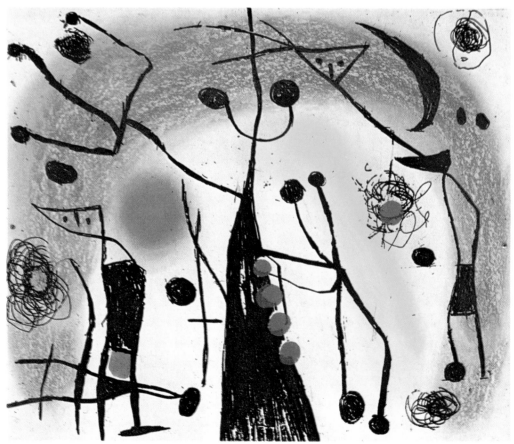

130

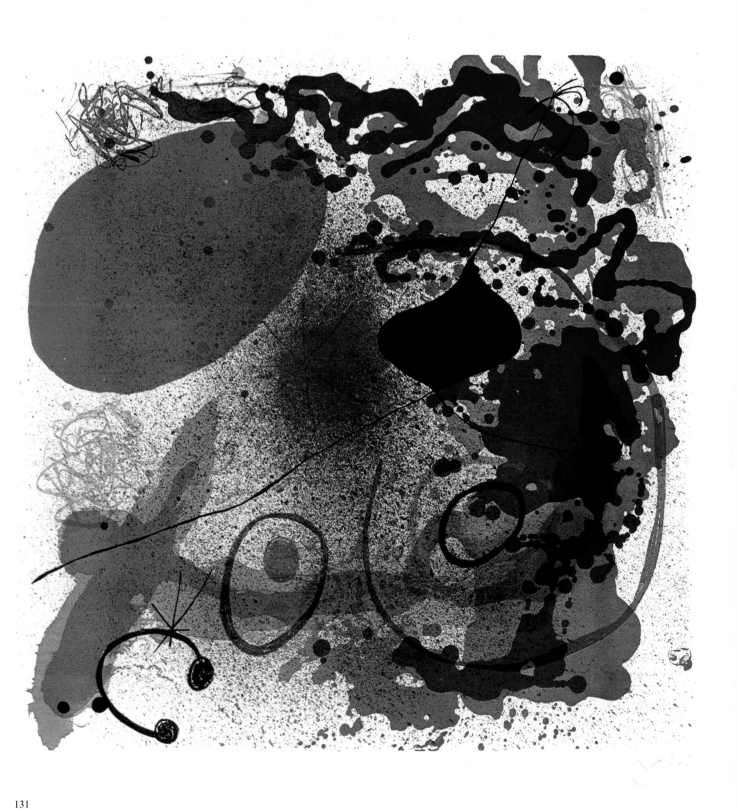

131

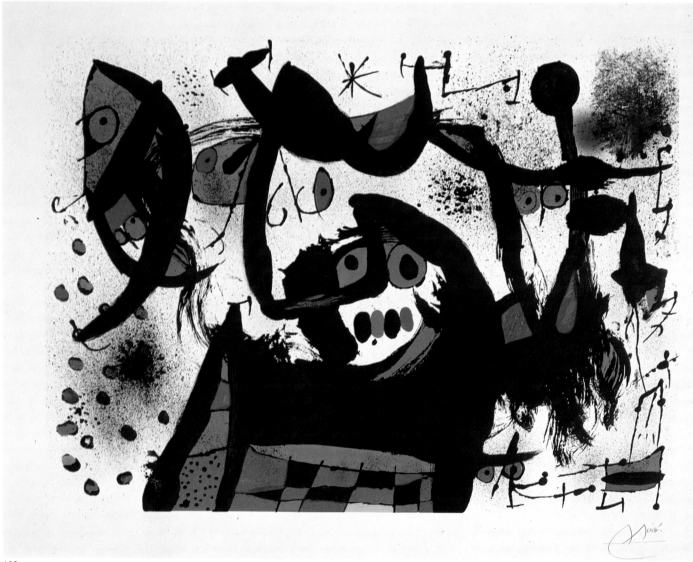

132

132. *Homage to Joan Prats.* 1971.
Series of 15 lithographs in colours,
65 × 86 cm.

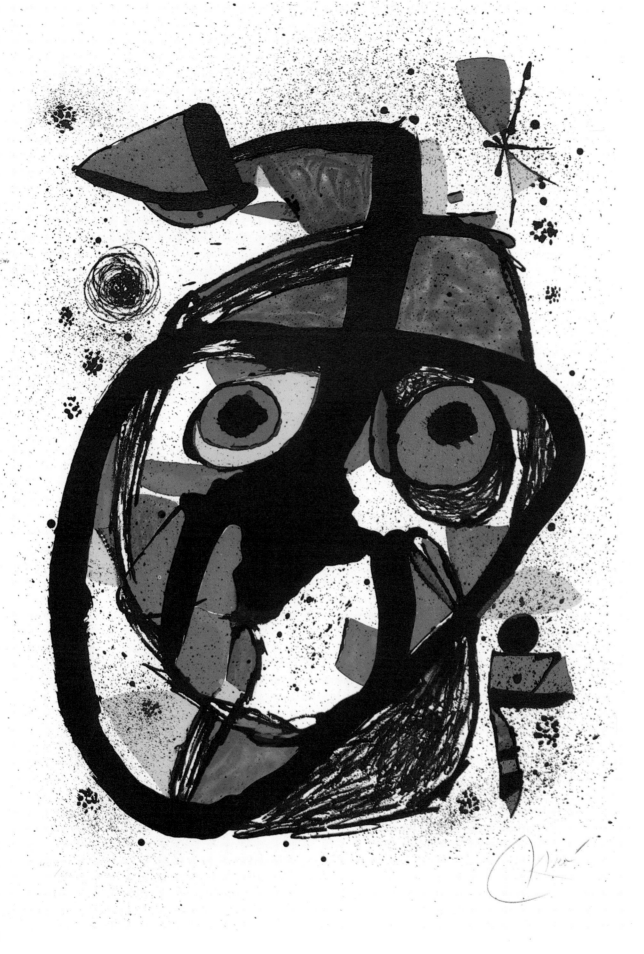

133

133. *Mask*. 1978.
Lithographs in colours, 56 × 76 cm.

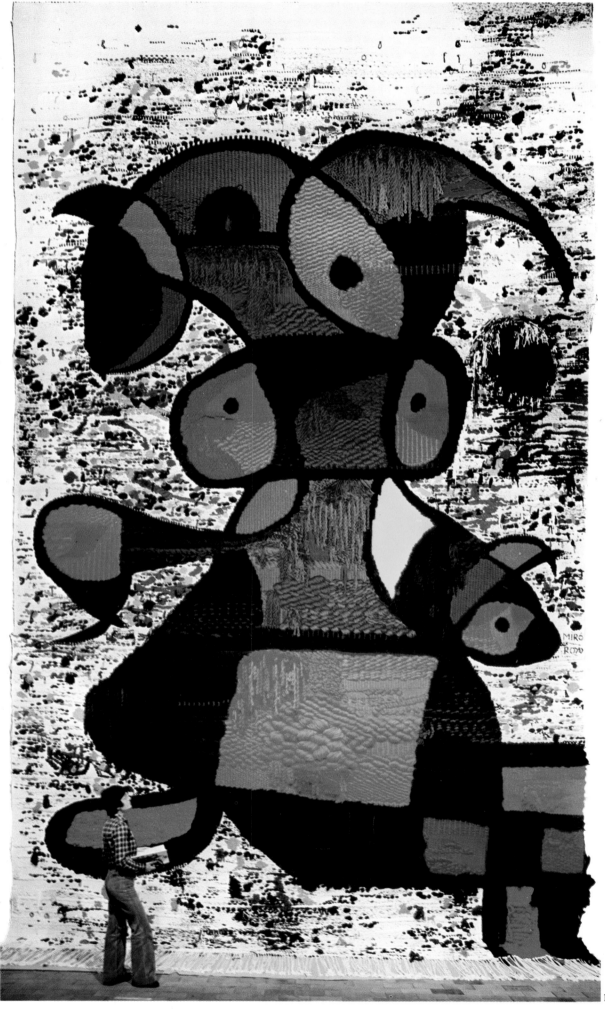

134

134. *Woman*. 1977.
Tapestry, with wool manufactured in Sabadell, 11×7 m.
Work executed by Josep Royo in Tarragona, following a maquette by Joan Miró.
National Gallery of Art, Washington.

135. *Great Tapestry*. 1974.
Wool, hemp and cord, 6×11 m.
Port Authority, New York.

135

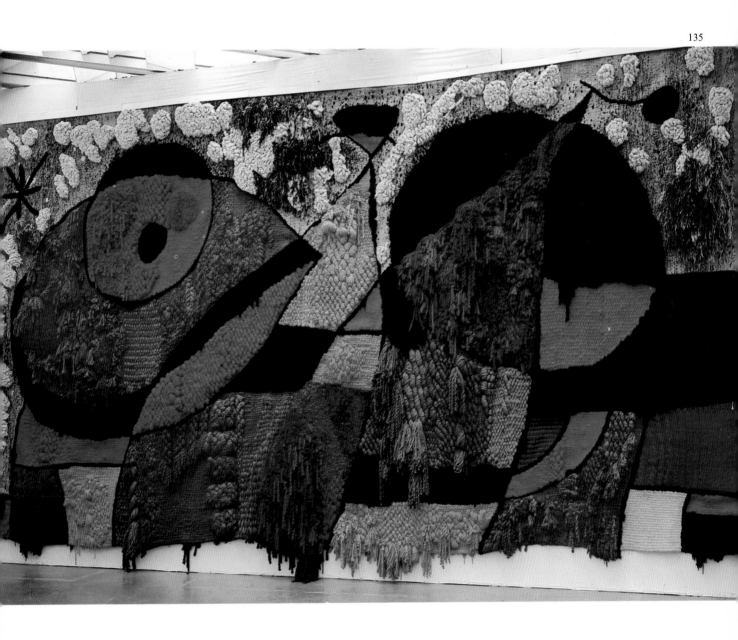

136

137

136. Building of the Architectural Association
of Catalonia and the Balearics, during the
exhibition "Miró otro," Barcelona, 1969.

137. Detail of the glass frontage of the Architectural
Association, during the exhibition "Miró otro."
Barcelona, 1969.

138-140. Three aspects of the puppets, masks and
decorations painted by Joan Miró for the work
Mori el Merma staged by the Claca Teatre group
in 1978.

Next page:

141. *Woman and Bird.* 1981-1982.
 Cement, most of which is covered
 by pottery fragments. 22 m.
 Work executed in collaboration with
 Joan Gardy-Artigas.

138

139

140

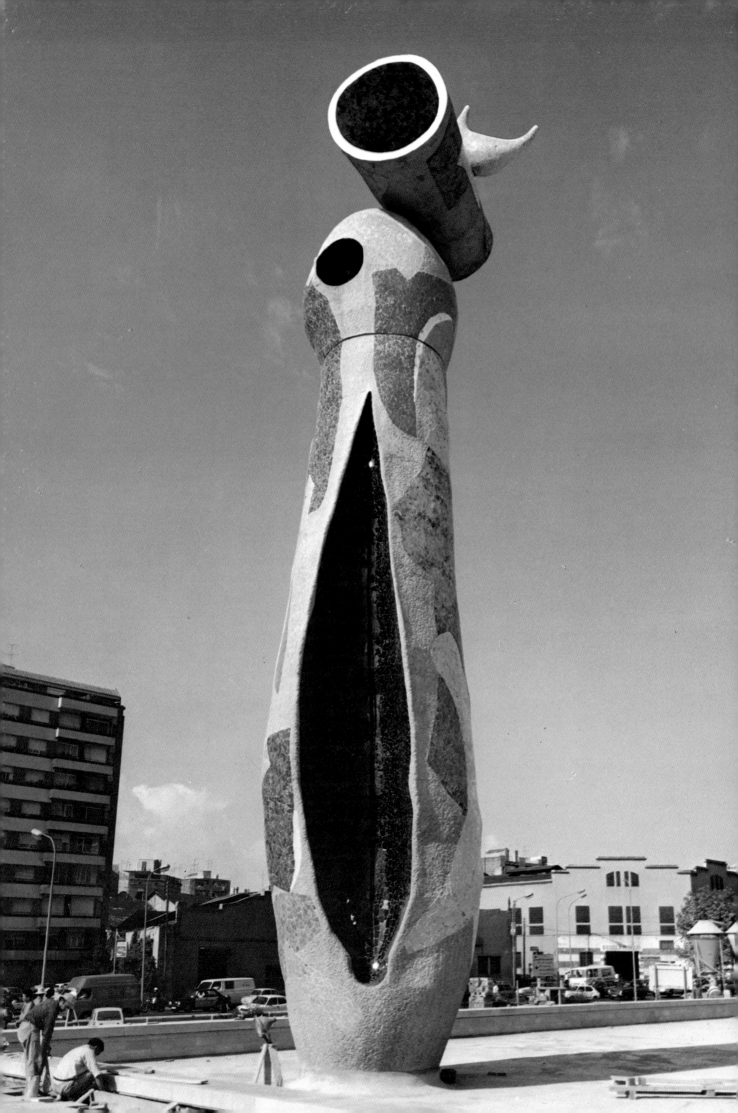

INDEX OF ILLUSTRATIONS

65. *Characters in the Night.* 1950.
Oil on canvas, 89×115 cm.
Genia Zadok Collection, New York.

66. *Dragonfly with Red Wings Pursuing a Serpent Gliding Spirally towards the Comet-Star.* 1951.
Oil on canvas, 81×100 cm.
Joan Miró Foundation, Barcelona.

67. *Smile of the Blazing Wings.* 1953.
Oil on canvas, 33×46 cm.
Pilar Juncosa de Miró Collection, Palma.

68. *Blue II.* 1961.
Oil on canvas, 270×355 cm.
Galerie Maeght, Paris.

69. *Blue III.* 1961.
Oil on canvas, 270×355 cm.
Pierre Matisse Gallery, New York.

70. *Red Disc.* 1960.
Oil on canvas, 130×165 cm.
Mr and Mrs Victor K. Kiam Collection, New York.

71. *Painting I.* 16-10-65.
Oil on canvas, 19×25 cm.

72. *Character and Bird.* 1963.
Oil on cardboard, 75×105 cm.

73. *Character and Bird.* 1963.
Oil on cardboard, 75×105 cm.

74. *Friend's Message.* 1964.
Oil on canvas, 264×275 cm.
Galerie Maeght, Paris.

75. *Women and Birds.* 1967.
Oil on wrinkled paper, 91×74 cm.

76. *For Emili Fernández Miró.* 1963.
Oil on canvas, 75×280 cm.
Emili Fernández Miró Collection, Palma.

77. *For David Fernández Miró.* 1964.
Oil on canvas, 75×280 cm.
David Fernández Miró Collection, Palma.

78. *Woman III.* 1965.
Oil on Canvas, 116×81 cm.
Joan Miró Foundation, Barcelona.

79. *The Skiing Lesson.* 1966.
Oil on canvas, 193×324 cm.
Galerie Maeght Collection, Paris.

80. *Song of the Vowels.* 1967.
Oil on canvas, 350×144 cm.
The Museum of Modern Art, New York.

81. *Woman and Bird in the Night.* 1967.
Oil on canvas, 78×60 cm.
Private collection, Paris.

82. *Bird in the Night.* 1967.
Oil on canvas, 190×277 cm.
Galerie Maeght, Paris.

83. *Character and Bird in the Night.* 1967.
Oil on canvas, 115×73 cm.

84. *Woman and Bird.* 1967.
Oil on canvas, 203×60 cm.
Galerie Maeght, Paris.

85. *The Wing of the Lark, Aureoled by the Blue of Gold, Reaches the Heart of the Poppy Sleeping on the Grass Adorned with Diamonds.* 1967.
Oil on canvas, 195×130 cm.
Pierre Matisse Gallery, New York.

86. *Bird's Flight by Moonlight.* 1967.
Oil on canvas, 130×260 cm.

87. *Hair Pursued by Two Planets.* 1968.
Oil on canvas, 195×130 cm.

88. *Drop of Water on the Pink Snow.* 1968.
Oil on canvas, 195×130 cm.
Galerie Maeght, Paris.

89. *Characters and Birds Rejoicing at the Coming of Night.* 1968.
Oil on canvas, 96×130 cm.
Antoni Tàpies Collection, Barcelona.

90. *The Gold of the Azure.* 1967.
Oil on canvas, 205×175 cm.
Joan Miró Foundation, Barcelona.

91. *The Flight of the Dragonfly before the Sun.* 1968.
Oil on canvas, 174×224 cm.

92. *Flight of Birds Encircling the Woman with Three Horses on a Moonlit Night.* 1968.
Oil on canvas, 92×72 cm.

93. *Character before the Sun.* 1968.
Oil on canvas, 174×260 cm.
Joan Miró Foundation, Barcelona.

94. *Letters and Figures Attracted by a Spark.* 1968.
Oil on canvas, 146×114 cm.
Joan Miró Foundation, Barcelona.

95. *Poem I.* 1968.
Oil on canvas, 205×174 cm.
Joan Miró Foundation, Barcelona.

96. *Woman and Birds.* 1968.
Oil on canvas, 195×130 cm.
Joan Miró Foundation, Barcelona.

97. *Woman and Birds in the Night.* 1968.
Oil on canvas, 205×195 cm.

98. *Woman and Birds in the Night.* 1968.
Oil on canvas, 146×115 cm.

99. *The Break of Day.* 1968.
Oil on canvas, 162×130 cm.
Private collection.

100. *Catalan Peasant by Moonlight.* 1968.
Oil on canvas, 162×130 cm.
Joan Miró Foundation, Barcelona.

101. *Fascinating Character.* 1968.
Oil on canvas, 106×73 cm.

102. *Woman and Bird before the Sun.* 1972.
Oil on canvas, 116×81 cm.
Private collection, Madrid.

103. *Burnt Canvas I.* 1973.
Oil on canvas, subsequently perforated and burnt, 130×195 cm.
Joan Miró Foundation, Barcelona.

104. *Woman and Birds in the Night.* 1969-1974.
Oil on canvas, 244×174 cm.
Joan Miró Foundation, Barcelona.

105. *Woman before the Sun.* 1974.
Oil on canvas, 260×195 cm.
Joan Miró Foundation, Barcelona.

106. *Woman before the Shooting Star.* 1974.
Oil on canvas, 205×195 cm.
Joan Miró Foundation, Barcelona.

107. *Woman before the Moon.* 1974.
Oil on canvas, 269×174 cm.
Joan Miró Foundation, Barcelona.

108. *Woman in the Night.* 1974.
Oil on canvas, 194×130 cm.
Museum of the Provincial Council of Alava, Vitoria.

109. *The Little Owl.* 1954.
Ceramic sculpture, 19×17 cm.

110. Antiplate, double-faced. 1956.
Ceramic, diameter 50 cm.

111. Antiplate. 1956.
Ceramic, diameter 50 cm.

112. *Wall of the Moon.* 1957.
Ceramic, 3×7.5 m.
UNESCO Building, Paris.

113. Mural for Harvard University. 1960.
Ceramic, 2×6 m.

114. Ceramic mural at the IBM offices, Barcelona. 1976.
2.80×8.70 m. Ceramic plaques. Fire clay.
Work executed by Joanet Gardy Artigas, Gallifa.

115. Ceramic mural at Barcelona Airport. 1970.

116. *Architecture.* 1962.
Ceramic, 15×62.5 cm.

117. *Man and Woman.* 1962.
Ceramic, wood and iron, 270×59×25 cm.

118. *Mask.* 1962.
Ceramic and wood, 176×57 cm.

119. *Moon, Sun and a Star.* 1968.
Bronze and cement, 380×100×100 cm.
Joan Miró Foundation, Barcelona.

120. *Sun Bird.* 1968.
Carrara marble, 122×180×102 cm.
Joan Miró Foundation, Barcelona.

121. *Moon Bird.* 1966.
Bronze, 230×205×147 cm.
The Museum of Modern Art, New York.

122. *Character with Three Feet.* 1967.
Cast at the T. Clémenti foundry, Meudon.
Painted bronze, 215×55×50 cm.
Joan Miró Foundation, Barcelona.

123. *Man and Woman.* 1967.
Cast at the T. Clémenti foundry, Meudon.
Painted bronze, 68×38×38 cm.
Joan Miró Foundation, Barcelona.

124. *Woman and Bird.* 1967.
Painted bronze, 260×85×48 cm.
Private collection, Paris.

125. *Maternity.* 1969.
Cast at the Parellada foundry, Barcelona.
Bronze, 83×45×27 cm.
Joan Miró Foundation, Barcelona.

126. *Woman and Bird.* 1967.
Cast at the T. Clémenti foundry, Meudon.
Painted bronze, 135×50×42 cm.
Joan Miró Foundation, Barcelona.

127. *Girl Running Away.* 1968.
Cast at the Susse foundry, Arcueil.
Painted bronze, 135×60×35 cm.
Joan Miró Foundation, Barcelona.

128. Working maquette of sculptures intended for La Défense, Paris. 1976.
Painted polyester. Right: height 480 cm; left: height 320 cm.
Joan Miró Foundation, Barcelona.

129. *Series I.* 1952-1953.
Etching in colours, 38×45.5 cm.

130. *The Magdalenian.* 1958.
Etching in colours, 11.5×14 cm.

131. *Beating II.* 1968.
Lithograph in colours, 65.5×63 cm.

132. *Homage to Joan Prats.* 1971.
Series of 15 lithographs in colours, 65×86 cm.

133. *Mask.* 1978.
Lithographs in colours, 56×76 cm.

134. *Woman.* 1977.
Tapestry, with wool manufactured in Sabadell, 11×7 m.
Work executed by Josep Royo in Tarragona, following a maquette by Joan Miró.
National Gallery of Art, Washington.

135. *Great Tapestry.* 1974.
Wool, hemp and cord, 6×11 m.
Port Authority, New York.

136. Building of the Architectural Association of Catalonia and the Balearics, during the exhibition "Miró otro," Barcelona, 1969.

137. Detail of the glass frontage of the Architectural Association, during the exhibition "Miró otro." Barcelona, 1969.

138-140. Three aspects of the puppets, masks and decorations painted by Joan Miró for the work *Mori el Merma* staged by the Claca Teatre group in 1978.

141. *Woman and Bird.* 1981-1982.
Cement, most of which is covered by pottery fragments. 22 m.
Work executed in collaboration with Joan Gardy-Artigas.